The Complete Guide to

digitaltype

HUMBER COLLEGE LIBRARY
205 HUMBER COLLEGE BLVD
P.O. BOX 1900
REXDALE, ONTARIO, CANADA
M9W 5L7

W9-CME-002

Creative Use of Typography
in the Digital Arts

123abcdefghijklmnopqrstuvwxyz

abcdefghijklmno

The Complete Guide to

digital type

Creative Use of Typography in the Digital Arts

Andy Ellison

HUMBER COLLEGE LIBRARY
205 HUMBER COLLEGE BLVD.
P.O. BOX 1900
REXDALE, ONTARIO, CANADA
M9W 5L7

160101

abcdefghijklmnopqrstuvw

COLLINS | DESIGN

An Imprint of HarperCollinsPublishers

THE COMPLETE GUIDE TO DIGITAL TYPE:
CREATIVE USE OF TYPOGRAPHY IN THE
DIGITAL ARTS
Copyright © 2006 Axis Publishing Ltd.

All rights reserved. No part of this book may be used
or reproduced in any manner whatsoever without
written permission except in the case of brief
quotations embodied in critical articles and reviews.
For information, address Collins Design, 10 East 53rd
Street, New York, NY 10022.

HarperCollins books may be purchased for
educational, business, or sales promotional use.
For information, please write: Special Markets
Department, HarperCollins Publishers Inc.,
10 East 53rd Street, New York, NY 10022.

First Edition

First published in the United States in 2006 by:
Collins Design
An Imprint of HarperCollins*Publishers*
10 East 53rd Street
New York, NY 10022
Tel: (212) 207-7000, Fax: (212) 207-7654
collinsdesign@harpercollins.com
www.harpercollins.com

Distributed throughout the Americas by:
HarperCollins*Publishers*
10 East 53rd Street
New York, NY 10022
Fax: (212) 207-7654

Created and conceived by Axis Publishing Ltd.
8c Accommodation Road
London NW11 8ED, UK
www.axispublishing.co.uk

Creative Director: Siân Keogh
Editorial Director: Anne Yelland
Managing Editor: Conor Kilgallon
Design: Sean Keogh, Simon de Lotz
Production: Jo Ryan, Cécile Lerbière

Library of Congress Cataloging-in-Publication Data

Ellison, Andy, 1967-
 The complete guide to digital type / Andy Ellison.--
1st ed.
 p. cm.
 ISBN 0-06-072792-6 (pbk.)
 1. Type and type-founding--Digital techniques. 2.
Computer fonts. I. Title.
 Z250.7E45 2006
 686.2'2544--dc22
 2005029204

Printed in China

First printing, 2006

contents

■ introduction

Typography is a craft that, until relatively recently, was practiced only by skilled individuals. It required a meticulous eye for detail and knowledge of legibility that few people possessed. Traditionally, graphic designers worked in conjunction with typographers (and printers) to set type, rather than learn the intricacies themselves.

When Apple introduced the Macintosh in 1984, all that changed. This new computer allowed designers to set type and manipulate it in ways that had not been previously possible or financially feasible. It gave them the freedom to experiment and a new way of working; type became just another element within the overall design composition. This freedom also prompted designers to question the rules held dear by previous generations of typesetters and enabled them to use typography in new and creative ways.

This book provides an insight into the typographic creativity produced by this digital revolution. It takes you through a brief history of typography and the anatomy and various classifications of fonts. You will see the influence that digital media has had on the practice of typography, in particular the role of software and digital formats.

Then you will see the conventions that govern typography. These conventions, laid down over time, provide a framework for creating legible text, both for display purposes and extended reading. These rules always apply, whether using digitally generated type or traditional methods. Also, the way in which text is used on the page is very important in determining its readability, so you will see how to use grid structures, then learn how to manage your digital fonts using software such as Suitcase Fusion.

Designers need to create maximum impact with their typography. You will see at length the various effects that can be applied to type using software such as Adobe Photoshop, Illustrator, and FreeHand. The rise of the internet has made reading type on screen as important as reading it on paper, so this effects section been divided in two, looking at print- then screen-based typography. The section on print deals with static display typography and demonstrates how to achieve a myriad of different effects, from mimicking screen-printing to warping and distressing type.

Since the internet can carry dynamic content as well as static type, you will see how to be creative with moving typography, within the limitations imposed by screen technology. These limitations are explored, showing you the typefaces and methods used to improve on-screen type recognition, along with a look at animation techniques.

Manipulating fonts is one thing but generating your own typefaces is something else. So the final section looks at font creation, taking you from a set of sketches to a working typeface, explaining the process of building and digitizing letterforms and creating font formats for use with both Mac and PC platforms. Because applications such as Fontographer and FontLab allow you to design and publish a font in a matter of hours, you will see how to construct various pieces of homemade typography, such as handwritten, modular, and hybrid fonts, including how to deal with spacing and kerning.

Together, you will learn how to create original, contemporary digital typography that is both beautiful and technically accurate.

typography and fonts

In order to produce beautiful, legible typography, the user must have a good knowledge of the subject: it is not simply a case of making type look pretty on the page. A typographer must also understand how the viewer will read and interpret the information displayed, and should know what is available in terms of fonts and printing techniques. With a brief history of printing technology and how it has advanced typographic composition, this section explains the terminology used to describe typography. There is also a discussion on the implications of digital technology.

a history of typography

In order to understand why typography looks the way it does, it is important to know how technological developments have affected the nature of typography over the centuries.

The modern-day practice of printing began with the advent of mechanization and, in particular, with the invention of moveable type, credited to Johann Gutenberg. He produced the first printed book, a 42-line Bible, between 1450 and 1455. Imitating the writing of contemporary scribes, he created over 300 characters to produce the various letterforms, including ligatures. Besides his Bible, Gutenberg's greatest legacy was the printing process and, in particular, punch cutting.

Punch cutting involved cutting the design of a glyph, in reverse, onto the end of a steel bar—the punch. Each character needed its own punch. These were then assembled to form words and sentences, which were printed using the letterpress.

early commercial printing

This process of hand composition was the first commercial printing method—a process of relief printing in which a raised, inked surface was pressed against the paper, leaving an impression of the ink behind. A typographer would use a composing stick to assemble type into words, character by character. Metal spaces were added between the words to justify the text over the desired measure and each line of type was separated from the next by a strip of lead (hence the term "leading"). Once set, the type was locked in a heavy metal frame, called a chase, and transferred to the press for printing.

The process was time-consuming and, with the invention of the Linotype and Monotype machines, was relegated to small independent printers who dedicated themselves to small print runs. Today it is undergoing a revival among a number of designers, such as Vince Frost, who appreciate the inaccuracies of the process: improperly inked letters can appear patchy and have a more handcrafted look to them.

the hot-metal revolution

Printing processes gained considerable speed with the introduction of "hot-metal" type. The term refers to the process of casting lines of type in molten metal. It had a huge impact on the printing industry. The first Linotype hot-metal line-casting machine was introduced in 1886. It comprised of a keyboard, matrix, and caster. The keyboard controlled the assembly of the matrix of letters. When a line was completed, it was cast as a single piece of metal, called a "slug." The slugs were then arranged to make up the required design for inking up and printing.

In 1887, the Monotype composing machine appeared, which cast each character individually. The keyboard and caster were separate, with the keyboard operation

⩬ Uncials and Black letter date back to the Middle Ages. By today's standards they are difficult to read when set in large amounts due to their heavy stroke widths: we are used to less complicated glyphs.

abcdefghijklmno
pqrstuvwxyz

ABCDEFGHI
JKLMNOPQRS
TUVWXYZ

generating a punched paper ribbon. When this was fed through the caster it gave instructions to move the type into position to produce the lines of text. These were then assembled in a galley to be printed from. Letters were cast quickly with this machinery (up to 150 per minute) and, since the keyboard was a separate entity, operators could generate type away from the noise of the machinery.

the age of phototypesetting

Electronics have played a key role in the progression of professional printing techniques and also in the availability of cheap and accurate ways to reproduce type for the home user.

The first generation of keyboard phototypesetters was introduced in 1950. Many others have been developed since but, despite this, they break down into two categories. These are Photo-optical and Photo-scanning systems. Photo-optical systems store characters in the form of a master font on film, disks, grids, or strips. These negative images are then optically projected onto photographic film or paper.

Photo-scanning also stores characters in the form of a master font, but they are not projected onto film or paper. Instead, they are scanned electronically and broken down into dots or lines. They are projected onto a cathode-ray tube (CRT), then onto photographic film or paper.

The advantages of this method over hot-metal type are significant: it is fast and flexible and can set up to 500 characters per second as opposed to just five using hot-metal machines.

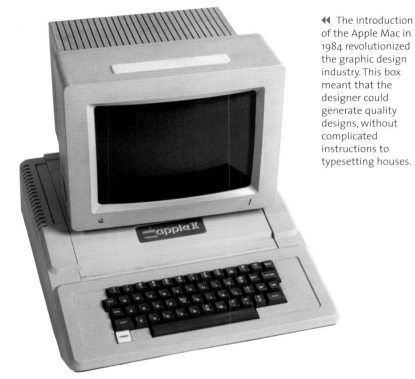

◀◀ The introduction of the Apple Mac in 1984 revolutionized the graphic design industry. This box meant that the designer could generate quality designs, without complicated instructions to typesetting houses.

The current mode of printing type professionally is that of digital typesetting. The first machine to use digitized fonts was the Digiset in 1965, designed by Dr. Ing Rudolph Hell. The method used a CRT to generate the image. It later gave way to the use of a laser with the introduction of the Monotype Lasercomp in 1976.

The 1980s witnessed considerable changes in the design world. Personal computers came down in price, WYSIWYG displays appeared and, most importantly, in 1984, the PostScript page language appeared via the Pagemaker software for the Apple Macintosh. The PostScript language enabled typefaces from any manufacturer to be used on any compatible computer and printer. Previously, this had been impossible and printing presses had only been able to use fonts released by the manufacturer of the press.

This upheaval resulted in a dramatic change in the relationship between typesetting and design. Computer workstations could now be networked directly to presses. Where, previously, designers had prepared pencil sketches for client approval, sending detailed instructions to the typesetting houses, each stage could now take place on a computer, complete and ready to print, cutting both time and expense.

One major difference between this and previous methods of printing type is that there is no physical type. The font information is stored as data in the computer's memory, viewed on screen and output directly onto paper, plate, or digital press cylinder for offset lithography.

anatomy of a typeface

It is essential to know and understand typography in order to use it convincingly and competently. This includes learning the terminology involved.

Innovations in typography have developed over centuries and, as a result, much of the terminology involved derives from technology that is now redundant. A good number of the terms we use today have no direct bearing on the generation of digital type. Type itself has a vocabulary and terminology and, in order to describe typography and identify fonts accurately, it is favourable to know and understand the basic technical properties of the characters that make up a font. Mastering these will help you to use type more appropriately within your design projects.

Just as our bodies are made up of different parts, each with its own anatomical name so, too, are type forms. This anatomy of type helps designers not only to identify one font from another but also helps identify faces for specific purposes, based on the curves, serifs, or stroke widths from which they are created. These are the factors that generate a font's personality.

Although each font has its own characteristics that distinguish it visually from other fonts, it also has a number of common reference points, to which all fonts conform. For example, each has a baseline on which the letters sit, an "x-height" to determine the height of lowercase letters, an ascender line, and a descender line. Although the measurements of these notational points may vary from font to font, they will always appear, giving us a range of visual clues with which to compare fonts.

Studying letterforms aids us to understand why certain fonts are more elegant than others—or more quirky. It is precisely for these reasons that we may choose to use a particular font or not. Some fonts have a large x-height-to-ascender ratio and so lend themselves well to display text. Conversely, those with a small x-height are better suited to body copy. Understanding how a well-proportioned font is constructed will also help if you are planning to design any fonts of your own.

THE BASIC TERMINOLOGY OF LETTERFORMS

Apex
The peak of the triangle on an uppercase "A."

Arm
A projecting horizontal stroke that is unattached on one or both sides, such as in a capital "E."

Ascender
The stroke on a lowercase letter, which rises above the x-height.

Bowl
A curved stroke, which encloses a counterform.

Counter
The negative space that is fully or partially enclosed by a letterform.

Crossbar
A horizontal stroke that connects two sides of a letterform.

Descender
The stroke on a lowercase letterform that extends below the baseline.

Ear
A small stroke that extends from the upper right side of the bowl on a lowercase "g."

Eye
The enclosed counterform of the lowercase letter "e."

Hairline
The thinnest stroke of a typeface of varying stroke widths.

Leg
The diagonal stroke in the lower half of a lowercase "k."

Link
The stroke that connects the bowl and the loop of a lowercase "g."

Loop
The bottom half of a lowercase "g."

Serif
Short strokes that extend from, and to, the major strokes of letters.

Shoulder
A curved stroke extending from a stem.

Spur
A projection, smaller than a serif, that reinforces the point at the end of a curved stroke.

Stem
A major vertical or diagonal stroke within a letterform.

Tail
A diagonal stroke or loop at the end of a letter.

Terminal
The end of any stroke that does not terminate with a serif.

serif · crossbar · ascender · cap line · ascender line

T l f p c x

shoulder · bowl · spur · x-line

x-height

stem · descender · counter · terminal

descender line

◀◀ All typography sits on a baseline and has set depths for ascenders, descenders, and capitals. The x-height is the height of lowercase letters as determined by the height of a lowercase letter "x."

slab serif

E

◀◀ A slab-serf letterform differs from a regular serif in that the stoke width is uniform all the way around. The serifs do not taper, as you would normally expect to see.

arm

g

ear

loop

link

k

hairline

leg

apex

A

▲ Hairlines refer to the thin serifs, which contrast with the thicker strokes of the rest of the letterform as demonstrated here on this lowercase "k."

e

eye

◀◀ Certain glyphs have terms that are unique only to them, such as the eye of a lowercase "e," the apex of an uppercase "A" and the loop of a lowercase "g."

descriptions and font classifications

Fonts are classified in categories, based on their visual and historical characteristics. This gives us an insight into their construction and helps identify them precisely.

There are numerous fonts available digitally and the choice can be very daunting for today's designer. There have been attempts to classify typefaces but it has proved challenging because many fonts have similar visual traits. One of the most widely used forms of classification is based on historical developments, and yet some of the most recent typeface designs are difficult to place within this classification because digital fonts do not necessarily conform to the historical standards of legibility. Many of them knowingly and deliberately break the rules and, as such, are in a class of their own.

old style or old style humanist

Known in the past as Venetian, these fonts were originally inspired by carved Roman capitals and based on 15th-century minuscules. Such fonts are identified by an oblique cross stroke on the lowercase "e," along with internal stresses of an angled nature. The forms are more rounded and have angled serifs on the tops of the lowercase letters.

transitional

Faces in the 1700s evolved from old style to modern. Those in the interim period, which include Baskerville, are classified as transitional. There is a greater contrast between the thick and thin strokes, with a more horizontal stress within the letterforms. Transitional fonts also appear wider than old style fonts.

modern

Modern typefaces, such as Bodoni, have more contrast between thick and thin strokes—the thin strokes are sometimes reduced to hairline widths. Stresses within characters are horizontal and serifs join stems horizontally, with no bracketing.

slab serifs

These typefaces are sometimes known as Egyptian faces. At the time they were introduced (around 1815) there was a huge interest in Egyptian artefacts and so some foundries used the term for their type designs. These fonts have heavy square, or rectangular, serifs. In many of the fonts, the stroke widths are uniform and there are horizontal stresses within characters.

sans serif (grotesques)

These first appeared in the 19th century. The characters have vertical stresses with no serifs and some contrast in stroke width. This group also covers categories such as Neogrotesque, Geometric, and Humanist. Neogrotesques are uniform in stroke width. Geometric typefaces are created using simple geometric shapes, such as the circle or rectangle. They have a single-storey lowercase letter "a." Finally, Humanist faces are based on the proportions of old style Humanist fonts but without serifs. They have some contrast in their stroke widths and have two-storey lowercase letters "a" and "g."

OLD STYLE

GARAMOND: abcdefghijklmnopqrstuvwxyz

ABCDEFGHIJKLMNOPQRSTUVWXYZ 1234567890.,?":;&%!-{}

BEMBO: abcdefghijklmnopqrstuvwxyz

ABCDEFGHIJKLMNOPQRSTUVWXYZ 1234567890.,?":;&%!-{}

◀◀ Old style fonts include Garamond and Bembo, designed during the 16th and 17th centuries.

TRANSITIONAL

BASKERVILLE: abcdefghijklmnopqrstuvwxyz

ABCDEFGHIJKLMNOPQRSTUVWXYZ 1234567890.,?":;&%!-{}

◄◄ Transitional fonts include Baskerville. They have wider forms and have no middle serifs on uppercase "W."

MODERN

BODONI: abcdefghijklmnopqrstuvwxyz

ABCDEFGHIJKLMNOPQRSTUVWXYZ 1234567890.,?":;&%!-{}

◄◄ Modern faces include Bodoni. They have a high contrast between the weight of strokes and serifs.

EGYPTIAN

ROCKWELL: abcdefghijklmnopqrstuvwxyz

ABCDEFGHIJKLMNOPQRSTUVWXYZ 1234567890.,?":;&%!-{}

◄◄ Egyptian faces, also known as slab serifs, have heavy rectangular serifs of uniform width.

SANS SERIF

HELVETICA: abcdefghijklmnopqrstuvwxyz

ABCDEFGHIJKLMNOPQRSTUVWXYZ 1234567890.,?":;&%!-{}

◄◄ Sans serif faces have uniform stroke widths and tend to be condensed.

UNIVERS: abcdefghijklmnopqrstuvwxyz

ABCDEFGHIJKLMNOPQRSTUVWXYZ 1234567890.,?":;&%!-{}

EUROSTILE: abcdefghijklmnopqrstuvwxyz

ABCDEFGHIJKLMNOPQRSTUVWXYZ 1234567890.,?":;&%!-{}

OPTIMA: abcdefghijklmnopqrstuvwxyz

ABCDEFGHIJKLMNOPQRSTUVWXYZ 1234567890.,?":;&%!-{}

descriptions and font classifications continued

Some of the terminology used in typography has been influenced by historical factors. This bears little relation to digital formats and typesetting today, but it is valuable to know where the terminology originates from and, more importantly, how it is used.

the em square

An em is a unit of measurement for any given typeface. The term derives from the width of an uppercase "m." This letter was originally as wide as the point size when cast in metal. For example, in a 10-point font, the capital letter "M" should be 10 points wide. This means that the measurement of an em is a square of equal size to the point size. An em dash is so called because it is the width of this square. (An en dash is half this size). Nowadays. with digital typography, the letter "m" has no real relationship to an em measurement, but the term has remained. When typesetting, paragraph indents are usually an em width, equal to the point size.

upper- and lowercase letters

Many people wonder why we have the terms upper- and lowercase to describe the characters within a font. As with much of the terminology used for typography, this derives from the printing trays that where used for storing the type. Two trays were used for each font, one stored above the other. The top tray, or upper case, was used for capital letters, while the bottom tray (lower case), held all the non-capital letters. The terms have stayed with us, despite bearing no relation to digital type.

point size

Type is measured in points, the term deriving from the days of the letterpress when a letterform was printed from a raised character cut on a steel punch (see p. 10). The point size refers to the body of the punch and not the letterform itself. The measurement therefore includes the space above and below the strokes of the letterform. As a result, when measured manually with a ruler, a character will always appear slightly smaller than its given point size.

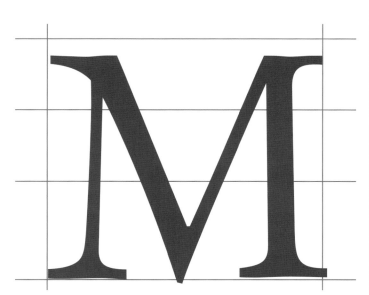

Historically an uppercase letter "M" was as wide as it was tall as demonstrated in this so-called "em square." This measurement has become the accepted norm for indenting text within a paragraph. As type design has progressed the measurement has prevailed but in name alone as it no longer bears any relationship to modern technology.

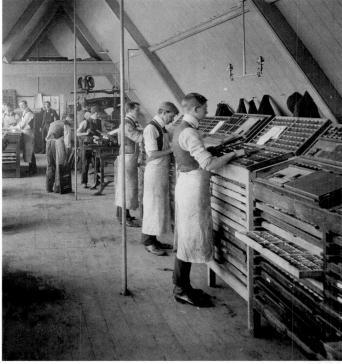

POINT SIZE

6 POINT abcdefghijklmnopqrstuvwxyz

ABCDEFGHIJKLMNOPQRSTUVWXYZ 1234567890.,?":;&%!-{}

8 POINT abcdefghijklmnopqrstuvwxyz

ABCDEFGHIJKLMNOPQRSTUVWXYZ 1234567890.,?":;&%!-{}

10 POINT abcdefghijklmnopqrstuvwxyz

ABCDEFGHIJKLMNOPQRSTUVWXYZ 1234567890.,?":;&%!-{}

12 POINT abcdefghijklmnopqrstuvwxyz

ABCDEFGHIJKLMNOPQRSTUVWXYZ 1234567890.,?":;&%!-{}

16 POINT abcdefghijklmnopqrstuvwxyz

ABCDEFGHIJKLMNOPQRSTUVWXYZ 1234567890.,?":;&%!-{}

18 POINT abcdefghijklmnopqrstuvwxyz

ABCDEFGHIJKLMNOPQRSTUVWXYZ 1234567890.,?":;&%!-{}

24 POINT abcdefghijklmnopqrstuvwxyz

ABCDEFGHIJKLMNOPQRSTUVWXYZ 1234567

36 POINT abcdefghijklmnopqrstuvwxyz

ABCDEFGHIJKLMNOPQRSTU

48 POINT abcdefghijklmnopqrstuvwxyz

ABCDEFGHIJKLMNOPQ

The text here is set in a variety of point sizes. The term refers to the dimensions of the typography. One point is equal to $1/72$ of an inch. It is worth noting that the size is determined by the height from the bottom of the descender to the cap height with a little extra space, and not just the measurement of an uppercase letter, as is often the misconception.

descriptions and font classifications continued

There are certain factors that influence the look and construction of any typeface. These can determine the way in which the font is used for legible texts.

proportions of letterforms

The proportions of letterforms are an important component when designing and using typography. There are four main factors that influence typographic proportions. The first is the ratio of stroke width to the height of the character. The second is the contrast between the thickness and thinness of the stroke weight. Third is the proportion of the x-height to the height of the capital letters, ascenders, and descenders. The final factor influencing proportion is the width of the letterforms.

stroke-to-height ratio

Roman letterforms are based on characters found in Roman inscriptions. When the glyphs are analyzed they are found to be around ten times as high as their stroke weight. Any variation of this ratio will have the effect of making letterforms bolder or lighter. The proportions of any font can be difficult to get right. They have to look correct optically, rather than mathematically. The function of the font may also play a factor in this relationship. A display font can break with several conventions for the sake of design, while a text face must obtain the optimum proportions to retain maximum legibility.

contrast in stroke weight

Original typeforms were based on the calligraphic penmanship of the Renaissance period. Since the pens had a flat edge, they created thick and thin strokes as the pen travelled around the letterform. Such variation within the contrast of a stroke is usually referred to as "stress." The pen produced angled stresses and, as such, the nib

STROKE-TO-HEIGHT RATIO

ABCDEFG

◀◀ Garamond is shown here, which has relatively tall and elegant proportions.

ABCDEFG

▶▶ The Baskerville letterform is slightly wider than that of the Garamond; it has more contrast between its stroke widths and is shorter.

▶▶ You can see when the Garamond letterform is placed on the grid that the proportions of the strokes are less pronounced than those of Baskerville, shown on the right.

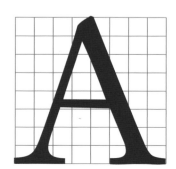

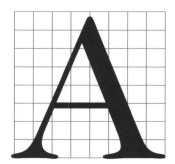

◀◀ The Baskerville letterform is slightly wider than that of the Garamond; it has more contrast between its stroke widths. It is also slightly shorter.

was used to create asymmetric letter-forms. As typefaces have progressed, the influence of the pen has declined and stresses have now all but disappeared. Most sans serif typefaces today have an almost completely even stroke weight. To balance the font optically, however, the horizontal strokes are normally drawn slightly thinner than the vertical ones.

x-height and proportion

The relationship between the x-height and the height of caps and ascenders and descenders can have a profound effect on a font. Some fonts have a very large x-height-to-ascender ratio making the font appear larger at specific point sizes. The reason for this is that the body of the typeface covers more space. Other fonts that have a longer ascender and descender compared to their x-height will appear smaller at the same point size.

As a rule, choose a typeface with longer ascenders and descenders for text type. The longer stems allow for better recognition at smaller sizes. It also means that short, stubby stems do not become invisible when reduced in point size. Conversely, display type works well with a larger x-height-to-cap-height ratio. Here, the shorter ascenders and descenders will work just as well as longer ones.

X-HEIGHT

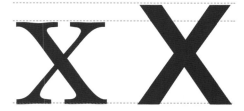

▲ It is a common misconception that fonts of the same size all conform to the same x-height. You often find that sans serif faces such as Helvetica, shown here on the right, have a much larger x-height and shorter ascenders and descenders.

STROKE WEIGHTS

hamburgerfont

hamburgerfont

hamburgerfont

hamburgerfont

◄◄ You can see in the fonts shown here the difference in stroke weights between typefaces. From top to bottom, Futura has a fairly uniform stroke width, whereas Optima has more contrast within the stresses of the shapes. Bodoni has the largest contrast of all, ranging from hairline serifs to broad strokes and stresses within the loops. VAG rounded at the bottom has a consistent thickness to its stroke.

descriptions and font classifications continued

Typefaces are available in numerous weights and widths, allowing the designer to use them to different effects within a piece of typographically based design.

extended and condensed styles

The proportions of letterforms can be changed dramatically by making them more extended or condensed. When choosing these kinds of fonts, consider their function carefully. Condensed letterforms are useful when setting fonts within a limited amount of space—for example, when used in a newspaper. Extra-condensed fonts, however, require more work on the part of the reader to recognize and read.

FRUTIGER'S GRID

The Frutiger grid shows type width and weight relationships. The grid ranges from 30 (the narrowest face) to over 80 (the most extended). Roman faces are given by odd numbers, italics by even.

39 univers

45 univers	46 *univers*	47 univers	48 *univers*	49 univers

53 **univers**	55 univers	56 *univers*	57 univers	58 *univers*	59 univers

63 **univers**	65 **univers**	66 *univers*	67 **univers**	68 *univers*

73 **univers**	75 **univers**	77 **univers**

83 **univers**

⤒ The Frutiger grid also shows the increase in stroke weight for light to black by increasing the numerical value from one to nine throughout the tens, for example, 53–59. This grid has also been used by many other typefaces including Helvetica, Frutiger, and Rotis.

type families and Frutiger's grid

A type family is a collection of fonts, all of which are based on the same proportions and design, but with a wide-ranging set including everything from condensed to extended and light to heavy.

The type designer, Adrian Frutiger developed a grid to show the variations of fonts within a type family in conjunction with a numbering system. In this system, the increments of ten indicate the weight of the

font, the single figure increases the width, with odd numbers for roman fonts and even numbers for italic.

Frutiger's font, Univers, designed in 1957, was the first to apply this grid. Originally, the font had 21 variations in five weights and four widths. The font family has since been added to and now includes more than 50 fonts, increasing the choice for the designer immeasurably.

Using just one extended type family such as Univers achieves a sense of clarity and uniformity within a design. This leads to clear, consistent communication with the least number of variables to detract from the information.

Many designers restrict themselves to just two type families per project for exactly this reason. It is far more visually pleasing to the eye to use several variations of one typeface, than to use several different, unrelated fonts.

There are now a growing number of typefaces that have multiple variations within a family, and these include typefaces such as, Futura, Rotis, Frutiger, Optima, and Meta. Most type designers recognize the demand and need for such families and produce different weights and widths as a result of this.

ABCDEFGHIJKLMNOPQRSTUVWXYZ 1234567890.,?";:&%!-{}

ABCDEFGHIJKLMNOPQRSTUVWXYZ 1234567890.,?";:&%!-{}

ABCDEFGHIJKLMNOPQRSTUVWXYZ 1234567890.,?";:&%!-{}

ABCDEFGHIJKLMNOPQRSTUVWXYZ 1234567890.,?";:&%!-{}

ABCDEFGHIJKLMNOPQRSTUVWXYZ 1234567890.,?";:&%!-{}

ABCDEFGHIJKLMNOPQRSTUVWXYZ 1234567890.,?";:&%!-{}

ABCDEFGHIJKLMNOPQRSTUVWXYZ 1234567890.,?";:&%!-{}

ABCDEFGHIJKLMNOPQRSTUVWXYZ 1234567890.,?";:&%!-{}

ABCDEFGHIJKLMNOPQRSTUVWXYZ 1234567890.,?";:&%!-{}

ABCDEFGHIJKLMNOPQRSTUVWXYZ 1234567890.,?";:&%!-{}

ABCDEFGHIJKLMNOPQRSTUVWXYZ 1234567890.,?";:&%!-{}

ABCDEFGHIJKLMNOPQRSTUVWXYZ 1234567890.,?";:&%!-{}

ABCDEFGHIJKLMNOPQRSTUVWXYZ 1234567890.,?";:&%!-{}

ABCDEFGHIJKLMNOPQRSTUVWXYZ 1234567890.,?";:&%!-{}

◀◀ As you can see here, a type family provides a wide variety of weights and widths within a typeface. These can be used for a variety of jobs to create emphasis or enforce hierarchy with a given design.

the digital age

The digital age has brought with it a newfound freedom in typography, allowing typographic design to push the boundaries of legibility and visual esthetics.

The advent of the computer has made huge changes within the graphic design industry. Once the realm of the skilled typographer, the computer has put type into the hands of anyone with a PC. Now type can be generated, manipulated, and output directly from the desktop.

The computer has revolutionized the design industry. The introduction of the Apple Macintosh, in 1984, brought about the digital age in design. Since its introduction, the computer has penetrated every aspect of the design industry.

In the beginning, it was visionaries such as April Greiman who realized the full potential of this little box. *Émigré* magazine also used it, not only to generate page layouts, but to experiment with designing coarse, bitmapped fonts, inspired by its limited screen resolution.

Such people understood that the computer could give a designer a degree of autonomy: he or she could now manipulate imagery, design page layouts, and even create typefaces for particular projects where, previously, collaboration with a host of specialists would have been necessary.

Designers like Neville Brody influenced how the computer was viewed and harnessed by the design community. His publication, *Fuse*, allowed the experimentation afforded by the computer to come to the forefront of the design process.

Type is no longer printed for large runs using letterpress or phototypesetting. The design industry embraced the new technology and utilized it to the fullest. Today, we research via the internet, acquire images and manipulate them digitally, and create and manage typography at our own computer work stations.

Such advances have opened up a debate about the standards of graphic design. People question whether this newfound freedom has resulted in a decline in typographic standards in particular, since

almost anybody can now use a computer to produce a piece of "graphic design." Should the unskilled be allowed to do this? Whatever your view, the digital age has certainly transformed graphic design for the better and produced some visually stimulating work over the last 20 years.

Today's designers constantly have to learn new skills in order to keep up to date with the latest hardware and software. It is important to know which software to use for a particular function, and most designers use image-manipulation packages, such as Adobe Photoshop, a vector-illustration package, such as Adobe Illustrator or FreeHand (the latter formerly made by Macromedia), and a page layout package, such as QuarkXpress or Adobe InDesign.

Digital typography has come a long way since 1984. You can buy and download fonts over the internet. Individuals now find it much easier to design their own fonts with the introduction of software such as FontLab or Fontographer (both made by FontLab). They can even market and sell their fonts via a website. Copyright is always a problem, as digital formats are easy to copy and pirate. In typographic terms, it is not only essential to know one type format from another, but also how to use it legally.

type formats

Fonts are used on every computer—whether an Apple Mac or a PC—and all designers need to know how to use them.

There are a number of type formats that are currently available to all users. In the past, Apple Mac and PC fonts have not been compatible with each other. PC fonts used one format, Mac ones another, regardless of whether they were PostScript or TrueType.

Various formats are described below, along with information on how the technology is changing with the growing number and availability of OpenType formats. Typography has, at last, a universal format that everyone can use, regardless of operating platform or computer language.

PostScript Type 1

The PostScript format, devised by Adobe, involves a file with two parts. The first part is the bitmap data for on-screen representation of the font. The second, and outline, file contains information for output on a printer. The operating system uses the outline file to accurately render the font's letterforms at the printing stage. It relies on outlines generated via bezier curves; these are then converted to bitmaps appropriate to the resolution of the printer for a greater degree of accuracy. This format requires a separate outline file for every font within

the typeface—regular, italic, bold, and bold italic, for example. The latest operating systems have built-in rasterizers to read the vector information contained within the file and produce more accurate and better-looking glyphs on screen. The older versions will require the addition on Adobe Type Manager (ATM) Light to be installed in order to produce a more accurate screen display of a font.

TrueType

TrueType is format that was developed jointly by Apple and Microsoft to rival

TRUETYPE FONTS

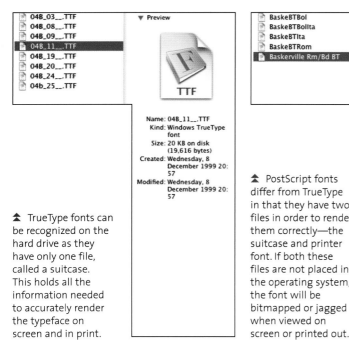

▲ TrueType fonts can be recognized on the hard drive as they have only one file, called a suitcase. This holds all the information needed to accurately render the typeface on screen and in print.

POSTSCRIPT FONTS

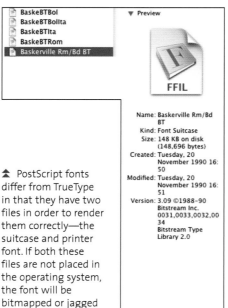

▲ PostScript fonts differ from TrueType in that they have two files in order to render them correctly—the suitcase and printer font. If both these files are not placed in the operating system, the font will be bitmapped or jagged when viewed on screen or printed out.

OPENTYPE FONTS

▲ OpenType fonts were developed by Adobe and Microsoft as a response to TrueType incompatibility problems between Macs and PCs. OpenType fonts use Unicode-based character coding to extend the TrueType format across all platforms.

Adobe PostScript Type 1. The character set is based on Unicode and the fonts combine both vector and bitmap data for screen drawing and printing within one file, known as a suitcase. It works on a similar principle to PostScript but uses quadratic as opposed to bezier curves. This allows them to be scaled infinitely with no loss of detail. Both the operating systems for the Macintosh and the PC have TrueType raster-izers built in, to allow the accurate repre-sentation both on screen and at the print-ing stage. The advantage of using TrueType over PostScript formats is that they will print more successfully using some of the cheaper printers available and so are better suited to the amateur designer or home user.

OpenType

OpenType was developed by Microsoft and Adobe and launched in 1997, and is currently gaining popularity within the type industry. The advantage of this format is that it is a single cross-platform file: it can contain both PostScript and TrueType outlines. It is based on the Unicode encoding standard and can therefore have an expanded char-acter set that includes small caps, ligatures, swashes, and any other variations. The font could also theoretically include characters from Greek, Cyrillic, and Latin, producing a multilingual font within a single file. The possibilities for this format are far reach-ing. All that remains now is for software to incorporate a provision for its use. InDesign, being an Adobe product, allows the use of OpenType formats, whereas, at the time of writing, QuarkXpress does not.

⬆ The current crop of desktop computers are powerful and have the ability to handle many high-definition applications with relative ease.

▶▶ Adobe software, such as Illustrator and Photoshop, supports OpenType formats, meaning that a whole host of specialist glyphs are now available in one type file.

using typography

Typography is a craft like any other. While once the province of skilled typographers, the digital age has allowed all designers to take control of their text. Despite the ease with which typography can now be generated and manipulated, the basic "rules" are the same now as they have always been. This chapter looks at the uses of typography and the principles that govern clear communication. It shows how to avoid some common mistakes and looks at how to lay out text within grids to obtain the most legible results.

■ type and fonts

Like all aspects of design, typography has to be learned. It has its own set of rules and conventions that allow it to be used to its full potential.

In order to get the most out of typography, it is important to first understand the terminology and differences between typefaces. Using the correct vocabulary results in clearer communication and allows designers to select and use the most appropriate font for the job.

Over the years, the definitions of the terminology associated with typography have become confused. Before the advent of the digital age, the terms type, font, and typeface had distinct differences. Today these differences are less clear. "Type" was used to describe the object itself—a piece of metal with a reversed, raised character on one side meant for the purposes of printing. "Font" (sometimes spelled "fount") refers to the set of characters of a particular typeface. These would be of the same style and size. A "typeface" refers to a set or related family of fonts. This applies to italic, bold, and bold italic versions of a font.

In addition to this are the classifications of display and text faces. Traditionally, any type 12 point and under can be described as text type. This type is usually used for body copy, or any text used for continuous reading of large amounts of information. Conversely, type sizes above 12 point are known as "display" or "headline" type. These

GARAMOND 12 & 24PT

Lorem ipsum dolor sit amet consectetuer adipis cing elit sed diam nonummy nibh euismod tind unt ut laoreet dolore magna aliquam erat volu tpat. Ut wisi enim ad minim veniam, quis nost rud exerci tation ullamcorper suscipit lobortis nisl ut aliquip ex ea commodo consequat.

Lorem ipsum dolor sit amet elit seddiam

⬆ Garamond was originally designed by Claude Garamond in 1530. It was still in use in the 18th century, and revived by most foundries in the 20th century. It is based on classical proportions with angled serifs and low contrast between strokes.

BEMBO 12 & 24PT

Lorem ipsum dolor sit amet consectetuer adipis cing elit sed diam nonummy nibh euismod tind unt ut laoreet dolore magna aliquam erat volu tpat. Ut wisi enim ad minim veniam, quis nost rud exerci tation ullamcorper suscipit lobortis nisl ut aliquip ex ea commodo consequat.

Lorem ipsum dolor sit amet elit seddiam

⬆ The Bembo typeface was designed by Aldus Manutius in 1496 to print Pietro Bembo's book *De Aetna*. Manutius's work was widely admired by his contemporaries. Bembo is referred to as an Old Style or Antique face.

TIMES 12 & 24PT

Lorem ipsum dolor sit amet consectetuer adipis cing elit sed diam nonummy nibh euismod tind unt ut laoreet dolore magna aliquam erat volu tpat. Ut wisi enim ad minim veniam, quis nost rud exerci tation ullamcorper suscipit lobortis nisl ut aliquip ex ea commodo consequat.

Lorem ipsum dolor sit amet elit seddiam

⬆ Times Roman was designed in 1933 for *The Times* newspaper in London, England, by typographer and type designer Stanley Morison. It was intended, and used, for both headlines and body copy and was defined by Classical forms.

are usually used for titles, headlines, signage, or any text that tries to grab attention at large sizes.

Body copy has to take many other factors into account. Text to be used for printed purposes at small sizes requires a certain amount of attention to detail in the design and selection of the font. Stanley Morison agreed with this by commenting that for a typeface to be successful, it must be transparent and go completely unnoticed by the reader. Our awareness of the means by which a message is transmitted only diverts attention from the real meaning of the message being communicated.

A typeface has its own personality or "tone of voice." The qualities of the font lend themselves to particular functions due to the nature of the design of the letterforms. We choose to use certain fonts because of the values they communicate to the reader or viewer. They can be strong, bold, forthright, whimsical, distressed, futuristic, common, or utilitarian, among many other personalities. Serif faces have more in common with traditional or luxury values, having a sense of history and integrity to them. Sans serifs are modern and uniform and so lend themselves to more functional purposes.

HELVETICA 12 & 24PT

Lorem ipsum dolor sit amet consectetuer adipis cing elit sed diam nonummy nibh euismod tind unt ut laoreet dolore magna aliquam erat volu tpat. Ut wisi enim ad minim veniam, quis nost rud exerci tation ullamcorper suscipit lobortis nisl ut aliquip ex ea commodo consequat.

Lorem ipsum dolor sit amet elit seddiam

⬆ The Neogrotesque face, Helvetica, was designed in 1959 by the Zurich-born type designer Max Miedinger. Originally known as Haas-Grotesk, Helvetica became the most widely used typeface in the world by the end of the 20th century.

GILL SANS 12 & 24PT

Lorem ipsum dolor sit amet consectetuer adipis cing elit sed diam nonummy nibh euismod tind unt ut laoreet dolore magna aliquam erat volu tpat. Ut wisi enim ad minim veniam, quis nost rud exerci tation ullamcorper suscipit lobortis nisl ut aliquip ex ea commodo consequat.

Lorem ipsum dolor sit amet elit seddiam

⬆ Gill Sans was designed by Eric Gill in 1931 and based on Edward Johnston's face for the London Underground. Due to its pleasing proportions and open, rounded counters, it is still widely used for both display text and body copy.

FUTURA 12 & 24PT

Lorem ipsum dolor sit amet consectetuer adipis cing elit sed diam nonummy nibh euismod tind unt ut laoreet dolore magna aliquam erat volu tpat. Ut wisi enim ad minim veniam, quis nost rud exerci tation ullamcorper suscipit lobortis nisl ut aliquip ex ea commodo consequat.

Lorem ipsum dolor sit amet elit seddiam

⬆ Designed in 1927 by the German artist Paul Renner, Futura took its inspiration from the Bauhaus arts movement and geometric forms. Its success relies on its simple construction, which is functional and friendly.

principles of good practice

Good practice relies on a set of conventions that have been built up over time. If adhered to, these conventions create more legible and credible results.

Information designer and founder of *MetaDesign*, Erik Spiekermann, wrote that he wanted to be a Minister of Typography. The reason for this was that he had noticed that with the rise of computer technology, the time-honored art of typography was being practiced by anyone and everyone. The results he found were ugly and an insult to his typographic sensibilities. Since his ministerial role was not going to come into being, his advice was that there was only one way to achieve high standards within typographic design, and that was to look, learn, and practice.

Although Spiekermann's desire to govern typography is a little extreme, his reasoning is sound. Typography has numerous subtleties that cannot be be automatically understood just because the user can use a keyboard. It takes time to understand the craft and to implement typography that communicates a message while still looking good. The key is to understand the problems that can arise when using type and not just relying on the computer's default settings. A good typographer will consider the function and meaning of the type and set text with that in mind, altering the control measurements to suit.

Over time a set of typographic conventions have been set up to ensure that the use of typography is competent and consistent. However, these rules are not definitive but provide a framework within which clear graphic design can be achieved. These rules can be broken and in doing so may provide a meaningful message within itself. If you understand the rules then you can judge when it is best to break or disregard them altogether to effectively achieve the desired message or idea. However, for the most part, these rules are for the benefit of everyone using typography. They provide for clear and concise text that communicates succinctly, while looking visually attractive.

Digital technology provides designers with a wealth of permutations at their fingertips, needing only the click of a mouse button. It is very easy to become seduced by

DEFAULT SETTING

Suspendisse at enim. In mattis, arcu at lacinia convallis, massa justo laoreet tellus, non consectetuer purus velit et felis. Quisque pellentesque. Nunc gravida tincidunt nisi. Vestibulum quis enim. Fusce nulla ante, tristique eu, vulputate eget, semper sed, mi. In tempor diam vel sem. Maecenas aliquet, tellus eu scelerisque pellentesque, arcu ante sagittis magna, in posuere ipsum risus sit amet mi.

⬆ Default settings for leading and tracking do not take into account variations between typefaces. Proportions and sizes may vary from face to face, even though they have the same point size. Always alter the settings to suit the job at hand.

⬇ Here, you can see that the default settings for Gill Sans look very different to those for Helvetica (left), as Gill Sans has a smaller x-height. Resetting the default settings to take account of this difference results in better proportions.

Suspendisse at enim. In mattis, arcu at lacinia convallis, massa justo laoreet tellus, non consectetuer purus velit et felis. Quisque pellentesque. Nunc gravida tincidunt nisi. Vestibulum quis enim. Fusce nulla ante, tristique eu, vulputate eget, semper sed, mi. In tempor diam vel sem. Maecenas aliquet, tellus eu scelerisque pellentesque, arcu ante sagittis magna, in posuere ipsum risus sit amet mi.

Suspendisse at enim. In mattis, arcu at lacinia convallis, massa justo laoreet tellus, non consectetuer purus velit et felis. Quisque pellentesque. Nunc gravida tincidunt nisi. Vestibulum quis enim. Fusce nulla ante, tristique eu, vulputate eget, semper sed, mi. In tempor diam vel sem. Maecenas aliquet, tellus eu scelerisque pellentesque, arcu ante sagittis magna, in posuere ipsum risus sit amet mi.

⬆ In this example, the text has been ranged right. For standard body copy, which is designed to be read as one piece, this can cause problems for the reader. If large portions of text are set this way, the eyes get tired.

AMAC FONT CHICAGO

Lorem ipsum dolor sit amet conse ctetuer adipis cing elit sed diam nonummy nibh euismod tind unt ut laoreet dolore magna aliquam erat volutpat wisi enim ad minim.

CLASSIC FONT UNIVERS

Lorem ipsum dolor sit amet conse ctetuer adipis cing elit sed diam nonummy nibh euismod tind unt ut laoreet dolore magna aliquam erat volutpat wisi enim ad minim.

CLASSIC FONT GARAMOND

Lorem ipsum dolor sit amet conse ctetuer adipis cing elit sed diam nonummy nibh euismod tind unt ut laoreet dolore magna aliquam erat volutpat wisi enim ad minim.

◀◀ In these examples, you can see the difference between using system fonts such as Chicago and classic fonts such as Univers and Garamond. Designed for reading continuous text in print, classic fonts have considered proportions and spacing. Chicago was designed to be viewed on screen. It has none of the subtleties of the classical fonts and proves hard on the eye when reading a lot of body copy.

EMPHASIS 1

Lorem ipsum dolor sit amet consectetuer adipis cing elit sed diam **nonummy** nibh euismod tind unt ut laoreet dolore **magna** aliquam erat volu tpat. Ut wisi enim ad minim veniam, quis nost rud exerci tation ullamcorper **suscipit lobortis** nisl ut aliquip ex ea commodo consequat.

▲ In this example, you can see the use of several fonts to create emphasis. This is confusing for the reader as they do not work in harmony with the rest of the copy and there seems to be no reason why a different font is used for each word.

EMPHASIS 2

Lorem ipsum dolor sit amet consectetuer adipis cing elit sed diam nonummy nibh euismod tind unt ut laoreet dolore *magna* aliquam erat volu tpat. Ut wisi enim ad minim veniam, quis nost rud exerci tation ullamcorper suscipit lobortis nisl ut aliquip ex ea commodo consequat.

Lorem ipsum dolor sit amet consectetuer adipis cing elit sed diam *nonummy* nibh euismod tind unt ut laoreet dolore *magna* aliquam erat volu tpat. Ut wisi enim ad minim veniam, quis nost rud exerci tation ullamcorper *suscipit lobortis* nisl ut aliquip ex ea commodo consequat.

▲ Do not choose typefaces that are too similar, such as Helvetica and Futura (top). The similarity means that the reader can often miss the difference. It is better to use an italic version of the same font (Helvetica) to create emphasis (below).

the options available. It is much more diffi-cult to represent the thoughts of the author and create beautiful, legible typog-raphy. The best typographers are those who express the meaning of the text while still retaining its legibility and making it appear visually stimulating.

The following "rules" are meant to reflect the principles of good practice. Many of them are common sense, others are the result of years of typesetting expe-rience and problem-solving. These prob-lems may occur due to the construction of the type or the nature of how information is best presented in order for readers to retain it. All the rules are designed to retain the integrity of typographic information as presented, by whatever means.

font selection

It is often better to use a classical typeface with a proven track record. These fonts have consistency within their characters and have legible proportions that aid the read-ing process and produce more legible pas-sages of textual information.

When trying to create emphasis within a piece of text or separate sections, it is advisable not to use too many typefaces at one time. If too many are used, the reader becomes confused and is unable to deter-mine what is important and what is not. There is no clear hierarchy.

When considering emphasis within a sentence, try to avoid using a typeface that is too similar in appearance to the main face. This often looks like a mistake. Strive for contrast within the text. Use a font that appears very different—a serif as opposed to a sans serif, or alternatively, use an italic version of the same typeface for a more subtle approach.

■ principles of good practice continued

sizes, hierarchies, and weights

The following "rules" relate to the choice, size, and style of font to select. It is best to exercise restraint in the design of typographic information. Throwing in everything only confuses the reader and degrades the information presented.

It is best to use text sizes that range between 8 and 12 point for body copy. This can be easily read from an average distance of 12–14 inches (30–35cm). These point sizes have proved to be more legible and comfortable for the reader. It is important to realize that typefaces of the same size may visually appear larger or smaller, depending on their relative x-height.

To establish clear hierarchy within typography, avoid using too many different type sizes and weights at the same time. It is easier for the reader if there is clear differentiation between all the sizes, but too many only serves to confuse and creates a cluttered design. Exercise restraint and use only two or three font sizes to maintain functional and esthetically attractive designs.

For text type, avoid using typefaces that are too light or too heavy. A font that is too light cannot be easily distinguished from its background; a font that is too heavy is less legible, as the thickness of the stroke diminishes the size of the counterspaces,

making the letterform less recognizable. Typefaces that have a book weight strike a balance between these extremes and are more suited to text type.

As a general rule, don't use condensed or extended faces for body copy. For the letter-forms to be easily recognized, the space in and around the letters is crucial at small sizes. Distorting letters by altering the proportions means the letters do not appear familiar to us and so retards our ability to instantly read them. Some type families may include extended or condensed fonts whose proportions fall within accepted proportions, but even these are best avoided for large amounts of body text.

OPTIMUM SIZES FOR BODY COPY

▶▶ The text on the right has been set in different sizes, varying between 6 and 16pt. You can see that the 6pt type on the top left is a little too small, whereas the 16pt type on the bottom right is a little too large to be read from a comfortable reading distance.

Lorem ipsum dolor sit amet consectetuer adipis cing elit sed diam nonummy nibh euismod tind unt ut laoreet dolore magna aliquam erat volu tpat. Ut wisi enim ad minim veniam, quis nost rud exerci tation ullamcorper suscipit lobortis nisl ut aliquip ex ea commodo consequat.

Lorem ipsum dolor sit amet consectetuer adipis cing elit sed diam nonummy nibh euismod tind unt ut laoreet dolore magna aliquam erat volu tpat. Ut wisi enim ad minim veniam, quis nost rud exerci tation ullamcorper suscipit lobortis nisl ut aliquip ex ea commodo consequat.

Lorem ipsum dolor sit amet consectetuer adipis cing elit sed diam nonummy nibh euismod tind unt ut laoreet dolore magna aliquam erat volu tpat. Ut wisi enim ad minim veniam, quis nost rud exerci tation ullamcorper suscipit lobortis nisl ut aliquip ex ea commodo consequat.

Lorem ipsum dolor sit amet consectetuer adipis cing elit sed diam nonummy nibh euismod tind unt ut laoreet dolore magna aliquam erat volu tpat. Ut wisi enim ad minim veniam, quis nost rud exerci tation ullamcorper suscipit lobortis nisl ut aliquip ex ea commodo consequat.

Lorem ipsum dolor sit amet consectetuer adipis cing elit sed diam nonummy nibh euismod tind unt ut laoreet dolore magna aliquam erat volu tpat. Ut wisi enim ad minim veniam, quis nost rud exerci tation ullamcorper suscipit lobortis nisl ut aliquip ex ea commodo consequat.

TYPE HIERARCHY

passage title

Lorem ipsum dolor sit amet consectetuer adipis cing elit sed diam laoreet dolore magna aliquam erat volu tpat. Ut wisi enim ad minim veniam, quis nost rud exerci tation ullamcorper suscipit lobortis nisl ut aliquip ex ea commodo consequat.

subheading

Lorem ipsum dolor sit amet consectetuer adipis cing elit sed diam nonummy nibh euismod tind unt ut laoreet dolore magna aliquam erat volu tpat. Ut wisi enim ad minim veniam.

passage title

Lorem ipsum dolor sit amet consectetuer adipis cing elit sed diam *laoreet* dolore magna aliquam erat volu tpat. Ut wisi enim ad minim veniam, quis nost rud exerci tation *ullamcorper* suscipit lobortis nisl ut aliquip ex ea commodo consequat.

subheading

Lorem ipsum dolor sit amet consectetuer adipis cing elit sed diam nonummy nibh *euismod tind* unt ut laoreet dolore magna aliquam erat volu tpat. Ut wisi enim ad minim veniam.

◂◂ On the left, the size of the type has been varied to create hierarchy within the type. Since the text in the middle of the sentence is the same size as the subheading text, this can confuse the reader at first glance. The example on the right uses bold to denote a subheading and italic to create emphasis within the copy. This results in a clear way of reading the text, letting the viewer know what is more important within the type.

OPTIMUM WEIGHTS FOR BODY COPY

▸▸ The Futura light (top) is too pale to be distinguished from the background for reading large amounts of continuous text. The bold version of Futura (bottom) is too heavy and proves to be tiring on the eye as the counterspaces are diminished, making it very dark on the page. The center example set in Futura Book has just the right weight to be easily recognizable from the background, without being too heavy.

Lorem ipsum dolor sit amet consectetuer adipis cing elit sed diam nonummy nibh euismod tind unt ut laoreet dolore magna aliquam erat volu tpat. Ut wisi enim ad minim veniam, quis nost rud exerci tation ullamcorper suscipit lobortis nisl ut aliquip ex ea commodo consequat.

Lorem ipsum dolor sit amet consectetuer adipis cing elit sed diam nonummy nibh euismod tind unt ut laoreet dolore magna aliquam erat volu tpat. Ut wisi enim ad minim veniam, quis nost rud exerci tation ullamcorper suscipit lobortis nisl ut aliquip ex ea commodo consequat.

Lorem ipsum dolor sit amet consectetuer adipis cing elit sed diam nonummy nibh euismod tind unt ut laoreet dolore magna aliquam erat volu tpat. Ut wisi enim ad minim veniam, quis nost rud exerci tation ullamcorper suscipit lobortis nisl ut aliquip ex ea commodo consequat.

Lorem ipsum dolor sit amet consectetuer adipis cing elit sed diam nonummy nibh euismod tind unt ut laoreet dolore magna aliquam erat volu tpat. Ut wisi enim ad minim veniam, quis nost rud exerci tation ullamcorper suscipit lobortis nisl ut aliquip ex ea commodo consequat.

Lorem ipsum dolor sit amet consectetuer adipis cing elit sed diam nonummy nibh euismod tind unt ut laoreet dolore magna aliquam erat volu tpat wisi enim ad minim veniam, quis nost rud.

Lorem ipsum dolor sit amet consectetuer adipis cing elit sed diam nonummy nibh euismod tind unt ut laoreet dolore magna aliquam erat volu tpat. Ut wisi enim ad minim veniam, quis nost rud exerci tation ullamcorper suscipit lobortis nislut.

◂◂ The light condensed version of Helvetica (top) can be difficult to read as the lack of space surrounding the letterforms makes it more difficult to distinguish word shapes. This is also true of the extended and bold extended versions (center and bottom), as the more space a word takes up, the fewer words per line, which slows our ability to read a comfortable amount of words per line.

■ principles of good practice continued

working with text in layouts

The following rules govern how to choose a font for a design layout. They tackle the measure of the text blocks, spacing, and when and where to use either upper- or lowercase letters.

For optimum legibility, do not set body text in capital letters—this hinders the speed at which you can read. A combination of upper- and lowercase letters provides a more readable piece of typography. This is because we recognize word shapes, not individual letters. The pattern of ascenders and descenders provides an easier way of recognizing the words and so aids legibility. However, since display text is normally only used in small amounts, you can use uppercase text successfully. It may require some extra word spacing or tracking to make it more visually appealing. Typefaces are normally kerned so that you can use combinations of upper- and lowercase letters, not all capitals. As a result, type made up of capitals only can look squashed.

Always use consistent letter- and word spacing to produce an even tone of text on the page. If you increase letter spacing for any reason, you should increase word spacing or tracking proportionally. This will result in an even flow to the text, aiding legibility.

For best results, use an appropriate line length, or "measure." This is normally 8–10 words per line. Lines that are too short or too long impede reading. Short lines interrupt the flow of text and cause the eye to flick back and forth, quickly tiring the reader. Long lines can cause problems, too, in that as the eye travels over the course of the line, it has difficulty locating the beginning of the next one.

Use appropriate leading or line spacing for text type so as not to break the flow from one line to the next. Type with too little leading slows reading as the eye takes in information from more than one line at a time. To improve legibility, add 1–4 points of space between lines, depending on the x-height of the typeface chosen.

CAPITALS & UPPER- AND LOWERCASE

LOREM IPSUM DOLOR SIT AMET, CONSECTETUER ADIPISCING ELIT. AENEAN LACINIA NULLA. NUNC VITAE ERAT EU TURPIS RHONCUS NONUMMY. SED LIGULA PEDE, FEUGIAT IN, FRINGILLA NON, VIVERRA NON, ORCI. PRAESENT PEDE. CURABITUR METUS. ETIAM TINCIDUNT, ODIO SED VENENATIS ORNARE, DUI PURUS DIGNISSIM TORTOR, A VULPUTATE PURUS FELIS AT NEQUE. UT LIBERO. PHASELLUS EGESTAS DOLOR EU IPSUM. QUISQUE PELLENTESQUE, URNA SIT AMET GRAVIDA SOLLICITUDIN, EROS MI CONSECTETUE.

Lorem ipsum dolor sit amet, consectetuer adipiscing elit. Aenean lacinia nulla. Nunc vitae erat eu turpis rhoncus nonummy. Sed ligula pede, feugiat in, fringilla non, viverra non, orci. Praesent pede. Curabitur metus. Etiam tincidunt, odio sed venenatis ornare, dui purus dignissim tortor, a vulputate purus felis at neque. Ut libero. Phasellus egestas dolor eu ipsum. Quisque pellentesque, urna sit amet gravida sollicitudin, eros mi consectetue.

TRACKING

Lorem ipsum dolor sit amet consectetuer adipiscing elit. Aenean lacinia nulla. Nunc vitae erat eu turpis rhoncus nonummy. Sed ligula pede feugiat in fringilla non viverra non orci. Praesent pede. Curabitur metus.

Lorem ipsum dolor sit amet consectetuer adipiscing elit. Aenean lacinia nulla. Nunc vitae erat eu turpis rhoncus nonummy. Sed ligula pede feugiat in fringilla non viverra non orci. Praesent pede. Curabitur metus.

◀◀ When we read, we recognize the shapes of letterforms. Setting text in capitals only means that word shapes are harder to recognize and so the speed at which we read is slowed.

▲ Increasing or reducing the amount of space within and between words— "tracking"—also makes it more difficult to recognize word shapes and so hinders reading.

OPTIMUM LINE LENGTH

Lorem ipsum dolor sit amet, consectetuer adipiscing elit. Aenean lacinia nulla. Nunc vitae erat eu turpis rhoncus nonummy. Sed ligula pede, feugiat in, fringilla non, viverra non, orci. Praesent pede. Curabitur metus. Etiam tincidunt, odio sed venenatis ornare, dui purus dignissim tortor, a vulputate purus felis at neque. Ut libero. Phasellus egestas dolor eu ipsum. Quisque pellentesque, urna sit amet gravida sollicitudin, eros mi consectetuer mauris, malesuada eleifend augue nibh vitae justo. Donec volutpat dui id tortor. Ut mattis. Integer id lectus ut tortor adipiscing aliquam. Nunc posuere massa sed urna ultrices volutpat. Class aptent taciti sociosqu ad litora torquent per conubia nostra, per inceptos hymenaeos.

Lorem ipsum dolor sit amet, consectetuer adipiscing elit. Aenean lacinia nulla. Nunc vitae erat eu turpis rhoncus nonummy. Sed ligula pede, feugiat in, fringilla non, viverra non, orci. Praesent pede. Curabitur metus. Etiam tincidunt, odio sed venenatis ornare, dui purus dignissim tortor, a vulputate purus felis at neque. Ut libero. Phasellus egestas dolor eu ipsum. Quisque pellentesque, urna sit amet gravida sollicitudin, eros mi consectetuer mauris, malesuada eleifend augue nibh vitae justo. Donec volutpat dui id tortor. Ut mattis. Integer id lectus ut tortor adipiscing aliquam. Nunc posuere massa sed urna ultrices volutpat. Class aptent taciti sociosqu ad litora torquent per conubia nostra, per inceptos hymenaeos.

Lorem ipsum dolor sit amet, consectetuer adipiscing elit. Aenean lacinia nulla. Nunc vitae erat eu turpis rhoncus nonummy. Sed ligula pede, feugiat in, fringilla non, viverra non, orci. Praesent ped bitur met.

⬆ Lines of type that are too long make reading difficult as the viewer can lose his or her place. Lines that are too short can mean the rapid movement of the eye across the text to digest the information can be very tiring. It is best to aim for 8–10 words per line.

⬇ Leading must be carefully considered when setting copy. Too little leading and the ascenders and descenders of the letterforms can touch, making it difficult to distinguish the word shapes. Too much leading can mean the eye loses its place on the return sweep between lines.

LEGIBLE LEADING

Lorem ipsum dolor sit amet, consectetuer adipiscing elit. Aenean lacinia nulla. Nunc vitae erat eu turpis rhoncus nonummy. Sed ligula pede, feugiat in, fringilla non, viverra non, orci. Praesent pede. Curabitur metus. Etiam tincidunt, odio sed venenatis ornare, dui purus dignissim tortor, a vulputate purus felis at neque. Ut libero. Phasellus egestas dolor eu ipsum. Quisque pellentesque, urna sit amet gravida sollicitudin, eros mi consectetuer mauris, malesuada eleifend augue nibh vitae justo. Donec volutpat dui id tortor. Ut mattis. Integer id lectus ut tortor adipiscing aliquam. Nunc posuere massa sed urna ultrices volutpat. Class aptent taciti sociosqu ad litora torquent per conubia nostra, per inceptos hymenaeos.

Lorem ipsum dolor sit amet, consectetuer adipiscing elit. Aenean lacinia nulla. Nunc vitae erat eu turpis rhoncus nonummy. Sed ligula pede, feugiat in, fringilla non, viverra non, orci. Praesent pede. Curabitur metus. Etiam tincidunt, odio sed venenatis ornare, dui purus dignissim tortor, a vulputate purus felis at neque. Ut libero. Phasellus egestas dolor eu ipsum. Quisque pellentesque, urna sit amet gravida sollicitudin, eros mi consectetuer mauris, malesuada eleifend augue nibh vitae justo. Donec volutpat dui id tortor. Ut mattis. Integer id lectus ut tortor adipiscing aliquam. Nunc posuere massa sed urna ultrices volutpat. Class aptent taciti sociosqu ad litora torquent per conubia nostra, per inceptos hymenaeos.

Lorem ipsum dolor sit amet, consectetuer adipiscing elit. Aenean lacinia nulla. Nunc vitae erat eu turpis rhoncus nonummy. Sed ligula pede, feugiat in, fringilla non, viverra non, orci. Praesent pede. Curabitur metus. Etiam tincidunt, odio sed venenatis ornare, dui purus dignissim tortor, a vulputate purus felis at neque. Ut libero. Phasellus egestas dolor eu ipsum. Quisque pellentesque, urna sit amet gravida sollicitudin, eros mi consectetuer mauris, malesuada eleifend augue nibh vitae justo. Donec volutpat dui id tortor. Ut mattis. Integer id lectus ut tortor adipiscing aliquam. Nunc posuere massa sed urna ultrices volutpat. Class aptent taciti sociosqu ad litora torquent per conubia nostra, per inceptos hymenaeos.

■ principles of good practice continued

text in columns and paragraphs

This final section is about the use of paragraphs and the problems that can arise when putting text into columns.

It is thought that legibility is better if you use justified left, ragged right, type alignment. Force-justified text causes the spacing between words to be altered to fit the copy and so results in ugly rivers within the text.

When using aligned left text, try to achieve consistent and rhythmic line endings. Avoid strange and awkward looking shapes that occur when the default settings are used. For best results, a long-short-long rag shape aids legibility. This can be achieved by using line breaks within the text (type Shift-Return) to shuffle the text around without creating unwanted paragraph breaks.

It is best to indicate any paragraphs clearly but take care not to upset the visual consistency of the copy. Indenting is the most common way to do this, along with adding space between paragraphs within a piece of text. The rule is to indent the text to the same measure as the point size; 12 point text requires an indent of 12 points.

Try to achieve text without widows or orphans as they create inconsistent text blocks and interfere with the flow of reading. They produce pages that look ugly and ill-considered. By definition, a widow is a very short line at the end or beginning of a paragraph; an orphan is a single syllable on one line at the end of a paragraph. The best ways to avoid both is to either shuffle the text around by looking at line endings and adding line breaks, or to subtly change the tracking across the text by a minute amount. This will rectify the problem without affecting the appearance of the text.

RANGED RIGHT

Lorem ipsum dolor sit amet, consectetuer adipiscing elit. Aenean lacinia nulla. Nunc vitae erat eu turpis rhoncus nonummy. Sed ligula pede, feugiat in, fringilla non, viverra non, orci. Praesent pede. Curabitur metus. Etiam tincidunt, odio sed venenatis ornare, dui purus dignissim tortor, a vulputate purus felis at neque. Ut libero. Phasellus egestas dolor eu ipsum. Quisque pellentesque, urna sit amet gravida sollicitudin, eros mi consectetuer mauris, malesuada eleifend augue nibh vitae justo. Donec volutpat dui id tortor. Ut mattis. Integer id lectus ut tortor adipiscing aliquam. Nunc posuere massa sed urna ultrices volutpat. Class aptent taciti sociosqu ad litora torquent per conubia nostra, per inceptos hymenaeos.

JUSTIFIED

Lorem ipsum dolor sit amet, consectetuer adipiscing elit. Aenean lacinia nulla. Nunc vitae erat eu turpis rhoncus nonummy. Sed ligula pede, feugiat in, fringilla non, viverra non, orci. Praesent pede. Curabitur metus. Etiam tincidunt, odio sed venenatis ornare, dui purus dignissim tortor, a vulputate purus felis at neque. Ut libero. Phasellus egestas dolor eu ipsum. Quisque pellentesque, urna sit amet gravida sollicitudin, eros mi consectetuer mauris, malesuada eleifend augue nibh vitae justo. Donec volutpat dui id tortor. Ut mattis. Integer id lectus ut tortor adipiscing aliquam. Nunc posuere massa sed urna ultrices volutpat. Class aptent taciti sociosqu ad litora torquent per conubia nostra, per inceptos hymenaeos.

RANGED LEFT

Lorem ipsum dolor sit amet, consectetuer adipiscing elit. Aenean lacinia nulla. Nunc vitae erat eu turpis rhoncus nonummy. Sed ligula pede, feugiat in, fringilla non, viverra non, orci. Praesent pede. Curabitur metus. Etiam tincidunt, odio sed venenatis ornare, dui purus dignissim tortor, a vulputate purus felis at neque. Ut libero. Phasellus egestas dolor eu ipsum. Quisque pellentesque, urna sit amet gravida sollicitudin, eros mi consectetuer mauris, malesuada eleifend augue nibh vitae justo. Donec volutpat dui id tortor. Ut mattis. Integer id lectus ut tortor adipiscing aliquam. Nunc posuere massa sed urna ultrices volutpat. Class aptent taciti sociosqu ad litora torquent per conubia nostra, per inceptos hymenaeos.

LINE ENDINGS

Lorem ipsum dolor sit amet, consectetuer adipiscing elit. Aenean lacinia nulla. Nunc vitae erat eu turpis rhoncus nonummy. Sed ligula pede, feugiat in, fringilla non, viverra non, orci. Praesent pede. Curabitur metus. Etiam tincidunt, odio sed venenatis ornare, dui purus dignissim tortor, a vulputate purus felis at neque. Phasellus egestas dolor eu ipsum. Quisque pellentesque, urna sit amet gravida sollicitudin, eros mi consectetuer mauris, malesuada eleifend augue nibh vitaejusto. Donec volutpat dui id tortor. Ut mattis. Integer id lectus ut tortor adipiscing aliquam. Nunc posuere massa sed urna ultrices volutpat. Class aptent taciti sociosqu ad litora torquent per conubia nostra, per inceptos hymenaeos.

Lorem ipsum dolor sit amet, consectetuer adipiscing elit. Aenean lacinia nulla. Nunc vitae erat eu turpis rhoncus nonummy. Sed ligula pede, feugiat in, fringilla non, viverra non, orci. Praesent pede. Curabitur metus. Etiam tincidunt, odio sed venenatis ornare, dui purus dignissim tortor, a vulputate purus felis at neque. Phasellus egestas dolor eu ipsum. Quisque pellentesque, urna sit amet gravida sollicitudin, eros mi consectetuer mauris, malesuada eleifend augue nibh vitae justo. Donec volutpat dui id tortor. Ut mattis. Integer id lectus ut tortor adipiscing aliquam. Nunc posuere massa sed urna ultrices volutpat. Class aptent taciti sociosqu ad litora torquent per conubia nostra, per inceptos hymenaeos.

PARAGRAPH INDENTS AND WIDOWS

◀◀ There are three different ways to justify text. The most common is ranged left, ragged right, which provides legible text. Another way favored by many designers is justified text, where the type lines up along both left and right edges. This is often used in newspaper design but can cause problems by creating big gaps (called "rivers") between words, which can be distracting to the reader. The third option is that of ranged right, where type lines up on the right edge only.

▲ Default software settings may create awkward shapes through inconsistent line endings within columns of text (above left). To rectify this, use line breaks to shuffle the text around. This will result in consistent short-long-short line endings, which aids readability (above right).

▶▶ Avoid single words at the end of paragraphs: they look ugly. In the left-hand column, there is no clear indication where paragraphs begin and end. The type in the right-hand column features an indent equal to that of the point size of the text.

Lorem ipsum dolor sit amet, consectetuer adipiscing elit. Aenean lacinia nulla. Nunc vitae erat eu turpis rhoncus nonummy. Sed ligula pede, feugiat in, fringilla non, viverra non, orci. Praesent pede. Curabitur metus. Etiam tincidunt, odio sed venenatis ornare, dui purus dignissim tortor, a vulputate purus felis at neque. Ut libero. Phasellus egestas dolor eu ipsum. Quisque pellentesque, urna sit amet gravida sollicitudin, eros mi consectetuer mauris, malesuada eleifend augue nibh vitae justo. Donec volutpat dui id tortor. Ut mattis. Integer id lectus ut tortor adipiscing aliquam. Nunc posuere massa sed urna ultrices volutpat. Class aptent taciti sociosqu ad litora torquent per conubia nostra, per inceptos.

Lorem ipsum dolor sit amet, consectetuer adipiscing elit. Aenean lacinia nulla. Nunc vitae erat eu turpis rhoncus nonummy. Sed ligula pede, feugiat in, fringilla non, viverra non, orci. Praesent pede. Curabitur metus. Etiam tincidunt, odio sed venenatis ornare, dui purus dignissim tortor, a vulputate purus felis at neque.

Ut libero. Phasellus egestas dolor eu ipsum. Quisque pellentesque, urna sit amet gravida sollicitudin, eros mi consectetuer mauris, malesuada eleifend augue nibh vitae justo. Donec volutpat dui id tortor. Ut mattis. Integer id lectus ut tortor adipiscing aliquam. Nunc posuere massa sed urna ultrices volutpat. Class aptent taciti sociosqu ad litora torquent per conubia nostra, per inceptos.

■ common mistakes

Good typography is one of the essential elements in any piece of graphic design. Being able to use it well will aid any design and communicate the message more clearly.

All too often, designers don't understand the subtleties of typography and so certain common mistakes occur that bring down the standard of their work. With a few pointers, however, these mistakes can be rectified to produce more esthetically pleasing results. The following section looks at these common mistakes and shows how they can be corrected. The first group looks at often-used punctuation marks and numerals.

apostrophe and quotation marks

Misuse of primes and apostrophes is common among people who set type. Primes are a leftover from the days of the typewriter and are now used to denote feet and inches. They are located on the keyboard to the right of the semicolon. An apostrophe is used to indicate a missing letter or a word that is possessive. The proper apostrophe, also known as the typographer's apostrophe, is hidden on the keyboard and can be accessed by typing Shift–Alt–] on the Macintosh or Alt–0146 on the PC. Quotation marks, also known as smart quotes, are also hidden on the keyboard and can be located by typing Shift–Alt–[on the Macintosh or Alt 147/148 on the PC. It is possible to automate this procedure by setting the preferences of the layout application, such as QuarkXpress, to use smart quotes, or typographer's quotes for InDesign.

numerals

In the majority of fonts the numerals are the same height as the capital letters. These are called lining figures. This is fine when setting using all caps or within display text. Using them in conjunction with lowercase text can cause problems since they tend to overpower the surrounding copy. For use with lowercase characters it is best to use old-style figures, which have numerals that conform to an x-height with tails protruding as ascenders or descenders. These retain the consistency of the text. On the other hand, it is usually best not to use old-style figures with caps or display copy.

The basic character set of most modern digital faces offers only lining figures. If your typesetting involves working with a large amount of figures, it is probably more effective to choose a font with an expert set—an extra font matching the design of the original with added features. These

SMART QUOTES

"Suspendisse at enim"

▸▸ Apostrophes and quotation marks are used in text. Set your Preferences to use

Smart Quotes to automate this function and avoid using primes.

"Ante sagitti's magna!"

PRIMES

2'6" 30'15"

◂◂ Primes are used with numerals (for example, feet and inches). The two

examples show how to write two feet, six inches and 30 minutes, 15 seconds.

features might include old-style figures, ligatures, ornaments, fractions, and sometimes even swashes.

hyphens, ens, and ems

Use a hyphen (-) to connect compound words or to divide words broken by line endings. The en dash (–) is used (with no space either side) in number ranges, such as dates. The em dash (—) is used (with no space either side) to denote a separate idea within a sentence or an abrupt change in thought. Depending on linguistic variations, en dashes can also be used in this way, with a space either side.

Again, depending on language, both ens ems can sometimes be used instead of parentheses. In this instance, ens appear with a space either side and are better suited typographically to sans serif type. Em dashes are used without space on either side and are typographically better suited to serif typefaces.

NUMERALS

1234567890

1234567890

⤒ As you can see above, there is quite a big difference between lining and old style numerals. The ascending and descending tails provide more rhythm within text if using a lot of numbers.

▸▸ The en dash is normally used without space on either side within dates, page numbers, and other numerical ranges.

ENS IN NUMBER RANGES

1920–1931
pp. 26–27

HYPHENS

Lorem ipsum dolor sit amet adip-iscing

ENS IN A SANS SERIF TYPEFACE

Lorem ipsum dolor – sit amet adipiscing
Lorem ipsum – dolor sit – amet adipiscing

◂◂ The function of the hyphen is to connect compound words or to divide words separated by line endings. Ens and ems have varying uses (above and left). Typographically, ens are suited to sans serif faces, ems to serif ones.

EMS IN A SERIF TYPEFACE

Lorem ipsum dolor—sit amet adipiscing
Lorem ipsum—dolor sit—amet adipiscing

■ common mistakes continued

These "rules" take into account the setting of text in blocks or paragraphs within a layout. Certain problems may arise due to the space available and the way the text flows within the column. These conventions point out the possible difficulties and ways of solving them.

drop capitals ("caps")

Drop caps are traditionally placed at the beginning of a chapter. If left with default settings you may see a large gap between the capital letter and the following word. Attention needs to be paid to the spacing between the cap and the rest of the paragraph to make sure it integrates with the text well. For best results, kern the cap and following text carefully and align it with the top of the body copy. The standard format is to place the cap a set number of lines within the copy. This can be easily controlled within the formats dialog box in QuarkXpress and InDesign.

hyphenation

Hyphens are used in compound words. When hyphenation is left on the default setting, words are hyphenated at the end of lines. It is preferable to do what you can to avoid this, as it breaks up the natural flow of the text and can be sufficiently distracting as to slow reading.

By setting the Hyphenation and Justification (H & J) preferences it is possible to adjust any unwanted hyphens. Alternatively, place manual line breaks in the text to avoid unsightly hyphenation, or edit and rewrite it to eliminate too many hyphenated line breaks. Unavoidable hyphenated line breaks should have at least two letters before the break and at least three at the beginning of the next

DROP CAPITALS

▼ To set a drop cap in QuarkXpress, select Formats from the Style menu. In the dialog box, check the Drop Cap box and set the Character Count for the number of glyphs you want to enlarge, then the Line Count for the number of lines you want the glyphs to drop down.

▶▶ On the near right, you can see the drop cap default setting, where there is a lot of space between the capital and the rest of the text. Use the kerning commands to close up this gap and align it with the rest of the copy for a more pleasing result (far right).

Suspendisse at enim. In mattis, arcu at lacinia convallis, massa justo laoreet tellus, non consectetuer purus velit et felis. Quisque pellentesque. Nunc gravida tincidunt nisi. Vestibulum quis enim. Fusce nulla ante, tristique eu, vulputate eget, semper sed, mi. In tempor diam vel sem. Maecenas aliquet, tellus eu scelerisque pellentesque, arcu ante sagittis magna, in posuere ipsum risus sit amet mi. Nunc ullamcorper, urna vel venenatis pharetra, lorem risus tempus arcu, at lobortis elit neque vel lectus. Quisque enim justo, tincidunt sit amet, porta et, vulputate in, eros. Mauris eget pede sed neque auctor commodo. Quisque ultricies, velit in bibendum porttitor, pede massa feugiat felis, nec aliquam magna sapien id sapien. In hac habitasse platea dictumst. Donec scelerisque sapien imperdiet purus. Nulla facilisi. Suspendisse ligula dolor, aliquet nec, tincidunt id, pretium a, justo. Nam eget justo. Morbi molestie lectus vel nibh. Morbi lectus.

Suspendisse at enim. In mattis, arcu at lacinia convallis, massa justo laoreet tellus, non consectetuer purus velit et felis. Quisque pellentesque. Nunc gravida tincidunt nisi. Vestibulum quis enim. Fusce nulla ante, tristique eu, vulputate eget, semper sed, mi. In tempor diam vel sem. Maecenas aliquet, tellus eu scelerisque pellentesque, arcu ante sagittis magna, in posuere ipsum risus sit amet mi. Nunc ullamcorper, urna vel venenatis pharetra, lorem risus tempus arcu, at lobortis elit neque vel lectus. Quisque enim justo, tincidunt sit amet, porta et, vulputate in, eros. Mauris eget pede sed neque auctor commodo. Quisque ultricies, velit in bibendum porttitor, pede massa feugiat felis, nec aliquam magna sapien id sapien. In hac habitasse platea dictumst. Donec scelerisque sapien imperdiet purus. Nulla facilisi. Suspendisse ligula dolor, aliquet nec, tincidunt id, pretium a, justo. Nam eget justo. Morbi molestie lectus vel nibh. Morbi lectus.

Paragraph Attributes

| Formats | Tabs | Rules |

Left Indent:	0 mm
First Line:	0 mm
Right Indent:	0 mm
Leading:	auto
Space Before:	0 mm
Space After:	0 mm
Alignment:	Justified
H&J:	Standard

☑ Drop Caps
Character Count: 1
Line Count: 3

☐ Keep Lines Together
○ All Lines in ¶
○ Start: 2 End: 2

☐ Keep with Next ¶
☑ Lock to Baseline Grid

(Apply) (Cancel) (OK)

line. Avoid more than two hyphens in a row, and avoid hyphenated word-breaks at the foot of a column of text and at the bottom of a page.

hanging punctuation

Punctuation placed inside a text block can create ugly gaps in the copy. Hanging punctuation is the process of placing any beginning or ending punctuation (particularly quotation marks) in the margin in flush left and justified text. This produces more pleasing visual consistency within the text, as there are no unusual gaps to break up the flow of the copy.

Software such as FreeHand and InDesign has preferences to set this function. QuarkXpress, however, requires that you set it manually, either by placing a non-breaking space before the quote and adding negative tracking between it and the text, or using the formatting dialog box to add a negative indent to the specified amount of the punctuation size.

rivers

"Rivers" are the negative spaces caused when using justified text. The justification process alters the space between words in order to force the text to fit the measure.

The inconsistent word spacing creates the appearance of a river of white space running down through the text. This can be distracting for the reader. Rivers are more common when type is set across a narrow measure or column width. To combat this, you could set your text flush left and ragged right so that word spacing is consistent, or if you really have to justify the text try setting it across a wider measure.

The general rule of thumb is that the length of the line in picas should be about twice the point size. So, for example, if your type size is 8 points, then your measure should equal around 16 picas.

HYPHENATION

In pulvinar, odio ac vulputate pharetra sapien arcu tempus nisl, vitae rutrum enim nunc ut lectus. Vivamus tellus. Aenean posuedre placesrat quam urabitas dedur sagittisimus orcsssin mettauris. Vivasmus sapien sodales dictum purusnteger ac risus. Maecenas porta mi non sem. Nullam tincidunt elit laoreet vitae augue. Fusce nulla sapien, faucibus non, congue in sceler laoreet isque laoreet pede. Quisque vehicula euismod ante.

In pulvinar, odio ac vulputate pharetra sapien arcu tempus nisl, vitae rutrum enim nunc ut lectus. Vivamus tellus. Aenean posuedre placesrat quam urabitas dedur sagittisimus orcsssin mettauris. Vivasmus sapien sodales dictum purusnteger ac risus. Maecenas porta mi non sem. Nullam tincidunt elit laoreet vitae augue. Fusce nulla sapien, faucibus non, congue in sceler laoreet isque laoreet pede. Quisque vehicula euismod ante.

⬆ The default setting for hyphenation pays no attention to how the text looks on the page. When using justified type the amount of hyphens within a given block of text can be very distracting. Adjust the hyphenation to rectify this problem or add line breaks within the copy to shuffle the text around.

Edit Hyphenation & Justification

Name: New H&J

☑ Auto Hyphenation

Smallest Word: 6

Minimum Before: 3

Minimum After: 2

☐ Break Capitalised Words

Hyphens in a Row: unlimited

Hyphenation Zone: 0 mm

Justification Method

	Min.	Opt.	Max.
Space:	85%	110%	250%
Char:	0%	0%	4%

Flush Zone: 0 mm

☑ Single Word Justify

Cancel OK

RIVERS

Lorem ipsum dolor sit amet, consectetuer adipiscing elit. Aenean lacinia nulla. Nunc vitae erat eu turpis rhoncus nonummy. Sed ligula pede, feugiat in, fringilla non, viverra non, orci. Praesent pede. Curabitur metus. Etiam tincidunt, odio sed venenatis ornare, dui purus dignissim tortor, a vulputate purus felis at neque.

Lorem ipsum dolor sit amet, consectetuer adipiscing elit. Aenean lacinia nulla. Nunc vitae erat eu turpis rhoncus nonummy. Sed ligula pede, feugiat in, fringilla non, viverra non, orci. Praesent pede. Curabitur metus. Etiam tincidunt, odio sed venenatis ornare, dui purus dignissim tortor, a vulputate purus felis at neque.

⬆ Rivers can be very noticeable when using justified text and small column measures (left). They create unsightly areas of white space within the text block, which can distract the eye. Increase the measure of the column or use range left, ragged right text (right) to avoid this problem.

■ the position of type on the page

The position of type on the page is as important as the selection and treatment of the typography. For a message to be communicated clearly, all elements must work in unison.

When considering how to use typography on the page, consider the different functions type performs. It communicates information in words, but also the way in which the type is laid out on the page can convey a message or an idea. It can also explain or caption artwork.

legibility and readability

Throughout this book, both the terms legibility and readability will be used. In this day and age these two terms can often be confused and used more or less interchangeably, so it is important from the outset to clarify their separate meanings.

Legibility relates to typeforms and how easy it is to distinguish individual characters or alphabets in certain fonts. Readability refers to typeforms and also, more importantly, its sympathetic and logical placement on a page: that is, how clear and easy it is to read a piece of text. There are many factors that may affect this, such as the choice of font, size, color, the use of space, and the arrangement of the typography within that space. The way in which the text is presented is also a factor in readability, for example, whether typography is viewed on screen, page, or within a dedicated exhibition space with ambient lighting.

Legibility has sparked a huge debate in recent years. Some designers argue that legibility is a conditioned factor and that we read best what we have become accustomed to; such designers cite using Black Letter as an example of how letterforms

▼ In another spread from the same project, the copy is noticeably more ordered. On this double-page spread, the text refers to the definition and principles of typography. For this reason, the typography has to be easier to access and read to back up the subject matter.

▲ In this example, the layout of the typography has been carefully considered to reflect the content of the copy, which is about how the principles of deconstruction have infiltrated graphic design. With this in mind, the design is deliberately playful and pushes the boundaries of readability to effectively illustrate the point.

have changed over time without any loss of quality in communication. This is true, but technology means we are now exposed to many differing types of lettering. This has and will continue to affect each generation and no doubt leaves its mark on the designs created, along with the subsequent ideas on what constitutes a legible typeface.

type for continuous text

The use of typography is essential to any good graphic design. It is the building block from which all the other elements hang. Get it wrong and the design will be flawed. Manuscript typography is very different from that of text type in a magazine or newspaper. The typographic design of continuous text requires attention to detail of a more precise nature. Nothing should interfere with the flow of information from author to reader and the typography should be transparent in that it should impart only the written information and not in some way add to the meaning through its treatment. Although newspapers on the whole are dealing with large amounts of typographic information, the information is broken down into different-sized chunks. Each chunk is separate in its own right. These pieces of information must attract attention to themselves with bold headlines or subheadings and are laid out within a distinct typographic grid to maximize the space. Magazines, on the other hand, strive to attract attention to the story or text. In addition, the typography is designed with the content of the information in mind: sometimes the design is given meaning through the expressive nature of the typographic elements.

It is for these reasons that the choice and treatment of the typography for these functions has to be different. Text type for books should be invisible in that it should not draw attention to itself. In a magazine, the article may be more experimental in its use of textual information to transfer the message or idea.

⬇ Here the text and grid structure are used to maximum effect to illustrate the relationship between insanity and genius. The treatment of the type automatically sets up the tone of the piece.

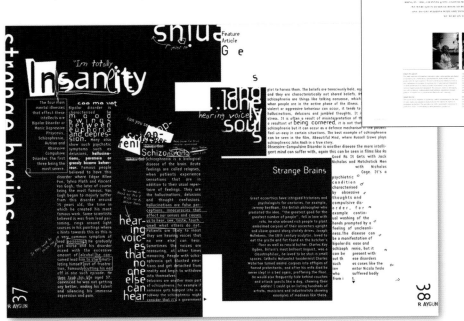

⬆ In a double-page spread from a promotional brochure for a university, the image plays a large role. The copy has to be easy to read without any loss of information. For this reason, there is a clear hierarchy and positioning for the reader to follow.

SEE ALSO

PRINCIPLES OF GOOD PRACTICE 30
THE TYPOGRAPHIC GRID 44
VISUAL HIERARCHY 46
CONSTRUCTING A GRID IN QUARKXPRESS 48

■ the typographic grid

A typographic grid adds structure to the resulting design and allows the designer the flexibility to put together professional, well-ordered pages with ease.

Margins for manuscript grids (books) normally look more esthetically pleasing when they work in harmony with the proportions of the document. By taking a line from the bottom corner to the top centerpoint and also to the opposing top corner, as shown, you get guides on which to place your text column to give balanced margins for continuous reading.

column widths, while the horizontal lines are determined by the space that a line of type occupies.

Designers use grid structures because they are practical, especially when producing multi-page documents such as books, magazines, and newspapers. They make the production process quicker and build in a visual consistency, bringing order to a page and imposing structured thinking on the design process.

There are four basic elements involved in a grid structure.

margins

A margin is the space around the grid structure that governs how close the text is placed to the edge of the page. If the grid uses small columns, one or more can be left blank to give a consistently large left or right margin; alternatively, large margins can be part of the grid structure. Extremes of all kinds make the page more visually dramatic.

the column and the field

Horizontally, the page is split into margins and columns. Vertically, the page is split into a baseline grid with top and bottom margins. In addition, the page can be divided into larger vertical units to form fields. These fields can be used to line up elements on the page such as photographs and illustrations with columns of text or headlines. Text can run across columns to create stimulating and dynamic pages.

Common to every page design is an underlying grid structure. This helps to divide the page into different areas for different purposes, such as columns of text, headlines, illustrations, and captions. A grid provides a framework within which a designer or typographer can order the potential chaos of letters or images on a page. They are about the organization of objects in space and involve decisions about proportion and scale.

The grid is the graphic design equivalent of a building's foundations. It is a starting point from which everything else is built. It is generally a series of vertical and horizontal lines in which the vertical lines relate to

1 For magazines, newspapers, and other documents, it may be necessary to have several columns for the text to follow. This four-column grid serves many design purposes well, but can prove inflexible.

2 Even numbers of columns often do not provide a designer with enough flexibility. An odd number of columns offers the opportunity to leave a column blank to give a page a more dramatic look.

3 Another way to achieve more drama within the design is to have margins that are not evenly measured. Here, the left and bottom margins are greater than those on the right and at the top.

4 The more columns you have across the document, the more flexibility you have within the design. You can take text across two or more columns, while allowing captions to occupy only one column.

5 To aid the design, many designers use fields along with columns to align elements on the page. Fields' horizontal lines create rectangular spaces into which text or images can be placed.

the baseline grid

The baseline grid is a series of horizontal lines running across the page. Each line represents a possible baseline of a line of type. The baseline of type is the line on which the bottoms of capital and lower-case letters sit. Two factors determine the space between baselines: the size of the type and leading.

In order to develop a system that gives maximum flexibility, the unit of the baseline grid is usually smaller than the measurement from baseline to baseline of the text type size. Normally, the unit is divided into three to give the designer a degree of flexibility when setting text for such elements as captions. Most layout application software allows you to specify the increments for the baseline grid within the preferences and to snap text to the grid. Text which all conforms to a baseline grid is more esthetically pleasing and ordered.

6 Here the baseline grid is a series of horizontal lines, which represent the baseline of a line of type. In page layout software, you can control the intervals of these lines by setting the measurement in points. It is also possible to make the text on the page snap to the baseline grid to make sure it all aligns perfectly.

Si meliora dies, ut vina, poemata reddit, scire velim, chartis pretium quotus arroget annus. scriptor abhinc annos centum qui decidit, inter perfectos veteresque referri debet an inter vilis atque novos? Excludat iurgia finis, "Est vetus atque probus, centum qui perficit annos."

Si meliora dies, ut vina, poemata reddit, scire velim, chartis pretium quotus arroget annus. scriptor abhinc annos centum qui decidit, inter perfectos veteresque referri debet an inter vilis atque novos? Excludat iurgia finis, "Est vetus atque probus, centum qui perficit annos."

7 Here, the baseline grid is set to 8pt. On it are placed 8pt, 16pt, and 24pt text, set solid. Notice how even though they are all different sizes, they all conform to the baseline grid. It is always best to set the measurements of the grid based on the point sizes of text you will be using.

■ visual hierarchy

Important in every design, visual hierarchy is a way for the reader to navigate around the information presented in a logical and linear order.

Without visual hierarchy, most information design would become chaotic, even when the designer uses a grid, because the user would not know where to begin to access information.

hierarchy

Hierarchy is the visual arrangement of elements in a graded order from most to least prominent. A designer must consider this hierarchy when designing any piece that deals with typographic information. The text creates a tone of gray on the page. Any variation in this tone will make elements recede into the background or appear to come forward into the foreground. You can use lighter or bolder text, smaller or larger point sizes, and reverse text out on a colored background, with graphic elements such as underlining and arrows to achieve this visual direction. All these lead the reader's eye around the page in a particular order.

symmetry vs. asymmetry

The grid grew out of a logical approach to legibility. Since we read from left to right, each word should be separated by an equal word space, and this automatically produces asymmetrical ranged-left, ragged-right typesetting.

The most visually stimulating designs tend to be those that employ asymmetry as a design criterion. Asymmetry lends itself to greater exploration of the visual potential of layout. The freedom to use space and scale dramatically has produced great beauty and dynamic tension in the work of designers, such as Jan Tschichold. His designs still look as fresh and modern today as when he designed them in the early part of the last century. Asymmetry can be achieved in the number of columns used within a layout—three or five, for example—and in their positioning on the page with larger left- or right-hand margins.

2 ◀◀ In this centered layout there is a clear hierarchy but the design does lack some visual dynamism.

1 ◀◀ This example of an exhibition program was inspired by a Jan Tschichold design. The asymmetrical design, used in conjunction with small typography and graphic elements such as colored shapes and rules, provides a dynamic and esthetically pleasing piece.

3 ▶▶ One of the easiest and most effective ways to draw attention to a piece of text is to make it bigger and bolder. In this example, the name and title copy have been given this treatment and so stand out above the rest of the copy.

4 ▶▶ In this example, the name is the biggest element on the page but since it is set in a light version of the typeface, it is not the most prominent component. The bold text underneath generates a darker tone on the page: it draws the eye in first and so plays a more dominant role.

5 ▶▶ Another way to create dominance on the page is to use visual devices such as colored boxes with the text reversed out of them. In this example you can see that the title text has been enlarged considerably but the name still commands attention because of the prominence of the black box.

6 ◀◀ Subtle use of typography can produce some very interesting results. Here, size and weight have been used with restraint. Attention is drawn using bold type at small sizes to maximum effect.

7 ▲ In this example, the tint of the typography has been used to make large text appear less prominent. Although the name is much bigger than the other elements, the choice of a paler tint means it does not "shout" off the page, creating visual harmony.

■ constructing a grid in QuarkXpress

A grid is relatively simple to construct in any page layout application. The introduction of master pages enables the user to design a variety of grid structures.

Master pages are invaluable. Any item placed on a master page appears on every document page to which the master is applied. Since you can name master pages and apply them to any page within your document, you can produce a range of grid structures to be used throughout the file.

producing a grid in QuarkXpress

To create a master page, locate the Document Layout palette. At the top of the palette find an A-Master A icon. Double click this icon to display the master page within the window. It is now possible to modify the number of columns and the margin guides. Select Master Guides from the Page menu. The dialog box shows the margin measurements—top, bottom, left, and right—along with the column guides and the gutter width. Key in the values you require and click OK. These values will now be applied to every page created with the master page. To create new master pages, select the blank page icon at the top of the palette and drag it to the master page area. It is then possible to rename and modify this new page.

QuarkXpress allows the user to place margin and column guides on any page. To create fields the user must pull down guides on the master page from the rulers and position them to the correct place.

The baseline grid will automatically be set to default. To change the measurements for the increments and also the position on the page from which it begins, locate the Measurements command within the software Preferences. This will control the start and also incremental measurements in points. In the Formats palette in the Style menu, you can lock any type to the baseline grid. Any text created will automatically snap to the baseline grid.

2 When creating a multi-page document it may be necessary to create several grid structures for different needs. Master pages are very useful as any elements you place on them are duplicated on every page you create using it. They are located in the Page Layout palette.

1 Normally when you begin a new project in QuarkXpress, a dialog box will appear. You can specify the page size, margin, and column guides. This provides the basic grid structure.

3 Select the master page by clicking on it and then select the duplicate icon (the middle symbol of two overlapping pages). You will see a new master page appear called B-Master B. You can rename this by clicking on the name and typing over it.

4 To change the number of columns and add guides, select Master Guides from the Page menu. This will bring up the Master Guides dialog box, where you can change the number of columns, the gutter width between them, and also set the margin guides.

BASELINE GRID

1 ▲ The baseline grid in QuarkXpress will be set to default. In order to see the grid, use the Show Baseline Grid command in the View menu.

2 ▲ To change the settings for the baseline grid, you need to alter the preferences. In the QuarkXpress menu, select Preferences.

3 ▼ Choose the Paragraph option in the left-hand window. In the right-hand pane, set your start point—normally the same measurement as your chosen margin. Set the increment amount in points. This will depend on your chosen point size and font.

4 ▲ Once you have set the measurements for the grid it is possible to make the text lock to it so it cannot be out of alignment. In the Style menu, choose Formats. In the dialog box, check the Lock to Baseline Grid command. All text will then snap to the guides without the need for positioning each line manually.

5 ▲ If you double-click on the master page icon, the master page will be displayed on screen for you to add elements to. You can be sure you are adding to the master page by the chain link icon displayed in the top left-hand corner of the page. Drag down guides from the ruler bars to place on your field guides or any other guides you may require. These will then appear on every page.

6 ◄◄ You can then begin to add in elements such as text boxes on the guides you have created.

type management

Fonts are a crucial part of any design. How to store them and manage them can be a problem for many users. Too many fonts can clutter up the hard drive.

Most graphic designers realize the value of a wide selection of fonts and so have a habit of collecting them and storing them for use on some future occasion. Although it is preferable to have a selection of typefaces that you can use at any time to suit every design need, too many of them stored on your computer can take away valuable memory from the operating system, slowing down your computer.

A solution to this problem is to use some sort of font management system, which allows you to organize fonts into categories and load only the ones you need when you need them. Not only does this speed up the operating system but also it allows you to locate fonts quickly and easily and load them according to job, client, or other criteria.

There are several pieces of font software on the market but the two main contenders are Adobe Type Manager Deluxe and Extensis Suitcase Fusion. Both of these are available for the Macintosh and PC. Currently, though, Adobe Type Manager does not support Mac OSX, and at the time of writing, there does not seem to be any plans to rectify this situation. Suitcase Fusion, on the other hand, supports all platforms, including OSX, without causing any operating problems.

The software works by storing fonts on the computer's hard drive in a place other than the System Folder. The application allows the user to load specified font sets

or to temporarily add fonts as they see fit. These temporary fonts will then be excluded on the next system start up.

Since the operating system is not reading all the fonts stored on the hard drive at the same time, it frees up memory to be used elsewhere, keeping your computer

running at optimum speeds. It also means you can categorize your fonts and also preview them at any time without having to load them each time. If you are using lots of fonts for different jobs it is advisable—and time effective—to invest in some font management software.

◀◀ Without any type management system, the Fonts folder in the System Folder, or in the case of the Mac, the Library, is full of font files. These files do not allow you to see what the fonts look like or categorize them. Too many fonts in the System Folder will slow down your computer.

Name	Date Modified	Size	Ki
▶ astigmatic fonts	14 Decemb...2004, 20:48	--	
▶ bitmapped faces	5 December 2005, 11:17	--	
▶ bitstream typefaces	Today, 15:23	--	
▶ coputer arts fonts	22 August 2004, 16:41	--	
▶ decorative	13 March 2005, 23:27	--	
▶ dingbats	13 March 2005, 23:00	--	
▶ distressed fonts	Today, 15:23	--	
▶ fonts folder	Today, 15:24	--	
▶ fonts from system folder	29 Septemb...003, 16:53	--	
▶ foreign	13 March 2005, 22:51	--	
▶ graphics course fonts	25 June 2005, 01:36	--	
▶ handwritten	13 March 2005, 23:26	--	
▶ historical fonts	13 March 2005, 22:55	--	
▶ kris font	13 March 2005, 22:35	--	
▶ letraset	20 April 2005, 13:50	--	
▶ my fonts	11 Decemb...2005, 18:35	--	
▶ ORNAMENTS	20 April 2005, 13:59	--	
▶ other	Today, 15:25	--	
▶ Retro fonts	20 July 2005, 17:15	--	
▶ sans serifs	10 May 2005, 14:34	--	
▶ scripts	7 December 2005, 15:31	--	
▶ serifs	13 March 2005, 23:25	--	
▶ stencil	13 March 2005, 23:25	--	
▶ techno fonts	13 March 2005, 23:17	--	
▶ vicki's fonts	Yesterday, 23:18	--	
▶ weird	Today, 15:24	--	

.49 GB available

◀◀ Here, the files are sorted by category on the hard drive but it is still difficult to know what they look like and to be able to use them effectively.

● NewsGothicBT-Bold

ABCDEFGHIJKLMNOPQRST...
abcdefghijklmnopqrstuvwxyz
1234567890!@#$%^&*()

● NewsGothicBT-BoldItalic

ABCDEFGHIJKLMNOPQRSTU...
abcdefghijklmnopqrstuvwxyz
1234567890!@#$%^&*()

◀◀ This is a shot from Extensis Suitcase Fusion. In this window, you can see the font chosen and also any other variations within the font family, providing a quick and easy way of viewing the font, along with a means of storing it until needed by the system.

● NewsGothicBT-Italic

ABCDEFGHIJKLMNOPQRSTU...
abcdefghijklmnopqrstuvwxyz
1234567890!@#$%^&*()

● NewsGothicBT-Roman

■ type management continued

The first font management software we will be looking at is Extensis Suitcase Fusion. It is currently a new system on the market and is available for both the Mac and the PC.

The software provides the user with a font management system that reads fonts located on the hard drive and loads them into the system software as and when needed. To gain the full benefit of the software it is best to move all fonts other than system fonts to a separate folder. To allow the program to access these fonts simply open the software and drag and drop the individual fonts or folders into the fonts pane on the lower left of the interface.

The font set window, on the top left of the interface, allows you to organize your fonts by whatever criteria you specify. You can activate or deactivate these fonts as you need them.

The preview window allows you to compare fonts to each other visually before you activate them. The top toolbar contains icons for the most commonly used commands, such as creating a new set, add fonts, remove fonts, and also the color coding to denote which faces are currently activated or not.

To create a new font set, click the New Font Set icon and name it. Select your appropriate fonts in the dialog box and click the Add button. Alternatively, you can click and drag faces from the fonts pane directly into the font set to be used. Once the set has been defined the preview window will display the fonts included.

When activating or deactivating fonts, there is no need to restart your computer. Suitcase Fusion allows you to specify one of three modes for the font: activated (green), deactivated (red), and temporary (yellow). These modes control whether the font is available to the system permanently, temporarily, or not at all. To change the status of a font, simply select it and choose the appropriate color-coded icon in the toolbar. This function allows you to specify fonts that you may use the majority of the time to be loaded on every start up. The temporary function allows you to use fonts that will be deactivated on the next system start-up.

1 Extensis Suitcase Fusion is one of the newest font management systems available.

2 When opened for the first time, the following window will appear. On the left are the font sets and suitcases, on the right, the preview window, where you can view the fonts. To begin a new set, click the New Set file icon at the top left of the box.

3
▶▶ A new folder will appear in the Sets window, which you can rename by typing a folder name.

5
▼ The font files you have added will appear in the suitcase window on the bottom left-hand side. You can see that if you click on one it appears in the preview panel.

4
▼ Click the Add button to attach font files. In the dialog box that follows, locate the font files to be added and click the Open button.

6
▼ To make these fonts available to the system, simply select them and then click the Activate button. A yellow dot will appear next to them to tell you that these have been temporarily activated.

7
▶▶ If you hold down the Option key while you click Activate, the fonts will be added each time Suitcase starts up and so will appear with a green dot next to them. It is also possible to manage the fonts in the System Folder by choosing Show System Folder Fonts in the View menu.

8
◀◀ Using the drop down menus on the preview panel it is possible to change the point size of the text previewed, in addition to the message shown.

■ type management continued

The other font management system is ATM Deluxe. It is an old favorite with many people and has a long history but it is now becoming increasingly out of date with newer operating systems.

Adobe Type Manager Deluxe works on the same principle as Suitcase Fusion. This program is not to be confused with Type Manager Light, which is a type utility for viewing and printing PostScript fonts. ATM Light works on the WYSIWYG (What You See Is What You Get) principle, which smoothes fonts and makes sure they print correctly.

ATM Deluxe locates font files on the hard drive and activates those required by the system, depending on the set specified within the interface. In essence, it manages the font folders for you, taking the responsibility of having to locate and load fonts manually into the system folder. It allows you to specify font sets, activate and deactivate them, and organize them according to job, style, or any other criteria you specify.

The interface is relatively similar to that of Suitcase Fusion and works on a series of tabs rather than icons. The Fonts tab enables the user to view all the fonts

installed on your system. You can add fonts into existing sets or you can start new sets. By double-clicking a font, you can view it in the sample pop-up window to check it is the one you require. To add a font to a set, simply drag and drop it into the required font set. It is possible to set temporary folders that can be either deactivated or even deleted by the software on restart.

The beauty of font management programs is that not only do you free up memory for the operating system but you can add fonts for immediate use, without the need to restart the computer.

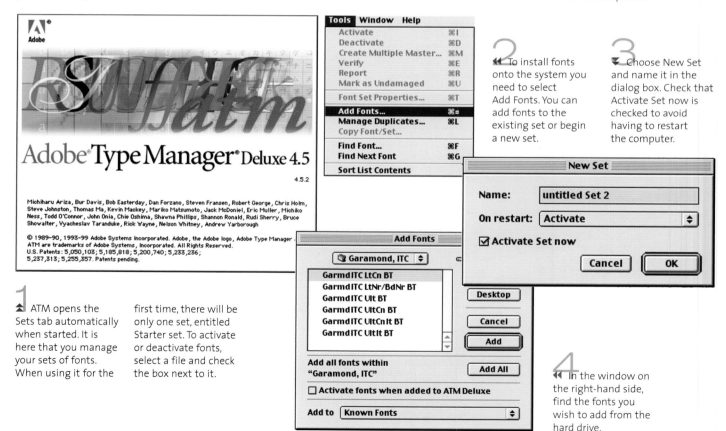

2 To install fonts onto the system you need to select Add Fonts. You can add fonts to the existing set or begin a new set.

3 Choose New Set and name it in the dialog box. Check that Activate Set now is checked to avoid having to restart the computer.

1 ATM opens the Sets tab automatically when started. It is here that you manage your sets of fonts. When using it for the first time, there will be only one set, entitled Starter set. To activate or deactivate fonts, select a file and check the box next to it.

4 In the window on the right-hand side, find the fonts you wish to add from the hard drive.

5 ◗◗ You can use the file from its current position without moving it to the system folder. To do this, click on the Add Without Copying File checkbox. Any fonts you have selected should be added to the set. To add any further files, simply select the set and use the Add tab to choose further typefaces.

6 ◗ Check for duplicate fonts when adding files to ATM and show system fonts in the Known Fonts Set by checking these options. Select Activate Fonts when added to ATM Deluxe.

7 ◗ As with Suitcase Fusion, it is possible to change the sample text viewed. In the Settings tab, choose the Advanced mode and edit the text how you want. Any fonts added will become immediately available to any software running without the need to restart the software or the operating system.

8 ◗◗ By double clicking any font in the set a sample window should appear, where you can view it.

Manipulating type is nothing new, but recent advances in software such as Photoshop, Illustrator, and FreeHand have made it simple for the designer, illustrator, and typographer to experiment with effects on their typography. It allows them greater control and enables them to add to the feel or atmosphere of the typography. This manipulation may in turn enhance the message transmitted from author to audience, giving subtle clues as to meaning. This chapter is concerned with the various forms of manipulation open to the designer. Here, we will demonstrate effects, giving you practical pointers on how to create them.

■ type on curves and circles

Setting type on curves and circles is a way for the typographer to guide the reader's eye around various pieces of information, in a particular order.

The advent of the computer and software such as Illustrator, FreeHand, and page layout programs such as QuarkXpress and InDesign, has enabled the designer to add subtle manipulations to typography to draw the reader's eye around the page. The "gesture" of the design, as it is sometimes called, is a way of using hierarchy and placement to make the reader follow the information in a particular order. Rather than placing blocks of type horizontally, vertically, or on a set angle, text can be placed on flowing curves that lead from one piece of information to the next: the

typography becomes a branch connecting the separate strands of information. It can create a more dynamic composition with added visual interest.

It is more commonly used in designs like beer labels, bottle tops, and information on CDs, where the text has to run around a circular or oval shape. With a few moves in one of the software packages it is possible to flow text around perfect circles or other shaped paths.

Adjust your tracking and kerning appropriately: text left on default settings can look poorly spaced and bunched together

as the tops or bottoms of letters intersect or overlap when placed on the baseline. Similarly, text tracked too loosely can be difficult to read as letter spacing becomes confused with word spacing. Small type on sweeping curves gives the most visually pleasing results. Large text on tight curves produces ugly, poorly set results.

If you are placing text in a perfect circle, don't start the text at the top but on the far left. Since the majority of us are conditioned to read from left to right, we automatically look for the first word in a piece of text in that position.

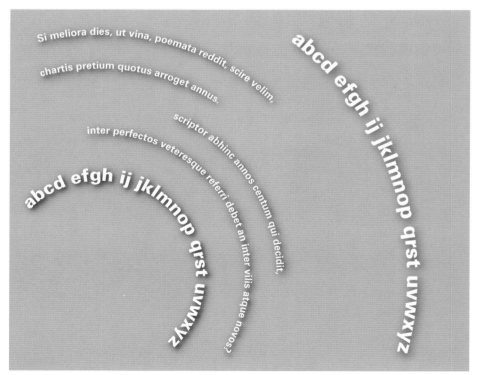

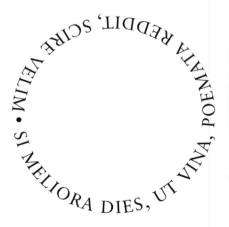

◀◀ Text on circles and curves is easy to achieve in most software packages and if done with care can add some dynamic tension to any composition. The placement of letters guides the eye.

▲ Type on curves can look great but you need to let the reader know where to begin. Since we read left to right it is always better to start on the left, rather than in the center. The bullet acts as a focal point to reinforce this fact.

ILLUSTRATOR

1 The easiest way to produce text on curves in Illustrator is to use the Pen tool to generate paths that can be manipulated.

2 Click and drag to use the tool to create anchor points and handles in the direction you want the curve to go.

3 Click and hold on the Type tool to reveal the other options. Select the Path Type Tool.

4 Using this text tool, click on the path then type your copy.

5 To put text on a circle, first create the circle using the Ellipse tool. Hold down the Shift key while dragging the shape to make a perfect circle. Once complete, use the Path Type Tool again to place the text on the shape.

QUARKXPRESS

1 Placing type on curves in QuarkXpress is similar to working in Illustrator. You have to draw the path first and then place the text on it. In the toolbox, choose the Bezier Text-Path tool.

2 In the same way as in Illustrator, click and drag the desired shape. Here guides are used to help to generate a circle.

3 Once you have completed the shape, simply click with the Content tool on the path to be able to type the copy.

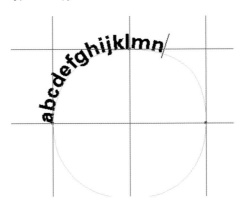

4 Another way is to use the Freehand Text-Path tool. This works like the Pen tool in Illustrator, in that you draw the shape and the tool calculates where the anchor points and handles should be.

5 Simply draw out the shape and the software automatically treats it as a text path. Use the Content tool again to generate the text.

■ outlined text

One of the main advantages of using vector software is that you can treat the typography as a series of shapes, rather than text.

Vector software such as Illustrator and FreeHand give greater flexibility and allow you to achieve results not possible with applications such as QuarkXpress. Vectors are coded as mathematical descriptions on specific points. Vector type is created from outlines, generated by points and Bezier curves. Because this type doesn't rely on bitmaps, it can be scaled easily and the points and curves themselves can be manipulated to produce intriguing effects.

Illustrator and FreeHand have the ability to take any text and outline it simply by using the Fill and Stroke function in the toolbox. If you wish to create further outlines, you can do so using the Path functions. Using the Outline Path or Offset Path function enables you to draw around any existing path. This takes the original paths and provides you with an outline of the stroke width placed on that letter. In effect, you outline the outline. You can then proceed to change the width and color of the new path.

Alternatively, select your chosen text and copy it to the pasteboard. Stroke your text as normal using the toolbox and add a small stroke weight. Paste your copied text behind and then color the stroke, changing the stroke weight to be greater than the first. For maximum impact, combine this with other effects, such as drop shadows. This function is currently unavailable in QuarkXpress, although InDesign has it—Adobe tied it in to Illustrator's operations and amended it to tackle page layout.

overlapping outlines

Once you have mastered using outlines in Illustrator, try creating other effects, such as overlaying. By copying and pasting you can build up text that has multiple offset outlines. This can also be achieved in Photoshop by placing a stroke on selected text. This can be duplicated through the layers and moved to the desired position. For a psychedelic effect, try blending solid text with misaligned outlines and vary the color and point size slightly.

Outlines can be used to great effect in logotypes, where designers need to create eye-catching, yet simple, typography. The outline does not detract from the message, yet draws attention to the letterforms.

OUTLINE EFFECT

1 Select your type, then select your outline color from the main toolbox.

2 In the Window menu, select Show Stroke to see the Stroke palette. Select the required weight in points or millimeters.

3 In the Object menu select Path, then in the submenu, choose Outline Stroke. You can change the stroke width of the outlined path using the Stroke palette and also change the color using the swatches.

■ misregistration effect

In the printing process, the colors cyan, magenta, yellow, and black overprint each other and by mixing together, create every color within a print.

Misregistration is a term that refers to the deliberate misalignment of the plates that make up the color printing process. If the plates are in correct registration, the colors will mix to give the correct tone and shade. If they are not in the correct alignment, the image will have a "ghosting" effect. This is most evident on colored text. If you are using small point sizes and one plate is only slightly out, you will see an outline of cyan, magenta, or yellow (or mixes of the colors) depending on which plate is not in the correct position.

It is possible to replicate this effect in Photoshop. There are two ways of doing this. First, because Photoshop splits the document into channels, these can be manipulated accordingly. By placing your type in the appropriate mode of CMYK you can alter the appropriate color channels. The second way is to use the Layers palette.

By copying your piece of text you can duplicate it and color it using the Type tools, filling the text in cyan, magenta, and yellow. Set the Layers Blending option to Multiply and every color placed on top of the other will have the "additive" effect, that is, when all the CMY colors are added together they produce the color black. You can make the text look like it has been printed poorly for graphic effect, by slightly moving the text on the relevant layers. This is only possible with black text.

Misregistration is an effect created when the printing plates are deliberately misaligned. The separate colors of the three color plates, plus some colors in between, become visible around the edges of the black letters.

MISREGISTRATION EFFECT IN PHOTOSHOP

1 ▶▶ Generate your type in Photoshop. In the Layer menu, select Duplicate Layer to create a second, copied, layer. Repeat the command one more time so you end up with three layers.

2 ▶▶ Select one of the layers, then double click on the Type Color box in the top menu bar to bring up the Color Picker dialog box. In the color values on the right-hand side, set magenta (M) to 100 percent and all the other colors to zero.

3 ▶▶ Perform the same action for the other two layers, choosing 100 percent yellow for one and 100 percent cyan for the other. Using the Move tool or the arrow keys on the keyboard, move the layers slightly out of alignment with each other and set the layer options to Multiply.

shadow effects

Shadows are an easy way to add some depth to your work. They work well visually and are an instant way of creating a focal point in the typography.

A drop shadow can make a bold, powerful statement and is best used for logos, titles, headlines, or drop capitals used at the top of columns in magazine articles or books. In the hierarchy of the typography, anything darker or bolder than the rest will draw attention to itself by appearing to jump forward.

A standard drop shadow consists of copying the original text and offsetting it behind to look like it is floating. This is still the easiest way to create an effective shadow, and can be achieved in any software that uses type. Illustrator and FreeHand also have the capability to produce soft shadows along with hard ones. They do this by applying a Gaussian blur filter to the shadow. Once you have selected Drop Shadow from the menu, you can control the distance it is offset, and its opacity, color, and blur.

Software manufacturers have recognized that their applications can be used for purposes other than those they were originally designed for. Photoshop, for example, now has enhanced type and layer options to take this into account. With the click of a mouse it is possible to create a drop shadow on any text. As with Illustrator, you can set the distance from the original, the opacity, and the angle. You can also add noise.

Once you have created a drop shadow, you can still manipulate it by using the Free

CREATING SHADOW EFFECTS IN PHOTOSHOP

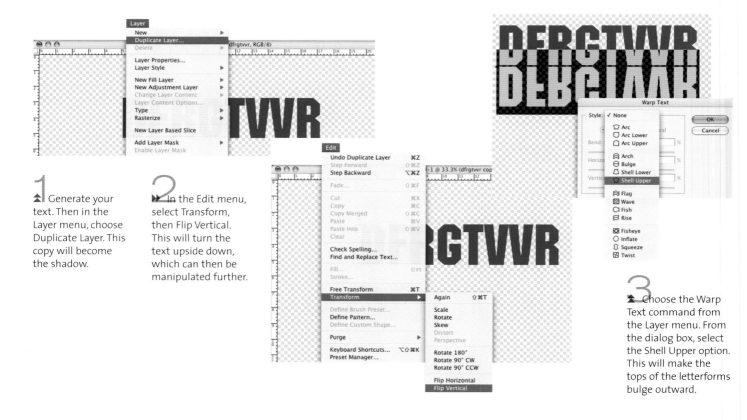

1 Generate your text. Then in the Layer menu, choose Duplicate Layer. This copy will become the shadow.

2 In the Edit menu, select Transform, then Flip Vertical. This will turn the text upside down, which can then be manipulated further.

3 Choose the Warp Text command from the Layer menu. From the dialog box, select the Shell Upper option. This will make the tops of the letterforms bulge outward.

Transform tools in the Edit menu. This allows you to shear, distort, scale, or even add perspective to the shadow to make it look as though it has been generated by a light source and cast against a plane. You can exaggerate it by moving grouping points together and moving them on an angle to make the effect more extreme.

You can create shadows inside type using the Inner Shadow function in Photoshop. This makes the typography seem to be debossed into the paper or the image it lays on top of. The software allows you to control the depth, angle, distance, and blur of the shadow.

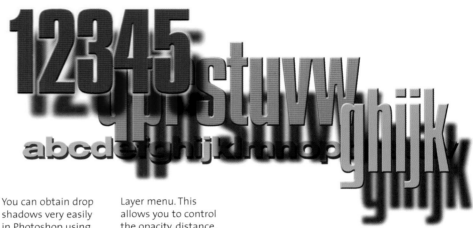

You can obtain drop shadows very easily in Photoshop using the Layer Style commands in the Layer menu. This allows you to control the opacity, distance, spread, size, and angle of the shadow.

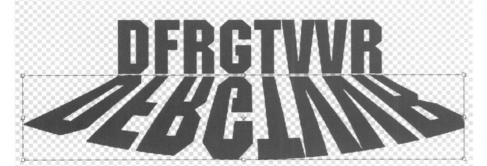

◀◀ **4** Use the Transform command from the Edit menu to scale the manipulated layer and then place it underneath the original, untouched, letterforms.

▼ **5** From Layer Style in the Layer menu, use Gradient Overlay to fade the shadow. Adjust the opacity of the layer in the Layer palette for a more convincing result.

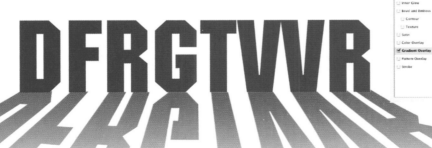

■ bevel and emboss

You can now create simple but eye-catching 3D-style effects for your type in Photoshop to take your work beyond using basic drop shadows.

The visual effects applied to type have a strong impact on the hierarchy of any design. They become a focal point that immediately attracts the reader's attention. Photoshop has several simple features that, used sparingly and with some imagination, can make your typography stand out. However, be aware that these effects will only work on display type, not body copy.

By using the layer effects in Photoshop, it is very easy to create slight three-dimensional effects without the need for specialist software, such as Adobe Dimensions. To get going, use Bevel and Emboss. This command adds depth by generating shadows and highlights on any type to which it is applied. There are several options to choose from including Inner Bevel, Outer Bevel, Emboss, and Pillow

Emboss. Each of these has its own personality. Inner Bevel makes the inside of the letterforms look raised from the background. Outer bevel keeps the characters flat but creates a shadow that makes the surface they sit on look elevated. Emboss raises both the surface around the text as well as its inner shape. Pillow Emboss makes the type look as though it has been set into the surface.

outer bevel This effect creates a shadow around the glyphs, which makes the flat surface of the letterforms look raised from their background.

opqrstuvwxyz

opqrstuvwxyz

inner bevel This effect creates highlights and shadows within the letterforms themselves to make the glyph look three-dimensional on a flat background.

emboss This option creates highlights and shadows along the edges of the letterforms, making them look raised from the background, but does not bevel the inside of the glyphs.

opqrstuvwxyz

pillow emboss This command creates a recessed shadow around the edges of the letterforms, while giving a three-dimensional quality to the inside of the glyphs.

opqrstuvwxyz

BEVEL AND EMBOSS FILTER IN PHOTOSHOP

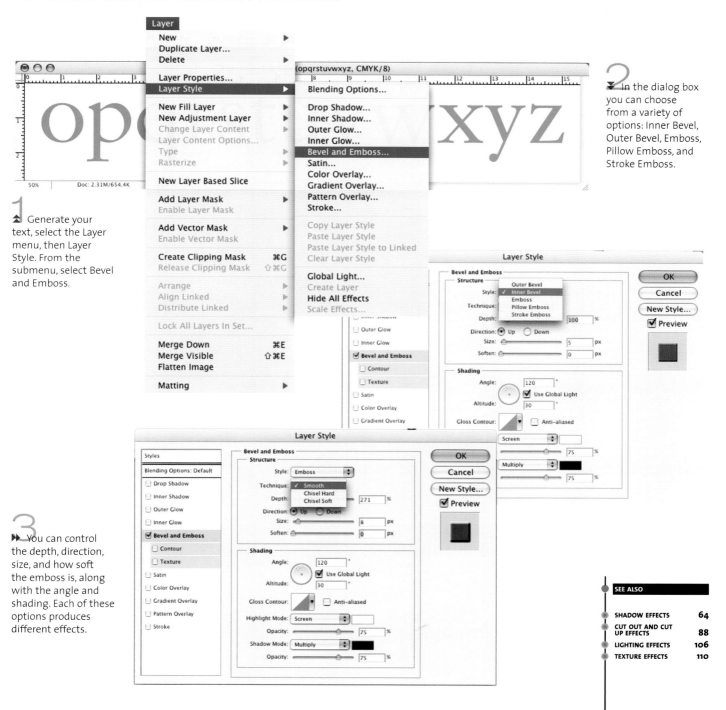

1 Generate your text, select the Layer menu, then Layer Style. From the submenu, select Bevel and Emboss.

2 In the dialog box you can choose from a variety of options: Inner Bevel, Outer Bevel, Emboss, Pillow Emboss, and Stroke Emboss.

3 You can control the depth, direction, size, and how soft the emboss is, along with the angle and shading. Each of these options produces different effects.

■ roughen, round, scribble & tweak, pucker & bloat

Illustrator is an extremely versatile piece of software. It allows the user to manipulate typography with ease and provides certain effects not possible with other software.

Vector-based software means that any text can be turned into a shape and manipulated. Work with the Filter menu in Photoshop or the Effect menu in Illustrator to see the available options.

applying effects

Typography generated at small sizes and then enlarged reveals some attractive qualities in that the lines, which appear smooth when small, show all the imperfections of the printed page when large. This can be replicated with the Roughen Edges filter, which takes the edges of the typography and adds points, moving the set to provide a suitably rough shape. For a subtle effect, keep the movement distance very small. This produces only a small distortion, making it appear that the contours of the paper have been blown up. This tends to work more effectively on display text at larger point sizes.

When creating types for logos, designers often want to modify existing type to give a different feel to the letters. The Round Corners command in the Stylize submenu is a useful tool to remember here. It rounds off letters and makes them more friendly.

Scribble & Tweak and Pucker & Bloat also work by moving, adding, or subtracting points. Pucker adds a gothic look by moving anchor points outward to look like horns, while Bloat bevels the straight lines between anchor points outward.

ROUGHEN EDGES

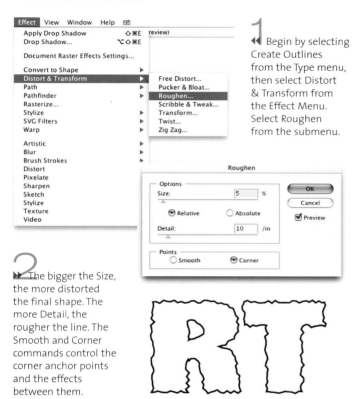

1 ◂◂ Begin by selecting Create Outlines from the Type menu, then select Distort & Transform from the Effect Menu. Select Roughen from the submenu.

2 ▸▸ The bigger the Size, the more distorted the final shape. The more Detail, the rougher the line. The Smooth and Corner commands control the corner anchor points and the effects between them.

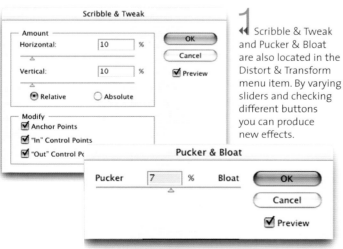

ROUND CORNERS

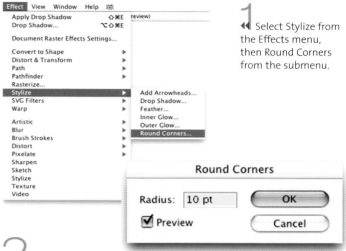

1 ◂◂ Select Stylize from the Effects menu, then Round Corners from the submenu.

2 ▸▸ This command allows you to round the edges of glyphs by changing the radius of the corners, measured in points. The greater the point size, the more rounded the corners.

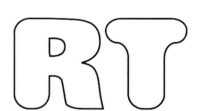

SCRIBBLE & TWEAK, PUCKER & BLOAT

1 ◂◂ Scribble & Tweak and Pucker & Bloat are also located in the Distort & Transform menu item. By varying sliders and checking different buttons you can produce new effects.

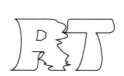

2 ◂◂ Alter Pucker & Bloat in percentages. Small movements are best. Pucker moves the anchor point out from the center. Bloat moves paths between anchor points out from the center.

■ blur functions

Blurring text can add the dimension of depth to your design work. When it is used appropriately, it can look sophisticated and modern.

Over the past few years, there has been a wealth of blurred text appearing in design work. It is simple to do and, with a little imagination and the use of the appropriate blur function, it can produce some stunning effects.

Blurring is a way of drawing attention to specific text and softening and adding depth to your typography. By layering and using multiple blurs you can make your type appear to be either in the foreground or background or fading onto the screen.

There are three main types of blur: Gaussian, Motion, and Radial. All three are available in both Photoshop (in the Filter menu) and Illustrator (in the Effects menu).

blur effects

The Gaussian blur produces the same effect as if rubbing petroleum jelly over the lens of a camera. On screen, it diffuses the pixels in feathered clusters, spreading them out over a set distance.

Motion blur makes the image look like it was taken with a moving camera, spreading the pixels out in straight lines, creating a streak effect.

Radial blur has two types, Spin or Zoom. Spin rotates the pixels around a central axis within a selected area. Zoom streaks the pixels out from the center, giving the effect of a photograph being taken while a zoom lens is being pulled into focus.

Another way of creating blurred type without diffusing it is to select Median from the Noise submenu in the Filter menu. This is designed to remove noise by averaging out the colors in a selected area. Visually, it blends the background into the text, making it appear distorted and out of focus while retaining a solid shape. This can produce a dreamlike quality.

A similar effect is produced by the Feather effect in Illustrator. This works by averaging out the colors across the edges of a selection and so again diffuses the shape.

Overall, you can add real depth to your work by using blurred text as a background or to add meaning to a piece of typography.

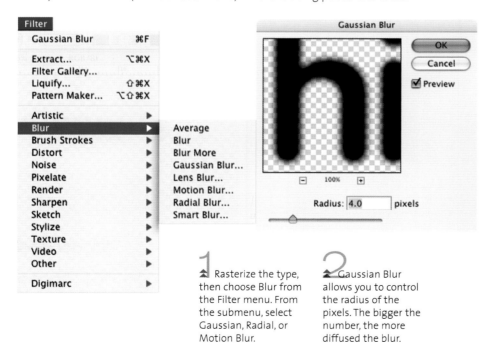

3 Motion Blur allows you to control the distance of the effect in pixels and also the angle of the direction of the effect.

1 Rasterize the type, then choose Blur from the Filter menu. From the submenu, select Gaussian, Radial, or Motion Blur.

2 Gaussian Blur allows you to control the radius of the pixels. The bigger the number, the more diffused the blur.

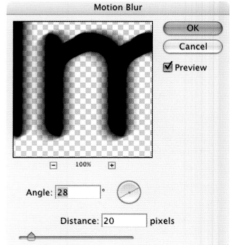

Radial Blur

Amount [14]

OK

Cancel

Blur Method:
- ● Spin
- ○ Zoom

Quality:
- ○ Draft
- ● Good
- ○ Best

Blur Center

5 Zoom produces an effect similar to focusing a camera. Use the slider and Quality buttons to control the effect. The better the quality, the more memory required.

Radial Blur

Amount [25]

OK

Cancel

Blur Method:
- ○ Spin
- ● Zoom

Quality:
- ○ Draft
- ● Good
- ○ Best

Blur Center

4 Radial Blur allows you to choose between a Spin or a Zoom effect. Spin affects neighboring pixels in a circular motion. Use the slider to control the effect.

The blur filter can give the illusion of depth to a flat piece of typography.

■ gradients

Defined as a progressive graduation of colors that fade into one another, a gradient is a way of adding subtle color to your typography.

The Gradient default settings are limited in their choices but it is not difficult to set up your own gradient fills, defining midpoints, angles, and colors. You can have as many as you want; you just have to click to add graduation points and drag your chosen colors to the relevant handles.

These effects are possible in all programs, although some have a greater degree of control than others. Currently, QuarkXpress can only produce simple blends after text has been changed to picture boxes.

It is best to be restrained with the gradient tool by not applying too many colors. Keep the number of colors to two or three at the maximum. Consider where it would be best to place the midpoint of the fade and also the direction of the gradient fill.

It is also possible to make type look as if it has faded to nothing by choosing a color and white when placed on a white background. Depending on the direction of the gradient, the fill will obviously depend on how the completed type looks, whether it fades from top to bottom or left to right. With some

care, it is possible to get some effective looking typography. Make sure you choose your colors carefully, along with the right type of fill. Radial graduations from the center out rarely look good in typography unless using extremely bold or black text.

Combining elements may help to obtain convincing results. For example, a drop shadow with a graduation may help to make the type look more lifelike. Also, using gradients on outlined strokes can add some depth to the type, making it appear more three-dimensional.

GRADIENTS IN ILLUSTRATOR

1 ▸▸ In the Window menu, select Gradient. Choose your type of gradient, either Radial or Linear. Click on the bar to indicate where you want a new color to appear.

Choose your color from the swatches and drag it to the new pointer. To change the midpoint of the gradient, move the diamond on top of the bar to the left or right.

2 ▸▸ Produce your type on screen then use Create Outlines in the Type menu to change the glyphs from Type to Shapes. Select all the glyphs you want to apply the gradient effect to. Choose the Gradient tool then click and drag in the desired direction across your type.

iiklmnop

GRADIENTS IN PHOTOSHOP

1 ►► You can have as many colors as you want in the Gradient palette, although it is usually more effective to use a few rather than a lot.

2 ◄◄ To add a color, simply click on the graduated bar at the bottom of the palette to show where you would like it to be.

3 ►► Move your chosen color from the Color palette to the square slider you have created on the Gradient palette by clicking and dragging with the mouse.

►► Create interesting effects by using gradients with other effects. This is a gradient of black and burgundy on an extruded drop shadow to create emphasis.

◄◄ Be careful not to add too many elements. This is a gradient with outline type and a drop shadow. The contrast in the gradient creates too much conflict.

►► This example is used to better effect. The gradient uses complementary colors and so creates a more subtle piece of type.

perspective

Typographic effects such as perspective used to be costly and time consuming to generate. Now, software allows designers to create convincing results quickly and easily.

In the past, text in perspective needed to be drawn or photographed. Today, the effect can be faked using software.

Currently, the most advanced applications for this kind of work are packages that produce three-dimensional effects, such as Adobe Dimensions, but other industry-standard software can go a long way to achieving credible results, too. One of these, FreeHand, has a feature called Perspective Grid. This enables you to place any object or typography on a special grid with one or more vanishing points. As is now standard, you can control the grid cell size and the color. You can then place your type on the grid using a combination of the Perspective tool and the cursor keys. The left cursor key places type on any left grids, the right cursor on any right grids, and so on.

It is also possible to obtain perspective effects in both Illustrator and Photoshop. In Illustrator, this is achieved by selecting the text and choosing Distort & Transform from the Effects menu. Select Free Distort from the submenu. This allows you to reshape the typography by moving the four corner anchor points. In Photoshop, once the text has been rendered, you can either use Transform or the Perspective function. Here, moving one of the corner anchor points moves the corresponding top, bottom, left, or right anchor to create the effect that your type is disappearing toward a distant vanishing point.

The advantages of using the Perspective tool in FreeHand over the Transform or Distort tools in Illustrator or Photoshop are that it conforms and snaps to a set grid. This allows you to make your work look very credible. In other software, you need to do this process by eye, which can be time consuming and frustrating.

PERSPECTIVE IN FREEHAND

1 From the View palette, select Perspective Grid and Define grid.

2 Set the cell size and also the number of vanishing points. Use the Perspective tool to drag the edges of the grid to obtain your desired perspective. Generate your type,

then, using the same tool again and holding down one of the cursor keys, drag your type to the grid. The left key will place the type on the left grid and so on.

Free Distort

OK
Cancel
Reset
☑ Preview

4 Once complete, you can see that the size of the text box remains unchanged and can be moved around the screen as before.

3 In Illustrator, create your type. In the Filter menu, select Distort, then Free Distort. In the dialog box, drag out the handles until you achieve your desired effect.

PERSPECTIVE IN PHOTOSHOP

1 In Photoshop, create your type and render it by using the Rasterize command in the Layer menu. In the Edit menu, select Transform, then Perspective.

2 This produces a box with handles around the text. By dragging one of these handles outward, the corresponding angle on the same side will also move out by the same amount.

SEE ALSO

■ halftones

Halftone is a printing technique that allows less ink to be used. Commercial printers can keep their costs down while still creating the illusion of a wide variety of colors and tones.

Halftoning is a process that transforms images into a series of dots. The size and proximity of the dots to each other create the illusion of tone. Lots of dots, close together, make a solid color; fewer dots, further apart, make a lighter shade. For example, if you wanted to print a red and a pink, rather than using two separate colors, you can use only the red ink. Where red ink dots are close together, they appear red, where spaced further apart, they appear lighter and give the illusion of being pink.

Over the years, designers have used this effect as a cue to introduce a much more experimental approach into their work. Letters that have the halftone effect can look very effective.

To some extent, both Photoshop and Illustrator have the ability to produce this effect on screen, but for best results, apply the effect to large typography. Photoshop has the most effective functions for controlling the effect.

applying the effect

Generate your text on screen. Then add a little Gaussian blur to obtain a more pleasing effect. In the Image menu, select Mode, then choose Bitmap from the submenu. Bitmap gives you the opportunity to set the halftone screen, the number of dots per inch (dpi), the direction of the dot angle, and the shape of the screen you require—in this case, round. Once applied, you will see that your typography is made up of differing dot sizes that generate the shapes of the letters. This image can be used as a background or, if the text is big enough and the halftone screen fine enough, as titles or logotypes. For inspiration, look at the work of Vaughn Oliver of V23, who, in the past, has generated traditional halftone screens.

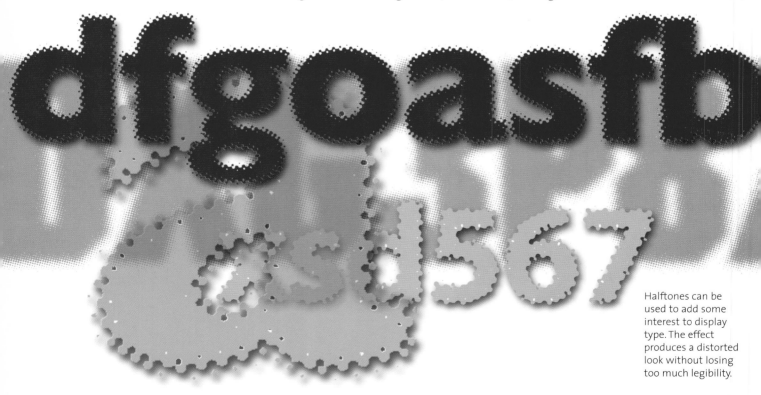

Halftones can be used to add some interest to display type. The effect produces a distorted look without losing too much legibility.

1 Once you have generated your type, use the Blur filter to add a slight Gaussian blur to the text. This provides a better result in the finished piece.

2 In order to create the halftone, change the Mode in the Image menu from RGB or CMYK to Bitmap. You may have to go through Grayscale first. In the dialog box, select Halftone Screen as your Method and set your Resolution. For a more accurate effect, choose a higher resolution.

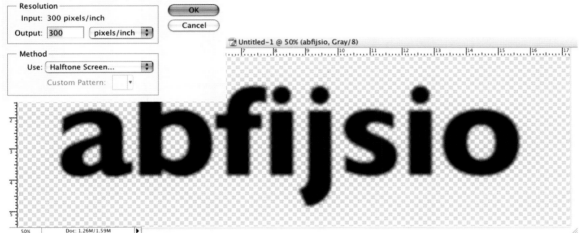

3 In the Halftone Screen dialog box, set the Shape to Round. To obtain more dots, choose a higher number for the Frequency and Angle.

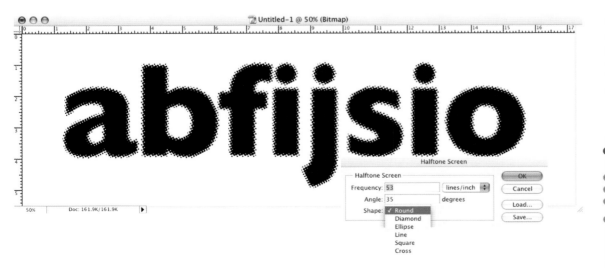

■ autotracing and drawing over existing type

The Autotrace function can be used to trace around letters and give them a deliberate rough, computer-generated quality.

Both the major vector-based applications, Illustrator and FreeHand, have Autotrace tools. However, there are differences between them. The Trace tool in Illustrator was set up to outline placed images so they could be treated as vector artwork. Images have to be in a PICT, TIFF, or EPS format for it to work properly. One of the tool's flaws is that it can add extraneous anchor points where they are not needed. Often, the shape of the letterform has to be cleaned up by moving or deleting appropriate points.

Autotrace can generate a curious effect when it does not exactly replicate the shape you have chosen. The distortion that results can be used very creatively. Designer Neville Brody exploited this in his Autotrace series of typefaces. He merged some existing sans serif faces using Fontographer to produce what he termed "a Univers for the digital age." He then traced this font to create a distorted set of glyphs. The resulting face was again traced to create an even more deformed typeface. He repeated the process with each resulting font until the final face, Autotrace nine, bears little resemblance to the original typeface.

The Autotrace facility in FreeHand is different. It can be used to outline images as well as any other vector artwork within a specified area. As a result, whole glyphs or sections of letters, words, or even sentences can be copied. These can be scaled, colored, and maneuvered at will. With some imagination, you can use Autotrace to produce fractured, fragmented, and multilayered typography that creates a complex and engaging atmosphere in piece of graphic design.

If you want to generate text from typography that only exists as hard copy, use the Pen tool to draw over existing letter shapes. With a little practice, the Pen tool can be used to create paths of characters that can be applied within artwork. If you want to generate a more handcrafted kind of glyph, try using the Pencil tool and drawing around the letters freehand. This will give a more emotive and low-tech atmosphere.

AUTOTRACE IN ILLUSTRATOR

1 Lock the image in place and choose the Autotrace tool in the toolbox. In Illustrator, import the artwork by selecting the Place command from the File menu.

2 By clicking on the edge of the shape, the tool will automatically trace the contours.

3 Unlock the image and delete it.

AUTOTRACE IN FREEHAND

1 ▶▶ In FreeHand, use Autotrace to produce a progressive effect by tracing a character created by the Autotrace function.

2 ◀◀ Generate your type and then select the Autotrace tool.

3 ◀◀ By clicking and dragging with the tool you can trace whole glyphs or just sections. Once complete, the outlines will be shown as anchor points.

4 ▶▶ These anchor points can be given a fill or stroke to produce opaque shapes or outlines.

5 ▲ The other way to trace glyphs is by eye using the Pen tool in Illustrator. Begin by clicking and dragging anchor points as you go around the glyph.

6 ▲ Generate smooth curves by having the least amount of anchor points possible.

7 ▲ Another way is to draw around the glyph freehand using the Pencil tool. This requires patience and a steady hand for good results.

■ fading type using masks in Photoshop

With the introduction of layers in Photoshop, it became possible to add typographic effects that were subtle, sophisticated, and looked great.

Applying layers means that all the elements that make up an image or piece of typography can be separated from each other and individually manipulated without affecting the rest of the composition. Each layer has certain effects that can be applied to it, such as changing the opacity. This means you can achieve a level of finesse with the typography that is separate from the simple rules of legibility, such as letter spacing and color; with the simple movement of a slider it is possible to make the type appear barely visible.

More complex effects can also be achieved by using the masks for each layer. By masking out the top layer and showing the one below, type can appear to fade from solid to transparent. A combination of the Layer Mask and the Gradient tool achieves this result accurately.

The Type Mask tool allows you to create selections in the shape of your text to mask out. You can also paste in other elements. This function makes creating masks simple. When combined with imagery, it is possible to make the type appear semitransparent

by "screening back." This is done by adjusting the levels affecting the contrast of the image to make it appear lighter or darker, or alternatively, to make the typography appear lighter or darker. This is easily achieved using Adjustment Layers.

For further ideas, you can also set the layer option to Difference to make it appear negative over darker areas and positive over lighter ones. This produces subtly presented typography that appears to come out of the image as a paler (or darker) version of the background.

USING LAYER MASKS IN PHOTOSHOP

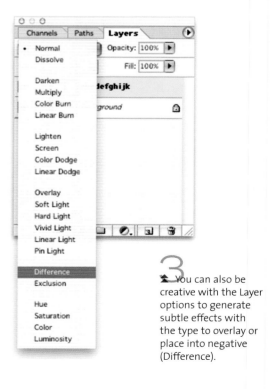

1 Generate your text using the Type tool. Then create a Layer Mask by clicking the icon at the bottom of the Layers palette (the white circle inside the gray rectangle.

2 Select the Gradient tool from the toolbox and make sure that the background/foreground colors are set to default black and white. Click and drag across the image. The foreground image—in this case, type—will be masked only where the white pixels are placed, partially masked where gray ones occur, and totally masked where black ones are generated.

3 You can also be creative with the Layer options to generate subtle effects with the type to overlay or place into negative (Difference).

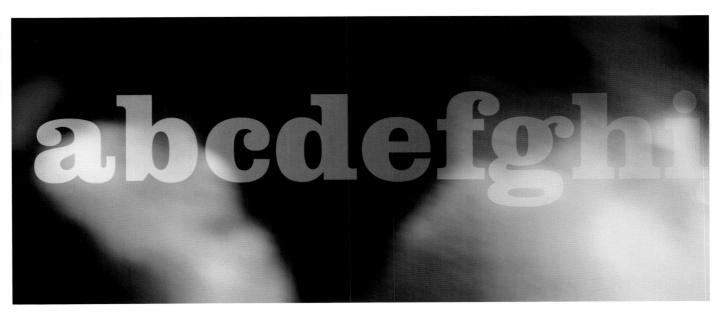

4

▸▸ Images can be placed within the type using the simple Paste Into command in the Edit menu. You will need to render the text to begin and then select it using the magic wand tool.

Edit	Image	Layer	Select
Undo Magic Wand			⌘Z
Step Forward			⇧⌘Z
Step Backward			⌥⌘Z
Fade...			⇧⌘F
Cut			⌘X
Copy			⌘C
Copy Merged			⇧⌘C
Paste			⌘V
Paste Into			⇧⌘V
Clear			
Check Spelling...			
Find and Replace Text...			
Fill...			
Stroke...			
Free Transform			⌘T
Transform			▸
Define Brush...			
Define Pattern...			
Define Custom Shape...			
Purge			▸
Preset Manager...			

5

▲ Open your image, choose Select All, then Copy. Use the Paste Into function in the Edit menu in your original file to paste your chosen image into the type. Once it is pasted in, you can edit it, scale it to fit and so on, using the Transform command.

6

▲ You will see in the Layers palette that your image is on top of the type layer with a layer mask in the shape of the text.

■ images in type using masks or a clipping group

With the introduction of masks and a clipping group, it is now possible to use text in exciting ways by combining it with photography and drawn imagery.

Display type is different from the rest in that it can be treated in an illustrative manner. Because this kind of type should be a short, bite-sized chunk, you can break many of the rules of legibility when considering how to manipulate it. Contemporary designs provide many examples of distorted and manipulated typography.

Software has revolutionized the graphic design industry with Photoshop in particular providing the means to treat typography with an illustrative approach. Text can be treated as a manipulated element within the wider content of a pictorial design, rather than just solid characters, which conform to set shapes.

Masks make it possible to utilize imagery in such a way as to place it inside letterforms. The application does this using the layers. By generating layer masks you can conceal the uppermost layer to reveal the contents of the layer below.

This capability can be applied to a variety of different design elements on a page or website, from logos and headlines to type that appears as in integral part of an illustration. It helps to use large, bold, or even extrabold, text that has been tightly tracked and kerned. The reason for this is that the letters will have larger stroke widths that may be touching, allowing more of the image below to be seen within the glyphs.

One of the more subtle applications of this effect is to make text appear to be semitransparent when placed on top of an image. By copying the image and placing it above the original and using a layer mask to mask out the text, you can subtly alter the contrast of the image and make it appear lighter or darker. By also adding a drop shadow, the transparent letterforms appear to be floating above the original image.

Adjustment layers are also useful because you can give the typography a subtle quality. It is possible to directly affect the color channels that make up the image to make text appear on the image as a slightly toned shape on the background.

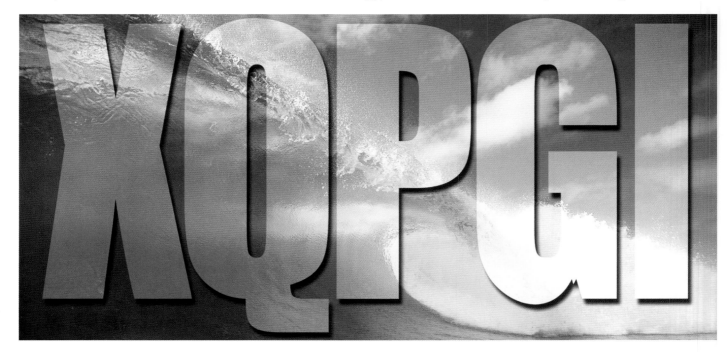

CLIPPING GROUPS IN PHOTOSHOP

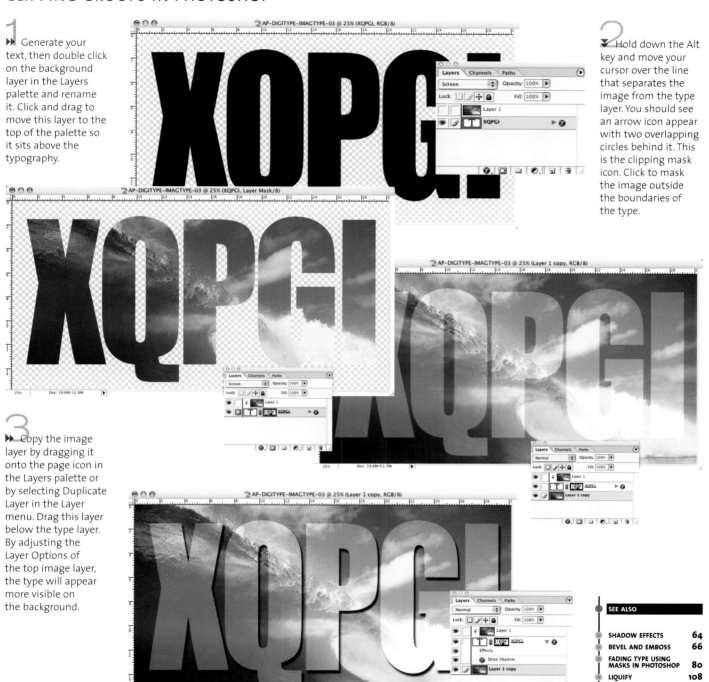

1 Generate your text, then double click on the background layer in the Layers palette and rename it. Click and drag to move this layer to the top of the palette so it sits above the typography.

2 Hold down the Alt key and move your cursor over the line that separates the image from the type layer. You should see an arrow icon appear with two overlapping circles behind it. This is the clipping mask icon. Click to mask the image outside the boundaries of the type.

3 Copy the image layer by dragging it onto the page icon in the Layers palette or by selecting Duplicate Layer in the Layer menu. Drag this layer below the type layer. By adjusting the Layer Options of the top image layer, the type will appear more visible on the background.

SEE ALSO

SHADOW EFFECTS **64**
BEVEL AND EMBOSS **66**
FADING TYPE USING MASKS IN PHOTOSHOP **80**
LIQUIFY **108**

■ type as a texture

As with all illustrative elements within graphic design, type can be generated that is not meant to be read, but rather appreciated as a decorative element.

Approached illustratively, typography can help to define the feel or atmosphere of a particular design. It can act as a background or ambient element that adds to the visual language and so supports the message being communicated. Typography as a texture is a common occurrence.

The approach you take depends on the atmosphere you want to create. Most software allows you to either overlay lots of text in an opaque color or create an array of subtle effects such as transparent, or faded, type. The latter is available in Photoshop.

The beauty of the more recent versions of Photoshop is that you can create your own brushes using scanned images. These brushes can be typographic in nature. Providing the image (or portion of text) measures no more than 2,500 x 2,500 pixels and is in grayscale, anything can be defined as a brush. The brush you create can then be used like any other to add texture to images or typography.

creating patterns

Photoshop has the ability to generate patterns from imagery. This function would normally be used for creating backgrounds or repeating elements within an image. As with most commands, it can also be used to create typographic patterns. Start by typing some text in Photoshop. Small point sizes work most effectively. Using the Marquee tool, define the area you require. Then in the Edit menu, select Define Pattern. Using the Cloning Pattern tool, you can choose your new pattern and then use the layer options on Overlay, Screen, or Difference to generate assorted effects. This works best over images. Alternatively, type some text and then in the Layer menu select Layer Styles, then Pattern Overlay. Here you can control the size of the pattern and also the layer option (Overlay, Screen, or Difference), as before.

1 Select the Marquee tool from the toolbox. In the Options palette, select Fixed Size as the option and define your size in pixels (no more than 2,500 x 2,500 pixels). Using the tool, define the area to become a brush.

2 From the Edit menu, select Define Brush.

3 A dialog box will appear, showing you a thumbnail of the area defined. It will also ask you to name the brush.

4 In the Brush palette you can now select the type (or part of a letterform) you selected as a brush to paint with.

5 It is possible to set type as a pattern to use over the top of other design elements. In the same way as you defined a brush, you can define a pattern. Use the Marquee tool to define the area you want. Then select Define Pattern from the Edit menu. Place a new layer above your pattern and fill it solid white. In the Layer menu, select the Pattern Overlay option.

6 A dialog box will appear where you can select your Pattern, control the scale of the pattern and also define the layer options, such as Overlay or Soft Light.

combining and overlapping type

Illustrator has several unique functions that allow you to combine letterforms. The Pathfinder palette is the key tool for manipulating glyphs.

Illustrator treats letterforms as paths. This means that the Pathfinder functions can be fully exploited. With a little creativity, these functions offer a wealth of possibilities.

The Pathfinder commands are broken down into the five categories. "Unite" joins objects together into one item. Separate faces, or even upper- and lowercase glyphs, from one font can be combined, blending them into one character. Other effects can then be applied, such as outlining or adding a drop shadow.

"Divide" splits overlapping shapes into separate, closed sections. These sections can then be moved independently of the rest with the Direct Selection arrow. In other words, it is possible to pull apart the separate parts of the overlapping objects and use the shapes to explode or extrude it.

"Exclude" makes areas where type overlaps transparent, giving the Stroke or Fill qualities of the foreground object to the new character. This is a way of knocking out a letter or text from a background. When placed over another object or shape, the type will appear transparent.

"Intersect" deletes any areas outside two overlapping objects, so only the parts that overlap each other exist. You can create unusual glyphs using this command.

"Crop" trims away anything beyond the boundary of the uppermost object. Type can be cropped within any shape, including other typographic characters.

experimenting

Get the best out of these functions by playing with them. If you have a particular result in mind, you may find you cannot achieve it, whereas exploring the technology with typography in mind may produce effects you had never thought of before. These commands provide the opportunity to create new letterforms that can be used in conjunction with several other effects detailed in this chapter.

MERGING TYPE

1 Generate the letterforms you want to overlap, in this case, an upper- and lowercase "a." Move them into position.

2 Use the Create Outlines command in the Type menu to create the vector outlines. Open the Pathfinder palette and select Exclude Overlapping Shape Areas (top row, far right). This will make the overlapping areas clear.

The top row has been manipulated using the Exclude Overlapping Areas command in the Pathfinder palette. The bottom row shows a variety of commands including Divide, Merge, Crop, and Trim.

ABCDEFG
ACDLEf

COMBINING TYPE

 1 To combine two letterforms into one, use the Combine tool. As before, generate the text and use the Create Outlines command. Overlap the letters.

2 Select the Merge tool in the Pathfinder palette (third from left on the Pathfinder row) to unite both letterforms into one shape.

CROPPING TYPE

1 Generate your text and place a shape over it. Here, we have used a simple square. Select both shapes.

2 Select the Crop tool in the Pathfinder palette (third from right on the Pathfinder row). This will crop everything outside the uppermost shape, creating some unusual effects.

■ cut out and cut up effects

Generating effective contemporary display type is about knowing when and how to break the rules. Society is now visually literate, so typographic boundaries can be stretched.

Letterforms can be cut out of a background, creating transparent letters that can be combined with other texture effects (see pp. 110–111). Work with the Layer Style command in Photoshop's Layer menu to give the text an inner shadow. This makes the letters appear three-dimensional. On a two-dimensional plane, they appear to be carved out of the background.

The effect will depend on the color of the type and the color of the background. If the type appears in a contrasting lighter color it will look as though it has been removed completely. If it is almost the same color as the background, it will look carved out to a set depth.

cutting up

You can also cut up and explode your type to create a distressed look.

When type has been rendered in Photoshop it is treated like any other pixel element and, therefore, can be cut up and copied like an image. By taking sections of the letters and copying them, you can paste over the original and then move them slightly. This results in fractured letterforms. Alternatively, select parts of the characters and move them out of their original positions using the Lasso and Marquee tools.

Repeating the procedure several times will give a multilayered feel to the piece as if using dry transfer lettering that has not attached perfectly.

CUT OUT TYPE IN PHOTOSHOP

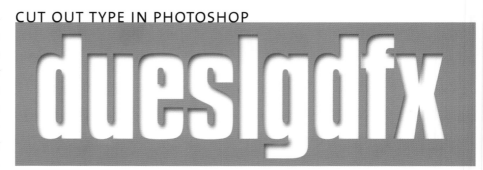

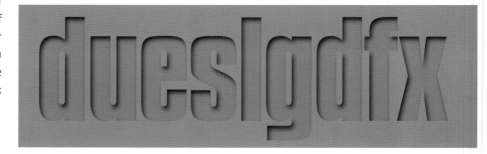

▲ By using a simple command in the Layers menu it is possible to make text look as though it has been cut away or carved out of a background.

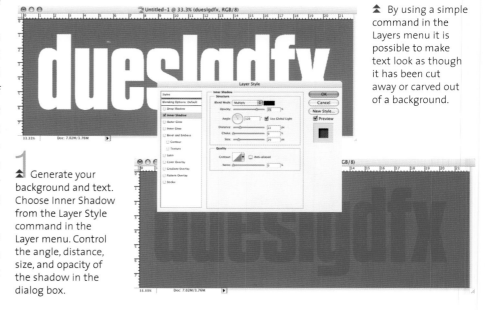

1 ▲ Generate your background and text. Choose Inner Shadow from the Layer Style command in the Layer menu. Control the angle, distance, size, and opacity of the shadow in the dialog box.

CUT UP TYPE IN PHOTOSHOP

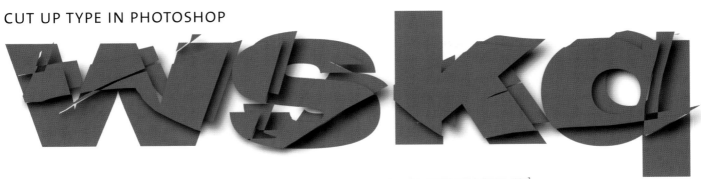

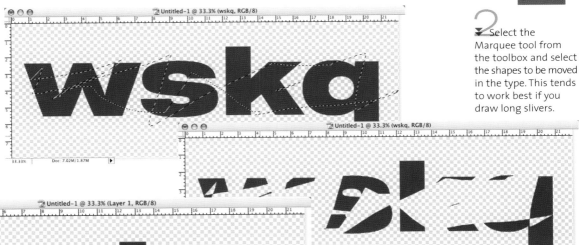

1 Generate your typography then rasterize it by selecting Rasterize from the Layer menu.

2 Select the Marquee tool from the toolbox and select the shapes to be moved in the type. This tends to work best if you draw long slivers.

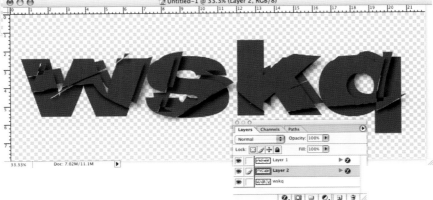

3 Select the Move tool. Use either the mouse or your direction keys on the keyboard to move the selection, pixel by pixel, until you obtain the desired effect.

4 You can build up a grungy effect by adding layers to the piece, selecting small slivers or huge chunks of the type.

■ mapping type on a shape

In the past, it has been difficult to create type on computer-generated objects and make it look realistic. Only 3D packages such as Adobe Dimensions or Maya could do the job.

Now, thanks to more advanced functions within Photoshop and Illustrator, it is possible to map type onto simple three-dimensional shapes such as cylinders, spheres, and cubes. Adobe introduced this capability on Photoshop 6 and placed it in the Filter menu. By using the 3D Render filter it is possible to bend and distort shapes and place them onto simple objects. Since this is not a true piece of three-dimensional software and you are mapping two-dimensional artwork, it is only possible to place the artwork on the visible part of the object.

Many of Adobe Dimensions functions have been incorporated into Illustrator. In the Effects menu you will now find three-dimensional options. As a result, it is now possible to extrude, revolve, and rotate two-dimensional artwork to make it appear as if it sits on a three-dimensional plane.

This will produce more convincing and authentic renderings of typography on objects. Again, though, if you use this function with a sense of playfulness the command need not just be used to place text on an object, but rather to manipulate the typography to make it appear as if it is traveling around corners. You can also distort its shape to make it appear as if it is contained in a bubble or another object.

TYPE ON A SHAPE

1 Generate your text, then select Render from the Filter menu. Choose 3D Transform from the submenu.

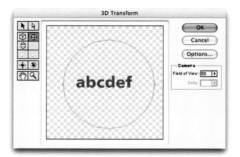

2 The dialog box lets you choose a cylinder, cube, or sphere shape. Use the Field of View and Dolly Control to view the shape and size in the window.

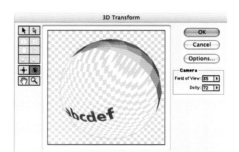

3 This technique takes practice. Type can only be rendered on part of the object, not all the way around.

3D TYPE

1 After generating your text, select 3D from the Effect menu. Choose Rotate from the submenu.

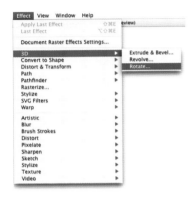

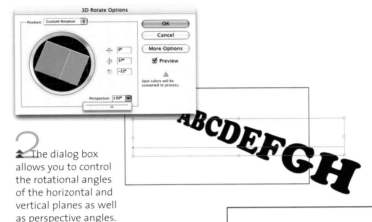

2 The dialog box allows you to control the rotational angles of the horizontal and vertical planes as well as perspective angles.

3 Once complete, notice that the selection guides—normally in blue—remain the same as they were before, only the text now flows out of the box.

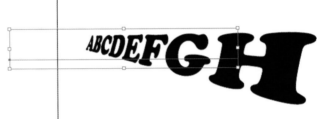

4 To give the typography some depth, go back into the Effect menu and select 3D again. This time choose Extrude & Bevel from the submenu.

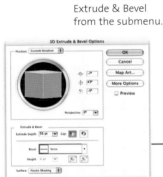

5 This dialog box has controls for Extrude Depth and Surface Quality, in this case, Plastic Shading. Clicking the More Options button allows you to control the direction of the lighting on selected text. The final rendered 3D type is shown on the right.

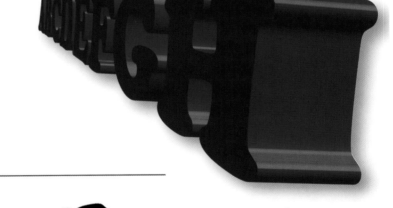

SEE ALSO

PERSPECTIVE 74
DISTORTION FILTERS 102
LIGHTING EFFECTS 106

blending in Illustrator

Illustrator has some very useful and underused commands within its menu functions. One of these commands is the Blend tool, which transforms objects.

Blending works by changing one shape into another in a specified number of steps. It creates intermediate shapes between the chosen objects, details the transition between them, and includes the color and stroke along with their form. This feature is usually used to change basic shapes like circles into squares or stars, but can be applied to any shape including text, providing you have created outlines from it in the Type menu. The possibilities are almost limitless because you can control the number of steps between the objects in the blend as well as the distance those objects are from the original. You can also "smooth" between the colors.

By selecting two contrasting typefaces it is possible to create some great intermediate ones that have qualities of both of the parent faces but look nothing like them. The greater the difference between the original typefaces, the more interesting the resulting hybrid ones are.

using the tool

The tool is simple to use. Just select the characters you wish to alter, then choose the Blend tool, which is located in the toolbox with the Auto Trace tool. Click on an anchor point in one glyph and then the corresponding anchor point in the contrasting face. The software will add in the intermediate steps. You will notice that a line is generated between the original shapes that trace the path of the interim steps.

These steps cannot be manipulated and need to be turned into outlines so that they can be treated as any other object within the software. By using the Expand command in the Object menu you can change the steps to objects and manipulate them as normal. You only have to ungroup them to move them around individually. Using this function, you can produce some unexpected letterforms, which can be turned into a typeface in their own right. This will be discussed in the next chapter.

1 Select the Blend tool from the toolbox.

2 Double click on the tool to bring up the Blend options dialog box. Here, you can control the number of specified steps between your chosen shapes and the orientation.

3 Generate your text in two different fonts. Here, we are using one uppercase and one lowercase. Select both pieces of text. Click once with the Blend tool on the first piece of text then click again on the second piece. The program will add the intermediate steps between the fonts.

4 So that these shapes can be moved and separated from the originals, select Expand from the Object menu. This will break the shapes away from their grouping and treat them as outline shapes.

5 Select the Ungroup command from the Object menu to move the shapes around independently of each other.

■ customizing letterforms

Software can be used in a variety of ways to manipulate typography. With a little creativity, you can quickly produce your own uniquely customized letterforms.

These letterforms in Garamond have been manipulated using Illustrator. By deleting particular anchor points, you can turn a classical font into a fresh and modern-looking set of glyphs.

Typography can be cut up, added to, subtracted from, combined with, rounded off, or roughened up (to name but a few). Only your imagination can limit you.

Historical fonts have additional characters—swashes and ligatures. Swashes are flamboyant strokes or tails added to characters. Ligatures are letter pairs that have been combined to be optically more pleasing. These characters were used to add individuality to the text being set. You can use them as inspiration for manipulating type. For example, produce swash characters for a modern sans serif font simply by combining elements of two fonts or rendering it in a vector program as outlines and adding to, or moving, specific anchor points. However, steer clear of performing such tasks as adding serifs to a sans serif font. They rarely look good, unless heavily worked on.

It is also possible to adapt existing typefaces and make them appear much more contemporary by rounding them off or deleting parts. Garamond, for example, could be updated for a modern generation in Illustrator or FreeHand by converting to outlines and manipulating, adding to, or subtracting from the anchor points and Bezier curves that make up the letterforms.

It is also possible, as demonstrated in Creating Hybrid Fonts (see pp. 160–163), to combine elements from completely opposing letterforms to become hybrids. Designers such as Jonathan Barnbrook have used this "sampling" approach to design new typefaces. It is feasible to take elements from particular faces and combine them into one font. The Unite Pathway command is a way of performing this operation. Take a look at some hybrid fonts that demonstrate this procedure such as Dead History by P. Scott Makela and Prototype by Jonathan Barnbrook. Both feature two or more typefaces merged into one.

Type	Select	Filter	Effect
Font			▶
Size			▶
Blocks			▶
Wrap			▶
Fit Headline			
Create Outlines			⇧⌘O
Find/Change...			
Find Font...			
Check Spelling...			
Change Case...			
Smart Punctuation...			
Rows & Columns...			
Show Hidden Characters			
Type Orientation			▶
Glyph Options			▶

1 ▲ To customize typefaces, instruct the software to treat the text as shapes. To do this, select Create Outlines from the Type menu.

2 Then select the Pen tool from the toolbox.

3 You will notice that the anchor points and Bezier curves that make up the letterform are now visible. By using the Pen tool, it is possible to add or subtract points, thus manipulating the outline.

4 By removing anchor points you can change the appearance of the glyphs. This can also be achieved by manipulating the direction of the handles of the Bezier curves.

5 It is possible to completely change parts of the glyphs, in this case, the tail on the lowercase "g."

6 Splice glyphs together by creating a box and positioning your type over the top, making sure the outside edge intersects with where you want the glyph to be cut. Use the Pathfinder toolbox and select Minus Back.

7 New characters can also be created from two different fonts using the same method to slice them up. They can then be united using the Merge command in the Pathfinder toolbox to become one glyph.

■ screen print effects

Good typography does not always have to look slick and smooth. Excellent creative results can be achieved by distressing your work.

Instead of using software to generate slick and smooth graphics, try using it to recreate processes that are rough and distressed, such as silk-screen printing. The beauty of the silk-screen process, as typified by artists such as Andy Warhol and Robert Rauschenberg, is that it is less than perfect. The viewer is able to see the build up of solid colors and the occasional misalignment of the separate screens.

You can use Illustrator and FreeHand to achieve this effect through the combination of commands already discussed previously in this chapter. A good digital representation of the manual silk-screen process can be accomplished with a combination of the Roughen filter and Misregistration. This produces coarse edges to the text and an off-center fill color.

However, it is best to use Outline text for the silk-screen effect as this achieves a more convincing outcome. Originate your text and create outlines of it. Leave the fill transparent and place a stroke width on it. Use the Effects menu to roughen up the typography. It is best to select a very low percentage—otherwise the result looks too contrived and the authentic look is lost. Once you have completed these commands, paste the text behind the original type, changing the stroke to None and the fill to a bright opaque color. Using the arrow keys, move the solid type a fraction out of sync with the rest.

calligraphy brushes

Another way of making your typography look handcrafted is to use calligraphic

Silk-screen printing uses bold colors to reproduce artwork. As with any handcrafted piece, inaccuracies are part of the look. For example, the screens may misalign causing misregistration, an effect that can be generated in FreeHand and Illustrator.

brushes. These are located in the swatches in Illustrator. Once used, these can change the stroke on your object to approximate to that of a calligraphy pen, with thick and thin lines. If used sparingly and in the correct context, this effect can look fairly credible. As with many commands, it works best when combined with other effects to create interesting typography. To obtain the best results, experiment with the angle, roundness, and diameter of the brushes. The more extreme the angle and the bigger the brush, the more prominent the effect, and vice versa.

2 In the dialog box, set Size to a small percentage only. Then select Detail in inches, again to a small number. More detail creates jagged edges when we want a relatively smooth result. Once complete, copy the text and change the stroke to None and the Fill to a solid color. Use Arrange, then Send to Back, to place the type behind the original. Then offset it slightly.

1 Type in your desired text. In the toolbox, select a stroke color with a background of None.

Select Distort & Transform from the Effects menu, then choose Roughen from the submenu.

3 Outline effects can be generated using Brushes. Select the text then choose a calligraphic brush. Different sizes and shapes will give different results. Flat, angled brushes are best to give an uneven outline.

■ glow effects

There are times when you want to fake an effect, such as neon light. Making objects look like they are glowing is now relatively easy in Photoshop.

The procedures described earlier in this section all stand alone but they can also be combined to create type that mimics the things we see in our everyday environment. Signs are a favorite.

Photoshop is ideal for creating the glow effects that surround lit signs. Type can have an inner or outer glow, as well as a neon effect. Photoshop's Effects menu actually has a command precisely for creating glow effects. The outer glow is similar to the drop shadow, although instead of producing a darker, diffused copy behind the text, it creates a brighter one, making your type look as though it is backlit. By contrast, inner glow again produces an area of lighter diffused tone, this time inside the letterforms.

We have seen how to outline text earlier in this section (see pp. 60–61). You can obtain an approximation of neon light by combining this outline command with the outer glow function and also copying the type and placing it on another layer using specific layer options such as Multiply or Screen. This produces a halo effect around the outlined typography. It is best if you choose a bright color to create a convincing result. Using adjustment layers, you can alter the Curves or the Brightness to obtain a specific glowing look. Using these controls, you can limit the amount of tones in specific areas of the color used. The more color effects layers you have, the more saturated the color of the glow.

NEON GLOW

1 ▶▶ Type in your desired text in an appropriate typeface. Here, we have used VAG rounded.

2 ▶▶ In Select, choose Load Selection and choose the text layer. In the Layers palette, select the Channels tab and create a new alpha channel.

3
▲ Select Stroke from the Edit menu and choose an appropriate stroke width. Here we have used 20 pixels.

4
▲ Still in the alpha channel, add some Gaussian blur of between four and six pixels. Select Curves from Image & Adjustments and give the curve a distinct spike to produce a solarized effect.

5
▼ Click back to your layers in the Layers palette and create a new layer. In Select, choose Load Selection, choosing the alpha channel you created.

6
▲ Choose a color and use Fill in the Edit menu to color the loaded selection. Copy this layer by dragging it to the page icon at the bottom of the palette. Select a layer option of Overlay or Vivid Light.

INNER GLOW

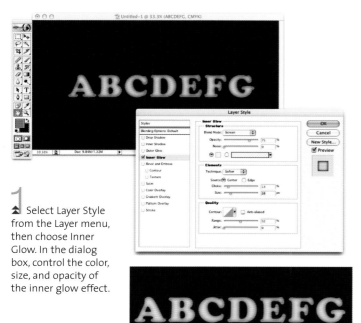

1
▲ Select Layer Style from the Layer menu, then choose Inner Glow. In the dialog box, control the color, size, and opacity of the inner glow effect.

OUTER GLOW

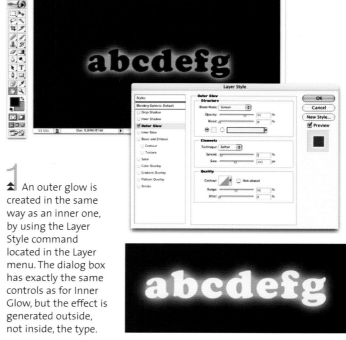

1
▲ An outer glow is created in the same way as an inner one, by using the Layer Style command located in the Layer menu. The dialog box has exactly the same controls as for Inner Glow, but the effect is generated outside, not inside, the type.

■ wood block style

There has been a renaissance in the popularity of the handcrafted look. Many designers are now seeking to give their work a more organic, emotional, and less technological look.

Wood block printing has a unique quality. The amount and kind of ink used, along with the quality and texture of the paper, all have an influence on the final outcome. Designers such as Vince Frost and Alan Kitching have used this traditional production method to its best advantage in their own designs. The drawbacks to this production method are that you need to have access to wood block characters and a printing press that can accommodate them. This is costly and impractical.

Digitally, though, there are ways to reproduce this craft. By analyzing the qualities of a piece of printed design, it is possible to replicate it. Photoshop has the ability to use images scanned in grayscale to be used as brushes within the software. By defining an area of an image no bigger than 2,500 x 2,500 pixels, you can simply use the Edit menu to Define Brushes. All you have to do is name your brush and it will appear in the Brushes palette. Alternatively there are plenty of free Photoshop brushes available on the internet.

By scanning all manner or marks, from ink splats to roller lines, the letterpress characteristics can be recreated. The main way of achieving this result is to generate the typography and then use several uniquely crafted brushes to distress the outcome. By overlaying the brushes it is possible to produce the same results as wood block printing, where the ink does not print uniformly on the page.

The texture of real paper can also be replicated by using scanned examples of textured papers as overlays on the typography. A Clipping Group or the Layer Blending modes can be used to merge these examples and produce authentic-looking printed results.

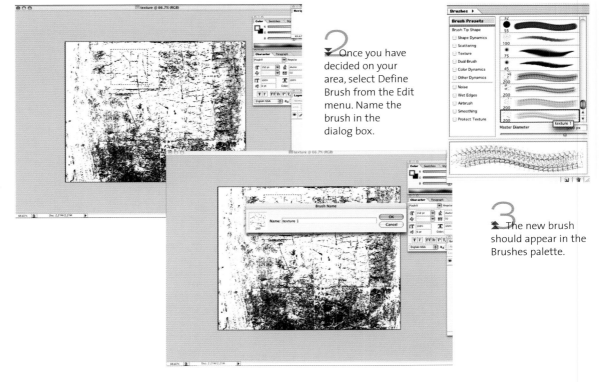

1 ▶▶ This is a scan of a drawing board, which has a distressed black-and-white texture. The contrast has been altered using the Levels command in the Image menu and Adjust to accentuate the texture. Using the Marquee tool, define the area to be made into a specialist brush. Select Fixed Size in the tool options and set your size in pixels, to a maximum of 2,500 x 2,500.

2 Once you have decided on your area, select Define Brush from the Edit menu. Name the brush in the dialog box.

3 The new brush should appear in the Brushes palette.

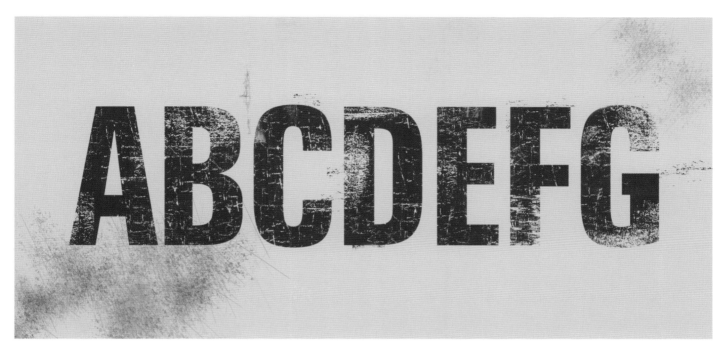

4 ▼ Generate your typography, then rasterize it using the Layer menu. Select the eraser and begin to use your new brush to remove parts of the letterforms. You may need to use several brushes to obtain a more credible result.

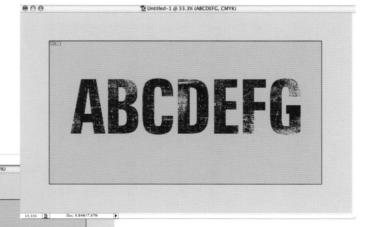

▲ Specialist brushes constructed from scanned artwork have been used to distress the typography. This replicates the effect of letterforms printed with a letterpress. With some practice it is possible to produce some very convincing results.

5 ▲ As you build up the effect, the type looks like it has been printed using a letterpress rather than created using computer technology.

distortion filters

Many pieces of software allow the designer to distort typography. Photoshop is one of the most effective, and a variety of effects can be achieved using the Distortion filters.

Each program has its advantages and disadvantages when it comes to distorting type. Photoshop has filters that are designed to manipulate imagery and, as we have already seen, many of these filters can also be applied to typography with excellent results. Located in the Filter menu are such commands as Twirl, Shear, Pinch, and Spherize. These commands work by manipulating the plane the typography sits on, almost like placing the type on a piece of fabric and then moving the fabric around until you get the result you want.

In his title sequence for the movie *The Sphere*, Mikon Van Gastel distorted the text to make it appear as if it was being viewed through a crystal ball, magnifying and beveling the type. This was achieved through a mixture of traditional photography and computer-generated text. With the filters in Photoshop, it is possible to attain similar, but less complicated, results.

You can manipulate the text so that it appears to have been pulled in or pushed out from a central point using Pinch; it can be mapped as if lying on a plane that has been pulled sideways using Shear; or placed on a convex or concave surface with Spherize.

Along with these filters, Adobe have introduced the Warp Text command, located in the Layer menu under Type. This function/command takes many of the distortion filter options and adapts them specifically for typography. It is possible to warp the text in a variety of ways, such as in a vertical or horizontal arc, arch, wave, or bulge, to name but a few. You can control the amount of distortion and transfer between horizontal and vertical axes to achieve a multitude of variations.

These functions, coupled with filters, allow you to change the look of the typography drastically, making it look as if it has been twisted, curved, or even photographed with a fish-eye camera lens.

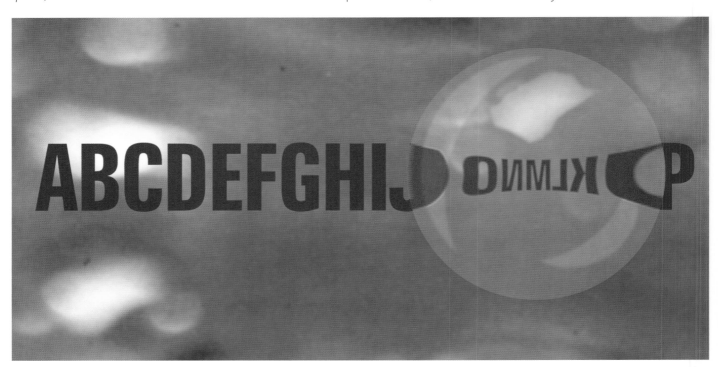

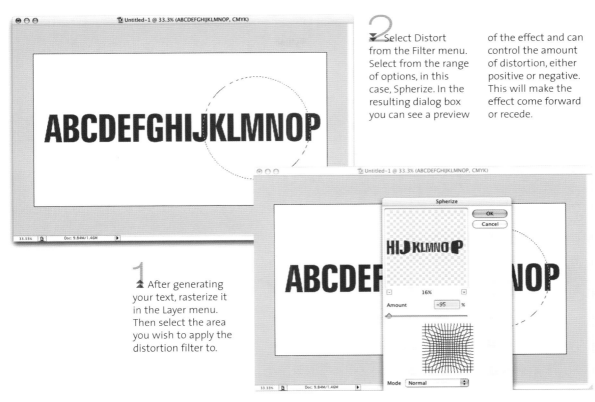

2 Select Distort from the Filter menu. Select from the range of options, in this case, Spherize. In the resulting dialog box you can see a preview of the effect and can control the amount of distortion, either positive or negative. This will make the effect come forward or recede.

1 After generating your text, rasterize it in the Layer menu. Then select the area you wish to apply the distortion filter to.

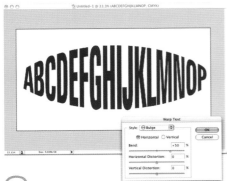

3 Warp Text has several options, such as Bulge. This option expands the text and increases its size in the center to make it bulge outward.

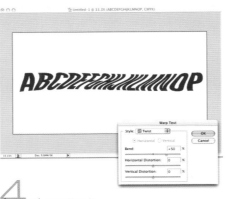

4 Another option in Warp Text is Twist, which, as its name suggests, allows you twist and bend the type.

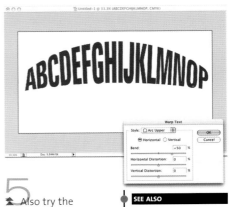

5 Also try the commands Arc Upper and Arc Lower, which distort the text by making it bulge across the top or bottom.

SEE ALSO

■ wave, zigzag, and ripple

We have looked at some of the filters Photoshop has to offer but there are several other ways in which you can distort your typography.

There are other ways of getting a watery look without using the Liquify tool. In the filters in the Distort command are the Wave, ZigZag, and Ripple functions. Whereas the Warp Text function (see pp. 102–103) acts to place the type on curves or arcs, these other functions allow liquid effects to be added to your typography. These effects are more subtle and replicate the distortions you see when you view objects through slow-moving clear liquid.

The Wave filter allows you to control the number of wave generators, the amplitude of the wave, and also the type, by choosing Sine, Triangle, or Square.

The ZigZag and Ripple filters affect the typography by making it appear as if it has an undulating surface. ZigZag distorts the text both horizontally and vertically to pull the characters in different directions around a central axis. This forms concentric ripples which makes the type look as if it is lying on

a watery surface. You can control the type of zigzag by selecting settings such as Pond Ripples, which is like a droplet falling on a smooth surface, or Around Center, which is a rotation around a central point.

Ripple is the less sophisticated of the two filters. It can be set to make the characters appear as if they were at the bottom of an undulating pool.

Using these filters can be time consuming and if not used with some thought, they

ZIGZAG

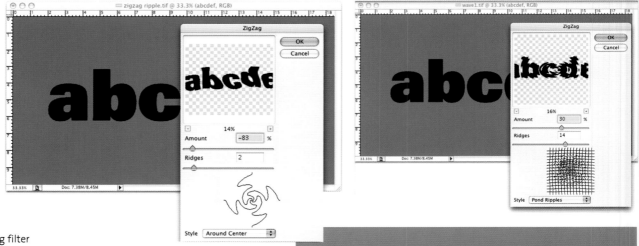

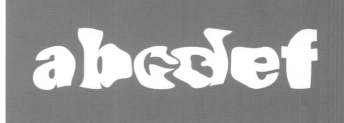

1 ⌃ The ZigZag filter has a variety of settings that determine the final effect. You can control the Amount and Ridges using the sliders. The main setting is Style. Here, we have used Around Center.

2 ▶▶ The Pond Ripples style replicates the effect of a droplet on smooth water. Also try the Out From Center setting, which has a similar effect.

can provide relatively contrived results. They need to be experimented with and practiced so that you understand the kind of results you can achieve with them.

They do not have the degree of control the Liquify command has, but they do provide a large array of results. These need to be used in conjunction with each other to gain the best effects.

There may be times when you want to make your typography look as if it is being viewed through some kind of liquid, as if it is at the bottom of a swimming pool. If used with a little thought, the wave, zigzag, and ripple filters can provide this kind of distortion effect.

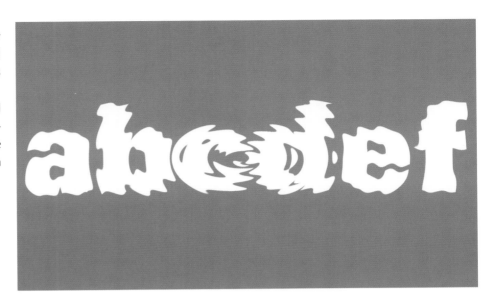

WAVE

1 ▶▶ The Wave filter makes type look watery. Set the Number of Generators, the Wavelength, the Amplitude, and the Scale. Use a smaller number of generators for a more convincing effect. There are also different types of wave—Sine, Triangle, and Square.

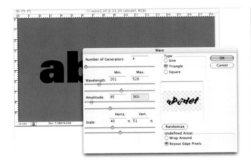

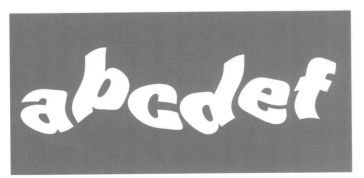

RIPPLE

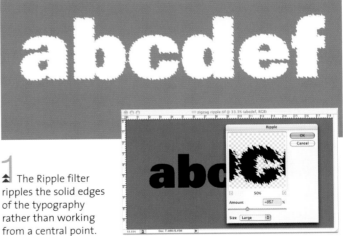

1 ▲ The Ripple filter ripples the solid edges of the typography rather than working from a central point.

■ lighting effects

Creating and controlling lighting on objects is a feature usually associated with 3D software packages. However, Photoshop can also produce some lighting effects.

Although Photoshop cannot provide the full three-dimensional effects created by more specific software, it can go some way to generating a textured surface.

The filter that Photoshop uses allows you to project up to 16 different light sources onto an image. With each of these it is possible to control the intensity, position, angle, and color of the light, along with the reflectivity of the surface on which they are projected. As we have seen when creating textures, you may want to focus additional light sources on them to make them appear more realistic. Your results can also be used in conjunction with layer styles such as Drop Shadow and Bevel & Emboss to further the illusion of a three-dimensional object.

Lens Flare is one filter that you may want to make a note of. Although photographers usually go to great lengths to avoid this kind of reflection appearing on their photographs, this filter adds halos and "hot spots" that mimic light bouncing off a camera lens. It has limited uses but it is a credible effect when used along with other filters, such as Lighting Effects.

We have already seen how Outer Glow works (see pp. 98–99). When used on typography, text appears to be lit from behind. If the typography is the same color as the background, the effect can have more impact. Combine this with Bevel & Emboss and a very subtle gradient using the glow color and the type color as a way of creating a convincing piece of typography.

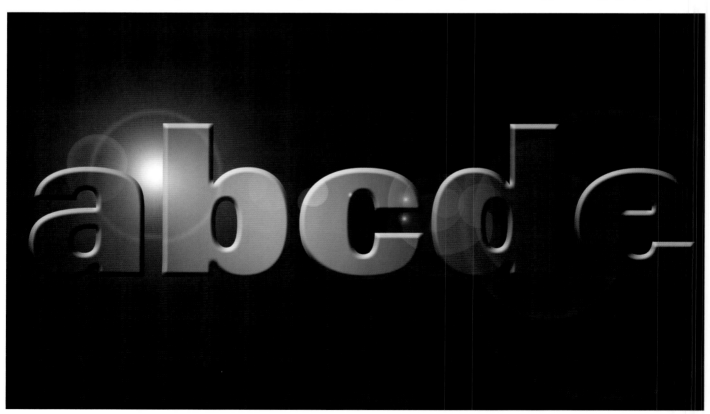

1 ◀◀ Generate your text, then rasterize it using Type from the Layer menu. Then select the Lighting Effects command in the Filter menu.

2 ◀ In the dialog box, it is possible to choose from several light sources, their direction, the material the light falls on, and the exposure. There are several styles of lights to choose from, including single and multiple sources. You can also change the color of the light. This filter effect can take some practice to master, so plan in advance what you want to do.

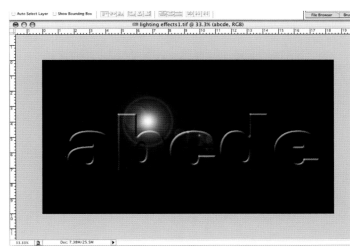

3 ▲ Another popular effect is to use Lens Flare, which gives the appearance of light being reflected off a camera lens as it takes a photograph. This is also found in the Filter menu.

4 ▶▶ With this filter, you can choose from the type of lens it mimics, the brightness of the flare, and the center point.

5 ▲ Apply the same Lens Flare effect to the background as well. This unifies it with the type— placing the flare on the type alone may not look as convincing.

■ liquify

The Liquify filter allows you to give a sense of movement to your designs. It enables you to twist, warp, stretch, and generally distort any layer.

Liquify makes any two-dimensional image appear as if it has been transferred to the surface of a liquid and allows you to manipulate it in a variety of ways.

The filter provides a variety of useful controls. First, you can see the effect in a full-size preview. You can also freeze part of the image to mask it from distortion and can reconstruct any areas. The other tools in the command are Freeze, Thaw, Warp, Twirl, Pucker, Bloat, and Shift Pixels.

The benefits of using this particular filter instead of the other distortion filters are that you can immediately see the effects full-screen and can use different tools on the same piece of artwork simultaneously. This allows greater control and flexibility and produces very credible results.

glass

The Glass filter produces a life-like effect and works best when text is placed over an image. Thanks to the clipping groups and Bevel & Emboss, the effect is easy to achieve and looks very authentic.

In effect, what you are doing is copying the image, distorting it, then viewing it through a clipping group with typography. In other words, by using the Displace filter, you are able to place a distorted image inside typography and then add depth to it by using the Layer Styles to give an inner bevel. The shadows and highlights can be set to specific layer blends, such as Multiply or Screen, to complete the effect. This makes the type appear raised and translucent.

GLASS EFFECT

1 ▸▸ The effect works best over an image or texture. Here, we have used an image from New York. Create your text, using a font such as Univers extra bold.

2 ▲ Next, create a new layer in the Layers palette and Fill Black. Load your text layer as a Selection and Fill White, then use a

Gaussian blur to soften it. This will be used to distort the image later. Save the image in a Photoshop 2 format.

3 ▸▸ Duplicate the background layer and move it above the text layer. Select Displace from the Distort command in the Filters

menu. In the dialog box, locate the Photoshop 2 file you saved. The software will use this text to displace the image.

4 ◂◂ Create a clipping group between the displaced image and the text by clicking and holding down the Alt key on the line that separates the layers. Use the Layer Style menu to add an inner bevel and drop shadow to the text. Finally, adjust the levels on the displaced image to make it appear slightly lighter.

Si ———a dies, ut vina, poem——a reddit, scire velim, chartis pretium quotus arroget annus. scri——abhinc a————centum qui decidit, inter perfectos veteresque referri debe———iller vi——atque—————Excludat iurgia finis, "Est vetus atque probus, centum qui perficit annos." ———qui deperiit———who mense vel anno, inter quos referendus erit? Veteres——————an quos et praesens et postera respuat aetas? Iste——————veteres inter ponetur honeste, qui vel mense brevi vel toto est iunior anno." Utor permisso, caudaeque————equinae paulatim vello——demo etiam unum, dum cadat elusus ratione———nervi, qui redit in fastos et vir————aestimat annis miraturque nihil nisi quod Libitina sacravit.

The Liquify filter can produce a watery effect on your text. The variety of tools in this filter means you can distort the text but exercise a degree of control not possible with the wave, zigzag, or ripple filters.

LIQUIFY

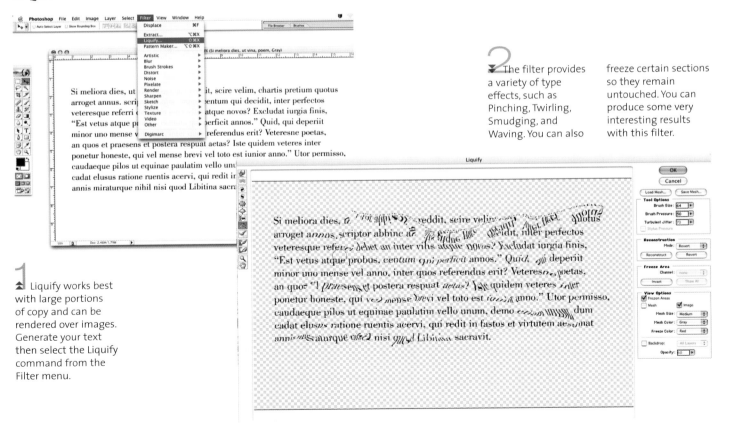

1 Liquify works best with large portions of copy and can be rendered over images. Generate your text then select the Liquify command from the Filter menu.

2 The filter provides a variety of type effects, such as Pinching, Twirling, Smudging, and Waving. You can also freeze certain sections so they remain untouched. You can produce some very interesting results with this filter.

■ texture effects

There may be times when you want to make your typography look as if it is made out of something other than printed ink.

Designers are always looking for new ways to present their work, particularly on packaging, in advertising, or on web splash pages. The more visually stimulating the imagery is, the more likely it is to stand out from the rest. Typography involving wood or slate effects can be used in a way that printed ink designs sometimes cannot. They can say something new about the nature of the website or product.

There are several different ways of producing textures. The traditional method is to take a photograph of the appropriate texture and then scan and apply this in software such as Photoshop.

With looming deadlines and perhaps no access to the relevant texture, this is not always feasible. Software developers have recognized this and Photoshop now has the capability to fake textures quickly and easily with some degree of credibility. The effects are more believable when they are subtle. Textures can be applied to the background or, if it is bold enough, to the typography itself.

Using an combination of the Noise, Render Clouds, and Texture filters makes it relatively easy to fake a number of appearances. Brick, wood, and slate are all attainable with the software.

WOOD EFFECT

1 ▶▶ Using the Filter menu, apply Add Noise on a new layer, then use the Blur commands to give the Noise a Motion Blur.

To give the texture more of a wood grain look, add a Wave distortion filter. This gives a more natural, less linear, look.

2 Colorize the texture using Hue/Saturation in Adjust in the Image menu. It takes some time to obtain the correct hue, saturation, and lightness.

3 ▲ Type in your text and move the layer with the wood texture above the text. Hold down the Alt key and click on the line that separates your text and wood effect to create a clipping mask. The texture should appear inside the letterforms.

Use the Layer Style menu item to control the Bevel and Emboss function. Add a drop shadow to create some depth.

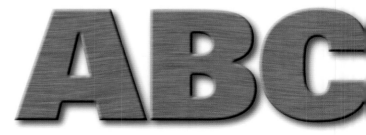

SLATE EFFECT

1 Create a new layer and use the Render filter to create clouds. In the Image menu, select Adjustments, then Posterize from the submenu. This commands flattens the tones of the clouds.

2 Using the Blur filter, apply a Gaussian blur to soften the texture. Use Select All and copy this. Select the Channels palette and create a new channel. Paste your copied texture into the new alpha channel. Use this later to create the texture for the slate.

3 Select the Lighting Effects from the filters. Choose Omni in Light Type and position it where you want it. Set the Texture Channel to Alpha 1. This uses the rendered clouds you generated earlier to act as the texture onto which the light source is projected. You can also set the Height of the texture here, either Flat or Mountainous. Relatively flat is best.

4 As you did with the wood effect, use Hue/Saturation to colorize the texture and give it a slightly blue cast.

SEE ALSO

BLUR FUNCTIONS — 70
LIGHTING EFFECTS — 106
OTHER EFFECTS — 112
METAL EFFECTS — 116

■ other effects

There are several other effects that are easy to produce. However, use them with caution—used on their own, they may not always be credible.

perforated edge

The edge of a postage stamp is a good example of a perforation-style look that works well and this tear-off effect can be applied elsewhere. Be cautious when using it, though, as it can just make the edges of your type look fuzzy and undefined.

It is best to use very bold sans serif characters. Serif fonts are too fussy and have too many subtleties to allow you to achieve the effect properly. By using paths and making custom brushes, you can stroke the edge of the path in a consecutive manner to make it look serrated. Couple this with an inner border to complete the look.

PERFORATED EFFECT

1 ▶▶ Generate your type, then with the text layer selected, load it as a Selection using the Select menu. In the Paths palette, select Make Work Path. Keep the Tolerance low—about 0.5—to make it as close to the original as possible. You will see a vector pathway created around your type.

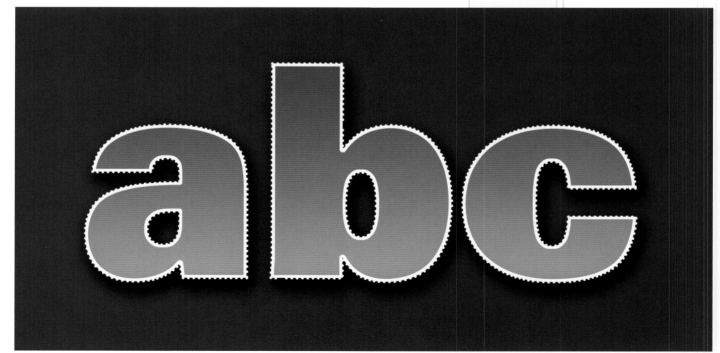

2 Create a new layer in the Layers palette to generate the perforated edge.

3 Create the brush necessary to complete the effect. To do this, open the Brushes palette and select Brush Tip Shape. Set your diameter to 12 pixels, hardness to 100 percent, and spacing to about 150 percent. An example of how this will look appears at the bottom of the palette. Select the Work Path you created in the Paths palette and select the Brush tool. In the Paths palette drop down menu select Stroke Path. A series of dots will appear around your text.

4 In the Layers palette, select the text layer again and load the text as a Selection. Click on the layer with the dots and fill the required color. Load the Selection again and create another new layer. In the Select menu choose Modify, then Contract, from the submenu, and set it to 10 pixels. This will create an inner shape on the text. Fill the selection with a color of your choice. Here, we have also added a background color and an inner gradient and drop shadow.

■ other effects continued

rough textured surfaces

This is another effect that has limited uses on its own, although when combined with others, as is usually the case, it can prove to be more practical. When several filters are used together, they can have startling results. By utilizing the Sketch filters and mixing these with layer styles such as Bevel and Emboss or Lighting Effects, you can generate three-dimensional surfaces on two-dimensional text.

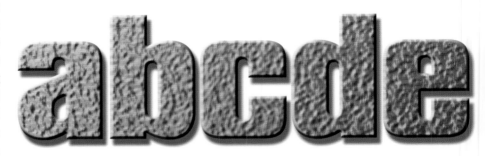

HAMMERED EFFECT

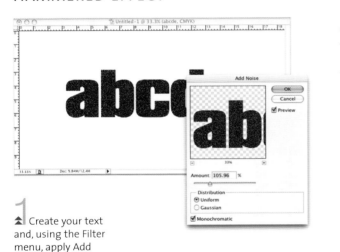

1 ▲ Create your text and, using the Filter menu, apply Add Noise to it.

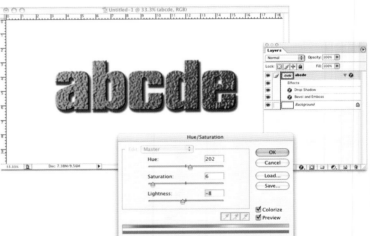

2 ▶▶ Then select Sketch from the Filter menu and choose Bas Relief from the submenu to add texture to the Noise. Set the Detail, Smoothness and Light Direction to gain the desired effect.

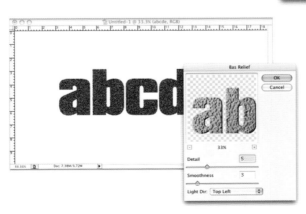

3 ▲ Select Adjust from the Image menu, then Hue/Saturation from the submenu to colorize the image. Set Saturation very low, and make it slightly darker with a pale blue Hue. To complete the effect, add a drop shadow and inner bevel using the layer options.

three-dimensional depth

Photoshop's filters offer this function. By using the Motion Blur filter to a considerable depth you can induce a large drop shadow with a soft edge. Changing the curves on this drop shadow so that you have a very sharp cut-off solidifies the shadow into a hard-edged shape. Use the curves again to clean up the edges. Paste the original text on top in any color other than black for a three-dimensional shadow.

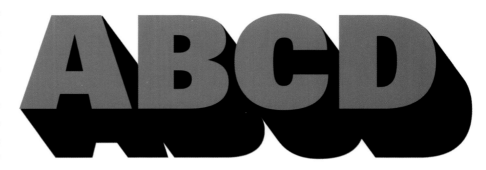

THREE-DIMENSIONAL EFFECT

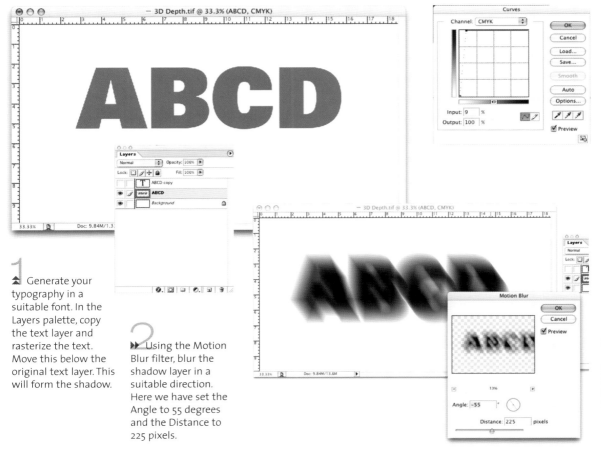

3 ◀◀ To make this layer more solid and less translucent, use the Curves in Adjustments from the Image menu. To sharpen the edge, the curve needs to be almost vertical at the beginning. Repeat this step to solidify the type completely. Then move your text layer to the correct position and set the color.

1 ▲ Generate your typography in a suitable font. In the Layers palette, copy the text layer and rasterize the text. Move this below the original text layer. This will form the shadow.

2 ▶▶ Using the Motion Blur filter, blur the shadow layer in a suitable direction. Here we have set the Angle to 55 degrees and the Distance to 225 pixels.

SEE ALSO

BEVEL AND EMBOSS	**66**
LIGHTING EFFECTS	**106**
TEXTURE EFFECTS	**110**
METAL EFFECTS	**116**

■ metal effects

As the number of commercial websites increases, designers have to make their logos stand out above all others. As well as wood and slate effects, metal finishes also work well.

The medium used to communicate an idea goes a long way to hinting at the message contained within. Without realizing it, we expect certain subject matters to be presented in particular ways. Adding a texture to bold typography can give clues as to the nature of the message being communicated within the text or the nature of the subject matter. Type involving aerosol graffiti immediately gives a "street" look. Type involving big round plastic letters indicates that the target audience is children. To create that all-important texture, Photoshop is the most effective piece of software. It can recreate a large amount of textures with relative ease.

Metal finishes can make typography imposing and different types of metals have their own personalities. In the 1970s, designers used airbrush techniques to get a stylized chrome effect. They built up images with painstaking detail to achieve a smooth, reflective surface. Photoshop can achieve the same effects without the need to build up numerous color layers.

With a mixture of a Gradient Overlay and Bevel & Emboss you can obtain a chrome effect in minutes. This can be improved on by adding other layer options such as Satin, Inner Bevel, and a small amount of distortion. It is also easy to create other types of metal effects, too. Using the qualities of the metal as inspiration, you can create smooth-brushed aluminium textures using Noise and Motion Blur filters. Rough cast metal can be recreated using Noise, Relief, and Bevel & Emboss commands.

These textures can then be accentuated with Lighting Effects and layer options to provide a three-dimensional effect on two-dimensional typography. The effects can be very convincing.

The chrome look was very popular in the 1970s. Then, it was achieved by applying several layers of paint using an airbrush. Now, it is easily achieved using software such as Photoshop.

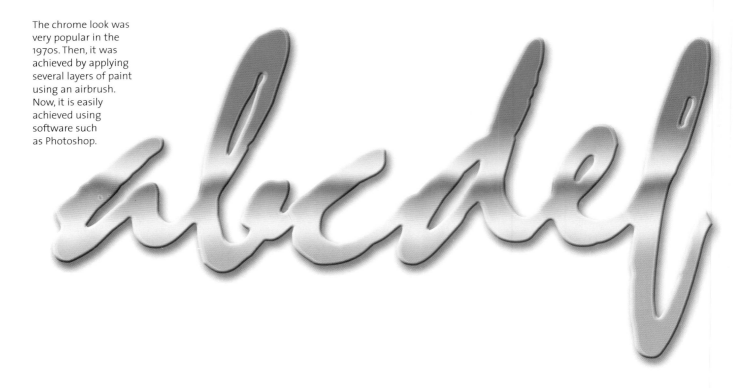

CHROME EFFECT

1 Generate your type. Here, we have used Mistral. In the Layer Styles menu, select Gradient Overlay and choose the blue and brown gradient. You can customize the settings by clicking on the gradient bar and moving the sliders.

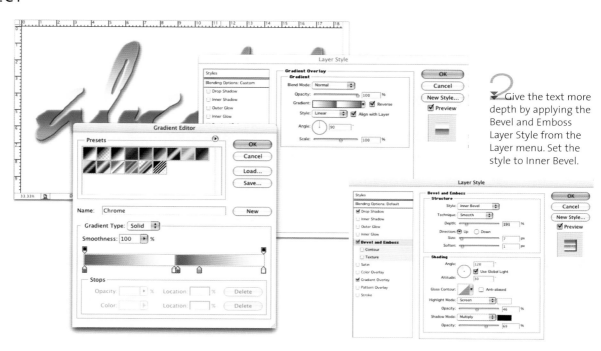

2 Give the text more depth by applying the Bevel and Emboss Layer Style from the Layer menu. Set the style to Inner Bevel.

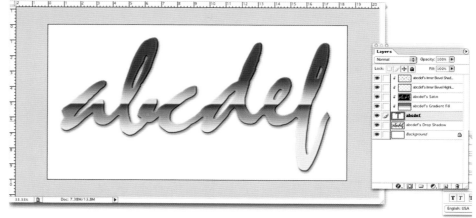

3 Access the other layer styles in the same palette. Activate the Drop Shadow option and apply a small drop shadow to the text, along with a slight amount of Satin to bring out the highlights.

4 Use the Create Layers command in the Layer Style menu to turn each of these effects into separate layers. You can now adjust them individually by adding filters. Select the Gradient Layer and apply a Wave filter to it to soften its strong horizontal line. Finally, apply a Gaussian blur to blend the colors.

■ metal effects continued

CAST METAL EFFECT

1
▶▶ Generate your text, then load the text as a Selection using the Select menu. Then choose Modify, then Contract, from the Select menu to make the selection smaller—about 10–15 pixels. This creates the outer rim of the type. Then apply Add Noise to the selection.

2
◀◀ To obtain the look of cast metal, select the Bas Relief filter from Sketch in the Filter menu. You can control the Detail, Smoothness, and Light Direction in the dialog box.

3
◀◀ To make the texture appear recessed, apply a Bevel and Emboss layer style. Select an appropriate Depth and Size, making sure Direction is set to Down.

4
▲ Load the text as a Selection again, apply Add Noise, then rasterize the type layer. Apply a Motion Blur filter with a diagonal angle to provide the machined edge to the text. Contract the selection by the same amount as you did before and delete the inside. To make the edge look three-dimensional, add a Bevel and Emboss to this layer.

5
▶▶ Finally, add some Lighting Effects to the edge of the type to make it look more credible. Here, we have used a Spotlight with a wide focus. To complete the effect, add a Drop Shadow.

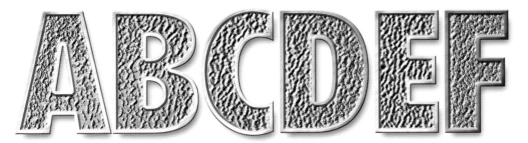

The letterforms look as though they have been made up from cast metal. This effect was generated through a process of building up several filters.

Several filters have been applied to the background to make the type look as though it has been cut out. These effects could also have been applied to the text itself, to create an aluminum look.

ALUMINUM EFFECT

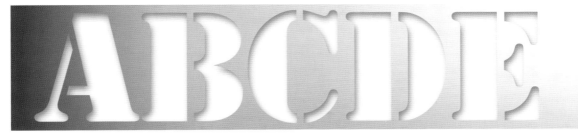

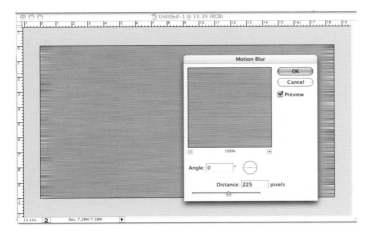

1 Fill a layer white and apply Add Noise. Then use the Motion Blur filter to replicate the polished surface. Choose an Angle of zero and a high pixel Distance.

2 Apply some lighting effects to this surface. Here, we have used a soft Spotlight with a wide focus. Set the Texture Channel to any of the RGB channels and set a fairly flat Height.

3 Generate the type on a layer above in white and apply an Inner Shadow using Layer Style to make the text look cut out of a sheet of metal.

editable text using HTML

HTML is the basic tool used for writing and constructing simple web pages. Limited typographic detailing is possible by using Cascading Style Sheets.

HTML (Hypertext Mark-Up Language) contains all the formatting instructions needed to send information between computers. Its original purpose was to place the control of the presentation of the information in the hands of the user. This lack of control at the originator's end means that typographic detailing is very difficult to achieve.

Using HTML, there are three basic types of fonts: proportional serif, proportional sans serif, and monospaced. These are the default web fonts since they are the only ones guaranteed to be available on every users' operating system.

cascading style sheets

The World Wide Web Consortium developed the language of Cascading Style Sheets (CSS). Its function is to work alongside HTML in order to give the originator more control over the typography.

What CSS does is take all the instructions regarding the font and centralize it. It offers the designer a way of formatting the text to refine how it is displayed in particular browsers. It embeds a set of instructions in the page that controls letterspacing and leading. It also allows designers to specify size, color, weight, case, and line endings along with the type's position on the page.

These directions then apply to all the typography contained within the site. You can apply different styles to "blocks" of text, thus gaining some control over how the type is presented. Most browsers support CSS and any that have difficulty with it just ignore the coded instructions it provides.

Dreamweaver has been set up to provide this complicated coding within the software to try and make it as easy as formatting text in any page layout software.

For those wanting to use specialist fonts and preserve typographic detail there is another choice—creating text as graphics, which can then be placed on the page.

HTML

1 ►► This is HTML created on a Microsoft Word document. It will construct a very basic web page. All the information it needs to present the page in the browser is included, such as a title bar, headline, and body copy within the tags.

2 ►► This image shows the above code in use. There is a title bar to the browser, a title, body copy, and a web link. These are denoted by the typeface, size, and color. The text is "live," meaning that it can be highlighted, copied, and pasted into other applications.

3 ▲ This simple page was created in Dreamweaver. The text has basic page formatting. The copy runs almost all the way across the page. We have used the Shift-Return keystroke to put in line breaks. Having resized the browser window to make it smaller, you can see it has moved the "live" text around in the window to make it all visible. However, the line breaks have produced poorly formatted text, with large gaps evident in it.

CASCADING STYLE SHEETS

2 You can control the Positioning of the text within the browser window by using a variety of measurements, such as pixels or centimeters.

1 Cascading Style Sheets work in the same way as the style sheets in QuarkXpress. From the CSS Styles palette, select New from the icon. You can then use the left menu bar to select the items you want to apply the styles to.

3 The Box tab allows you to control the width and length of the box in which the text is sitting.

5 It is possible to edit all of the properties for a style sheet using the CSS Styles palette, by clicking on the chosen style and making amendments to the requirements as needed.

4 If you apply these commands to the text used above, the formatted text occupies a smaller block within the window and there are now no awkward-looking line endings.

■ bitmap and GIF images

Since you cannot predict the fonts installed on a user's system, it is better to use images to ensure that your typography doesn't default to the fonts used by the browser.

One of the most common ways to add specialist type to a web page is to bypass pure HTML and to embed the type as a bitmap image created in another software package. There are two main formats that are used for web-based images. They are JPEG and GIF. JPEG (a format developed by the Joint Photographic Experts Group) is better for handling photographic images where there is continuous tone. GIF (Graphics Interchange Format) is better suited to images made up of flat color, such as buttons and text.

Creating your type in an image format means you can experiment and present texts in any font you wish and apply a whole host of effects, such as drop shadows and texture fills. You have more control over the type than pure HTML will allow. Many of the effects detailed earlier in this chapter can therefore be applied to web-based images.

The disadvantage of using type as an image is that every pixel has to be rendered, which makes it slow to download when you have several making up a page, even if compression rates are high. It is also no longer a

piece of "live text" that can be copied or pasted, as with HTML. Search engines cannot add it to their databases, and you cannot embed hyperlinks.

With this in mind, use GIFs and JPEGs for creating title text, headlines, or rollover buttons only. This allows you the freedom to experiment and create eye-catching typography where particular attention has to be paid to the detailing of the text. However, these formats are not suitable for body copy—for this, use typefaces that have been designed for the screen.

⬥ Bitmaps are constructed from colored pixels as opposed to anchor points, such as those used to construct vector images. You can see the difference in the smoothness of the outlines of the two letters above. The one on the left has been generated in

Photoshop, and, although it uses the antialias function, the limit on the number of dots per inch (dpi) results in a jagged edge to the letterform. The character on the right has been generated in Illustrator and has none of these problems.

⬥ Here you can see a typical print image at 300dpi. The shape of the outline is smooth and consistent with relatively good detail.

⬥ The same image has been reduced to 72dpi, the typical screen resolution. This version has lost a lot of detail and, when enlarged, shows jagged edges.

abcde

abcde

⮟ Titles and navigation bars are the best places to use bitmap or GIF images. Here you can obtain subtle effects not possible with "live" text. In this navigation bar we have used simple typography and arrows to click between pages. When a link is clicked it becomes the focus of the navigation by making it the darkest element in the bar. The other links are still live and when clicked will also behave in the same way.

⮝ This is text saved as a GIF image. It has been designed to be a button on a web page. By using images of text for items such as buttons, title text, and headlines it is possible to produce a range of possibilities. Rollovers can look like the button has been depressed by changing the color and even the depth of a simple bevel filter in Photoshop.

⮝ One of the advantages of using GIFs is that you can always use your own fonts, such as the one above, in titles, headers, or on buttons.

⮝ GIF images can be used to display modern typographic designs without being constrained by the system fonts.

■ antialiasing

Some fonts, presented at low resolution on screen, are not very legible. When reduced to small sizes, their letter shapes are not recognizable and are inadequately spaced.

The quality of digital type as it appears on screen is dependent on the screen resolution. Since the user sets the screen resolution, it is impossible to predict exactly what this will be. The coarse type produced at 72dpi does not work well when reading large amounts of type on screen.

Another issue is the difference between viewing text on an Apple Macintosh and viewing it on a PC. On the Macintosh, a font is displayed at roughly the same size as it would appear in print, matching a pixel for a point (creating 72ppi). However, the PC displays font sizes larger than they would appear in print. In our example, this would create 96ppi. Thus on a PC, 12-point type appears closer to 16 points.

When a font is rasterized on screen, only the pixels that fall inside its outline shape are drawn or filled in. This causes inconsistencies within the font, as fine details, such as serifs, can be lost in the process. In an attempt to counteract this problem, a process called antialiasing can be used.

This function smoothes the jagged edges created through bitmapping. It adds pixels of varying shades to the shape of the letters along curves and diagonal lines, creating the illusion that the font is more rounded and refined.

This function is excellent for fonts above a specific size, notably 14 point. They appear smooth and legible. At small sizes, though, antialiased text can be difficult to read, as glyphs produced with a stroke width of only one pixel look fuzzy due to the added tones around it. At small sizes, it is far better to use fonts that have been optimized for screen use (see pp. 126–127).

1 ▶▌ This font, Georgia, has been antialiased on the top line. On the bottom line, the antialias option is set to None. The difference in the precision of the letterforms is clear.

Abcdefghijkl

Abcdefghijkl

2 ◀◀ The antialias command has several settings—None, Sharp, Crisp, Strong, and Smooth.

3 ▸ Antialiasing works well with large point sizes. Any text below 14pt tends to look fuzzy and becomes illegible.

Si meliora dies, ut vina, poemata reddit, scire velim, chartis pretium quotus arroget annus.

Si meliora dies, ut vina, poemata reddit, scire velim, chartis pretium quotus arroget annus.

18PT BODONI

18PT TIMES

18PT UNIVERS

4 ▴ Type sizes above 14pt look smooth and retain more of their original shape when the antialias command is used.

8PT BODONI

8PT TIMES

8PT UNIVERS

5 ◂ Type sizes below 14pt do not retain their legibility as the software adds the varying shades of pixels. This makes them harder to read on screen.

■ fonts optimized for screen

The constraints of screen resolution mean that viewing fonts at small sizes is problematic. Specific screen fonts with large, open counters and ample letter spacing solve this issue.

Antialiasing is used to smooth jagged edges on pixelated fonts for presentation on screens at low resolution. Although this works well for larger display type it does not work well for smaller body copy.

The problem is that the designer can never predict the resolution of the screen the type will be viewed on. It may vary from 640 x 480 pixels to 1,600 x 1,200 pixels depending on user set up.

The solution is to work within the constraints imposed by the screen. Body copy fonts that look legible at both high and,

more importantly, low screen resolutions are needed. Serif fonts do not transfer well to low-resolution screens because of the nature of the pixel grid. This means that detail is lost at small sizes. For this reason, most body fonts viewed on the web are set in sans serif typefaces.

HTML, being a basic language, allows three types of font to be used within any site. They are proportional serif (Times New Roman), proportional sans serif (Arial and Helvetica), and monospaced (Courier and Monaco). Working with these limitations

means the choice of typeface within a site is crucial for small text. If the user doesn't have the specified fonts installed, the software will default to one of the above faces.

The problem of legibility for the screen has been addressed a little by the development of new typefaces. These have been designed with how well they read at 72 pixels per inch (ppi) in mind. Internet Explorer will install these fonts, which have generous character spacing, larger x-heights, and open, rounded features to make them more suitable for online reading.

Monospaced, proportional sans serif and proportional serif faces. The top two lines are monospaced fonts— Courier New and Monaco. Both have glyphs that are all the same width, whereas the sans serif face, Helvetica (in the third line), and the proportional serif face, Times New Roman (in the bottom line), have characters of varying widths.

▶▶ On the left-hand side is type set in Futura and Bodoni, in varying point sizes. These fonts are often chosen in print design for their classical proportions. On the right-hand side is type set in Verdana and Georgia, in the same point sizes. These fonts were designed with screen resolution in mind. At small sizes, Futura and Bodoni become difficult to read. Verdana and Georgia do not, as they have more rounded and open characteristics.

abcdefg

abcdefg

abcdefg

abcdefg

abcdefg

abcdefg

abcdefg

abcdefg

abcdefg

abcdefg

abcdefg

abcdefg

Andale Mono

arial

arial black

comic sans

courier new

georgia

impact

Times New Roman

Trebuchet MS

Verdana

◀◀ These are the fonts installed by internet browser software onto the user's hard drive. They are "safe" fonts that everyone will have and be able to use. Some have been designed with screen resolution in mind and so will be better for rendering body copy on screen.

abcdefghi

abcdefghi

▲ **Georgia 10–72pt**
Although Georgia is a serif font, the 10pt version (bottom) is still legible. Although the glyphs don't look exactly like the originals (above), they retain some essential characteristics.

abcdefghi

abcdefghi

abcdefghi

abcdefghi

▲ **Bodoni 10–72pt**
The 10pt version of Bodoni (bottom) is illegible and unrecognizable. The amount of hairline serifs and the varying stroke widths do not render at such low resolution, proving what works in print does not on screen.

▲ **Verdana 10–72pt**
Screen fonts are designed to be as simple as possible with large x-heights and open, rounded proportions. Even though the 10pt version of Verdana (below) is quite crudely rendered it is still legible.

▲ **Futura 10–72pt**
Notice how a simple feature such as the round dot on the lowercase letter "i" becomes a square at small sizes. All the rounded qualities of the font are lost and the spacing has been distorted.

■ hinting

Hinting is a process of manipulating a letterform so that it retains its legibility and essential characteristics when reproduced at small sizes and low resolution.

When fonts are reduced to small sizes on screen, irregularities and problems with legibility occur because pixels are restrictive in size. Letterforms can have an unattractive, blocky appearance, because the glyphs don't always fit easily into the screen's pixel grid. This is especially noticeable when the stroke widths of the font are only one pixel wide, making fonts look inconsistent and uneven. Antialiasing (see pp. 124–125) attempts to solve this by smoothing out fonts at larger sizes by adding tones.

The other solution is called Hinting. This is the best way to present type at small sizes at screen resolution. It subtly modifies the text presented on screen by mapping it onto the pixel grid while retaining the characteristics of the chosen font. It influences the proportions of the letterforms, including line thickness, form, and serifs. It is a way of ensuring that positioning and spacing are uniform. As a result, it slightly changes the appearance of the text at small sizes, to make it more legible.

TrueType and PostScript fonts are both defined as a vector and they are not prepared for the pixel grid. So hinting information is contained within the TrueType or PostScript file for the font. The manufacturers set control points on the letterform to aid the process.

These hints change some of the qualities of the letterforms so that counterspaces and serifs have the correct proportions

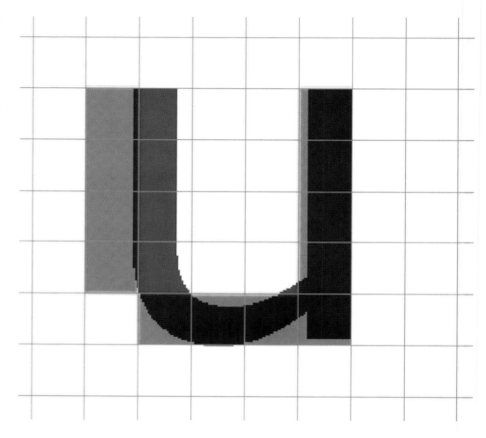

when made up from only a limited number of pixels. This may actually slightly distort or stretch the original letters to fit the grid, but doing this improves legibility enormously. The letterforms become more recognizable and have a uniform thickness and form.

When compared with other type without hinting you can see why it is so important—letterforms do not merge together when reduced to small, blocky glyphs.

The knocked-back, blocky image is a lowercase "u" that has been set in Verdana. When the character is "hinted" to render at small sizes at 72dpi, it has to conform to the pixel grid (the blue lines). You can see that the character has been adapted to fit the grid by forcing the left-hand side over to the right.

▶▶ The four characters on the left are set in Verdana, the four on the right in Times New Roman. The bitmapped characters are enlargements of text tendered at 8pt on screen. As you can see, the bitmapped characters don't have the same proportions as the original glyphs.

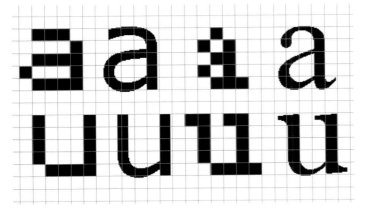

▲ When the characters are on the pixel grid, you can see how the glyphs have had their proportions altered in order to fit it. The Verdana characters on the left have been compressed horizontally, whereas the Times New Roman "a" has been extended horizontally.

abcdefghijkl

abcdefghijkl

abcdefghijkl

abcdefghijkl

abcdefghijkl

▲ This type, set in 8-, 10-, 12-, 14-, and 16-pt Verdana, shows how the proportion of individual characters actually changes across the point sizes. For the most part, glyphs with enclosed counters become more extended. This is most evident in the changes between 10 and 12pt and 14 and 16pt. If you look carefully, you can see that this affects the letters "a" and "e" the most.

■ color and type for the web

The internet is viewed on screen, which emanates light. Color type viewed on screen can have some unusual side effects, making the choice and use of color a major consideration.

When using type on a page it is important to maintain adequate contrast between the foreground text and the background it sits on. We are familiar with the printed page, where text is usually presented as black type on white paper. This does not work on a web page due to the nature of the screen presentation. White is made up of pure light emanating from the monitor. When large amounts of black text are placed against it, it can be hard on the eye.

To get around this problem, it is best to use light text placed on a dark background—this is less tiring to view. However, this can make the type appear larger and bolder on screen than it actually is, an effect sometimes called "blooming." This is caused by light appearing to seep into the darker color.

Since many designers view black as too dark and somber, they try and find other color combinations that look visually stimulating without hindering reading. This must be done using the limited 256 color palette used on the internet.

Achromatics or monochromes can be combined with color in this instance. These can help lower the tonal contrast, making the page easier on the eye. They also provide subtle color that is unobtrusive.

To guarantee legibility, the designer must ensure that the contrast between text and background is neither too strong or too weak. Contrasts of complementary colors can work well, providing the intensity of the color is not at full saturation. This can cause an optical illusion where colors that have the same tonality seem to vibrate next to each other. It is better to use contrasting or complementary colors where one is a lighter tone (for the type) and the other is a darker tone (for the background). Alternatively, use a light color for the background and a darker gray, or other darker hue, for the text.

These are the different color combinations available. From left to right are columns of contrasting color schemes; complementary color schemes; light type on a dark background and dark type on a light background; two columns of combinations of colored type on gray backgrounds and gray type on colored backgrounds.

1 When comparing combinations of black and white and gray and white, gray and white is easier on the eye. Since a monitor works by emanating light rather than reflecting color (as happens on a printed page), expanses of white on the screen can cause eye discomfort. It is better to use light type on either a darker background or a shade of gray.

3 Photoshop and Illustrator both offer swatches that use web hues. These can display the 256 colors acceptably viewed on screen. Each of these hues has a HTML code, which identifies it for display.

2 This simplified version of the color wheel shows how the colors in the spectrum relate to each other. Complementary colors are opposite each other (for example, orange and blue) while harmonious colors are adjacent to each other (for example, red and violet or orange). When choosing color combinations, bear in mind the tonal quality of the shades. If they are too similar, you may find the colors seem to vibrate, causing optical difficulties. It is better to choose colors of varying tones for effective contrasts.

4 There are three alternatives. By clicking on the options arrow on the right-hand side of the palette you can view the various swatches. Choose either Web Hues, Web Spectrum, or Web Safe Colors. Here, we have selected Web Spectrum to show the full range of available colors.

Dock to Palette Well
New Swatch...
✓ Small Thumbnail
Small List
Preset Manager...
Reset Swatches...
Load Swatches...
Save Swatches...
Replace Swatches...
ANPA Colors
DIC Color Guide
FOCOLTONE Colors
HKS E
HKS K
HKS N
HKS Z
Mac OS
PANTONE metallic coated
PANTONE pastel coated
PANTONE pastel uncoated
PANTONE process coated
PANTONE solid coated
PANTONE solid matte
PANTONE solid to process
PANTONE solid uncoated
TOYO Colors
TRUMATCH Colors
VisiBone
VisiBone2
Web Hues
Web Safe Colors
Web Spectrum
Windows

5 Web Safe Colors only has 216 hues and uses the colors that will display safely without any dither patterns on screen. They are more limited in their range but you have the assurance that they will show the exact same color on any monitor or system browser.

Dock to Palette Well
New Swatch...
✓ Small Thumbnail
Small List
Preset Manager...
Reset Swatches...
Load Swatches...
Save Swatches...
Replace Swatches...
ANPA Colors
DIC Color Guide
FOCOLTONE Colors
HKS E
HKS K
HKS N
HKS Z
Mac OS
PANTONE metallic coated
PANTONE pastel coated
PANTONE pastel uncoated
PANTONE process coated
PANTONE solid coated
PANTONE solid matte
PANTONE solid to process
PANTONE solid uncoated
TOYO Colors
TRUMATCH Colors
VisiBone
VisiBone2
Web Hues
Web Safe Colors
Web Spectrum
Windows

embedding fonts

Software now allows you to embed font files in a website so that type can be viewed as it was designed, rather than using typography in the form of a bitmap or GIF image.

By specifying some common fonts in font lists when constructing a website, you can add some variety to your typography. Because the font lists are quite limited in their choices, this method is far from ideal. The ideal situation would be to make the font available to the user over the web.

Font embedding provides exactly this service. It allows the user to view the site as it was designed. The font is sent with the HTML file so the user doesn't have to have it installed for the font to be displayed. At the time of writing, there are three main

pieces of software available to perform this procedure. They are Bitstream TrueDoc, Microsoft WEFT (Web Embedding Fonts Tool), and Adobe Flash.

TrueDoc has some drawbacks. Internet Explorer users have to download and install an Active X plug-in before being able to view a site with fonts embedded using its software. The amount of fonts available is limited and download times are long.

WEFT provides Embedded OpenType (.eot) files and has none of these problems. It can embed almost any typeface, it keeps

file sizes as small as possible, has high quality hinting advice and it works with Internet Explorer. The only drawback is that it currently does not have a Mac OS compatible version, although it will work with those running virtual PC. This means that Mac users can neither view nor create OpenType on the web.

The third and most effective way to embed fonts is to use Flash. This allows the designer to embed any font and produces lightweight vector files that can be viewed on any machine with a simple plug-in.

FLASH

1 Flash can automatically embed fonts within the SWF file. It saves the characters required as outline files so that the browser can read and display them. The downside is that this results in bigger file sizes. First, generate your text. Then in the Properties palette, select the Dynamic Text option.

2 Click the Character button to give specific instructions as to which characters to embed. The dialog box allows you to embed No Characters, All Characters, or specific characters, such as punctuation.

3 Flash cannot always convert every font to outlines to embed. Use Antialias Text in the View menu to verify the font. If it looks jagged, Flash does not recognize the font to export, and it may require an alternative choice. If it is smooth, the font should be exported without any problems.

WEFT

1 WEFT software is very easy to use. Create a simple web page in Dreamweaver then open the software. Using the Available fonts command in the View menu, you can find out which fonts are currently installed and which ones it is possible to embed. Those marked with a red cross will not work.

2 Open up the Fonts To Embed tab. You do not need to embed every typeface, because some of them will be device fonts found on all computers. Here, Gill Sans is a device font and so is marked in green. Andy is not, and is marked in yellow.

3 Only embed the necessary characters to keep file sizes to a minimum. So if you have used a font for a title only it would be wise to only embed those glyphs you have actually used.

4 Once you have selected the required fonts or glyphs, the software is ready to create the OpenType EOT font object file that automatically links to the web page and allows the user to see it as it was designed. Use the Create Font Objects dialog box to set the website location, from which the characters can be accessed. Once complete, the fonts on the site should display without any problems.

■ animated GIFs

An animated GIF is a simple and effective way of applying moving images to any website. The advantage of this format is that all browsers support it.

The process is easy to carry out and can be applied to typography, titles, buttons, and other page furniture. Photoshop comes with ImageReady software, which was an application designed for optimizing images for the web. It also has the capability to produce simple animated effects that can be saved in the GIF format, ready for online viewing. The software uses Photoshop files and allows the user to modify the layers and add frames to produce an animation. These animations can include objects that move, fade, warp, or change in other ways.

The document displays like a standard Photoshop file. It provides you with an existing frame in the Animation palette. By creating a new frame you can manipulate the image or type as desired. The Tween command adds new frames in between your selected ones to complete a sequence. The file can have several layers, each with something different going on, all at the same time. The animation can then be saved as a single file using the Save Optimized command. This automatically saves it in the GIF format.

Animated GIFs provide lots of opportunities to be expressive with typography. They also have the added dimension of time. Through this medium, typography can be dynamic and perform in a way that is not possible with print.

1 ▶▶ Open the ImageReady software by clicking on the icon at the bottom of the toolbox in Photoshop. Many of the software's features are exactly the same as Photoshop but it can perform functions for the web that Photoshop cannot.

2 Either open or create your type in a new document.

3 Open the Animation palette by choosing Show Animation in the window menu. This works in a similar way to the Layers palette in that you can create, duplicate or discard frames with the same icons that appear in the palette. Duplicate the first frame by dragging it to the new page icon at the bottom of the palette.

4 Select the first frame and, using the Move tool, place the text in the first frame at the desired starting position.

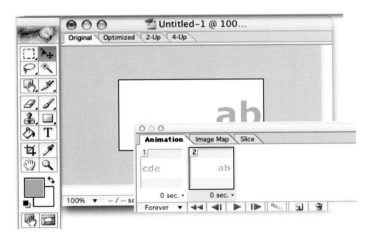

5 Select the duplicated frame and, using the Move tool again, place it at the desired end position. At the bottom of the palette, you will see the Tween Between icon located next to the New Frame icon. It appears as four circles on an incline.

6 This will bring up the Tween dialog box where you can specify how many frames the animation will have. This can be as many as 100 but remember that the more frames you use, the bigger the file size. You can also Tween between the previous frame only or all frames, meaning you can do several animations at once. By clicking the Play button in the palette you will be able to view the animation. This file can then be saved to be added to any site by using the Save Optimized command located in the File menu.

7 Making fading type uses the same principles as the previous steps, but here we are going to alter the opacity of the text. Create your type as before and duplicate the frame. To fade out, use the Opacity slider in the layers palette. Select the second frame and change the Opacity to zero. Click on the Tween command at the bottom of the animation palette to create the required number of frames.

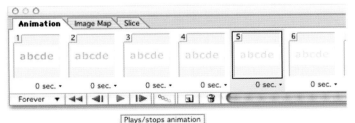

8 The new frames will appear in the Animation palette, where you can preview the motion. Select Save As Optimized to use as part of a website.

■ Flash animations

The internet has allowed designers to create interactive content in ways that were not previously possible. Simple dynamic animations can now be added to any website.

The best way to produce animations is by using Adobe Flash, a powerful application that has revolutionized web design. It allows the construction of everything from simple animations to full websites. Since it is vector-based software, it is scalable, file sizes are small, and you can add a wealth of effects to your typography, such as revolving, fading, and traveling along specified paths. All typefaces can be embedded. With the simple addition of a plug-in, the dynamic content can be viewed in any browser.

The software has many built in functions that can be adapted for typography. It works on the simple principle of specifying key frames and using the Tween button to add the necessary in-between movements. The completed animation can then be published as a Shockwave movie for inclusion in any site. Other programs, such as FreeHand and Illustrator, now offer the ability to export files in the Shockwave Flash (SWF) format to produce simple flick-book style animations.

Flash can be used to create dynamic navigation menus along with animated banners and introductions where typography can fly in or out, grow, shrink, or revolve to give interest and meaning to the page.

It has advantages over animated GIFs, in that the manipulated content can be used as buttons and links to other parts of the website, or even used to trigger other animations.

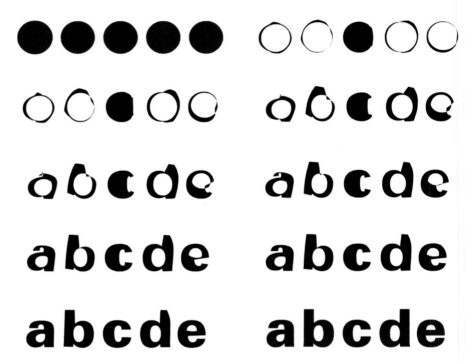

1 ▶▶ In this first example, we are going to morph shapes into text. This method should work for any shape but here we have used simple circles. Draw a circle on the stage using the tool.

2 ◀◀ Copy and paste this circle and use the Modify and Align functions to line them up and space them evenly.

3

▸▸ Move your cursor along the timeline and select a frame. Here, we have chosen number 25. Then in the Insert menu, select Blank Keyframe. This will give a frame without the original circles in the 25th frame.

abcdef

6

▲ In this next example we will be using similar commands to create simple movements. Again, begin by creating your text on the stage and use the Break Apart command to treat it as shapes rather than typography.

7

▸▸ Select a frame on the timeline. This time, select Keyframe, rather than Blank Keyframe, from the Insert menu. This allows you to retain the original type on the new frame. Using the cursor, click and drag around one or several of your characters.

4

▸▸ Use the Text tool to generate your typography. For the software to perform the morph, the text needs to be shapes rather than glyphs. Select the Modify menu, then Break Apart. Boxes will appear around the characters. Perform this command again to treat the type as

pure shapes. They should have a dotted appearance once complete. Select a frame between 1 and 25 and move the cursor to the Properties palette. In the Tween field, select Shape. You should notice the text on the stage distort. This has become one of the intermediate stages.

8

◂◂ Use the Modify command to modify the characters. We have chosen to rotate them 90 degrees clockwise. I have done this twice to revolve the text. In the same way as before, select a frame between the beginning and end. Then in the Properties palette, select Motion in the Tween field.

5

◂◂ When you play the animation you should see the text appear out of the changing shape of the circles. This animation can then be exported as a SWF file and placed in any website.

ɔqɐ def

9

▲ When you play the animation, you will see the characters you defined rotate between the beginning and

end frames. This can be exported as an SWF file to drop into any web development software.

4

The creation of fonts has long been the domain of the specialist, requiring years of experience and, often, great attention to detail. Using software such as Fontographer and FontLab, however, designers can now create and manipulate fonts in a way never thought possible. This chapter looks at the basics of font design and how to use software to create fun and unusual display typefaces. You will find methods for digitizing fonts as well as a number of functions for making a font more legible and esthetically pleasing.

the tools

Typographers, like graphic designers, employ a wide range of tools and working methods. You can work entirely digitally, or use a mix of hand-drawn and digital media.

You will need a scanner to produce the more handcrafted typefaces. This should not be expensive, as scans only need to be 300dpi. If using this method, you may also need software such as Adobe Streamline, which automatically traces bitmap images and turns them into outline files. You should also use vector illustration software. Many designers choose to construct individual glyphs in Illustrator or FreeHand directly, as this provides more control over the creation of characters than the more basic tools in some of the font packages. You can also autotrace scanned characters using the software, although it is not as accurate.

Whatever the approach, it is essential to have a font-editing program for building the typeface, controlling spacing, and generating the TrueType or PostScript format. There are several software packages available—Font Studio, Ikarus, and TransType, for example. Two, however, have emerged as the most widely used: Fontographer and FontLab, both made by FontLab. Both are available for the Mac and PC.

Fontographer is by far the most popular and has been since its introduction in 1986. The current PC version 4.1.5 has not been upgraded since 1996 and, as a result, is becoming incompatible with newer operating systems. Mac version 4.7.2 will run in Mac OSX. FontLab 4.6, on the other hand is gaining popularity. It has more up-to-date features, the ability to create OpenType formats and the option of editing Japanese

character sets containing thousands of characters. It is not as simple to use as Fontographer, but is proving to be a powerful piece of software.

FontLab has produced a cut-down version of the program called TypeTool 2.0. This still has many of the complex functions, making it ideal for those wanting to produce a specialist font, rather than use it as professional tool.

Another program produced by FontLab is ScanFont 4.0. It allows you to scan directly

To design a typeface, either by constructing your own original type or by working around scanned images, you will need a drawing application, such as Illustrator.

into the program and export to font-editing software, creating the outline glyphs in the process. By naming the glyphs in order, it places them in the correct position within FontLab or Fontographer. It is relatively cheap and takes much of the laborious work out of transporting characters into the font software.

1 Fontographer, until recently, was the most popular piece of font-generation software. The interface is easy to use and is based on old versions of FreeHand. It does have some shortcomings, including a lack of guides. The PC version has stayed the same for years, whereas the Mac version now runs on OS X.

2 FontLab has begun to gain recognition with the design community. It has a very similar interface to Fontographer, but has many features that the latter product lacks. It is available for OSX and is easy to use. Demo versions can be downloaded and will produce four full working fonts.

3 ScanFont, also produced by FontLab, is a great piece of software that takes much of the hard work out of preparing scans for the font-generation package. It is easy to use and links seamlessly with FontLab to reduce the amount of work involved with designing and creating a fully functioning font.

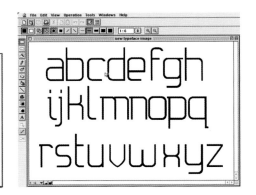

■ the basics—the groundwork

Inspiration for fonts can come from a variety of sources, from old signs to architectural forms borrowed from buildings.

Remain open to suggestion when looking for inspiration and look around for stimulation. Template Gothic, designed by Barry Deck, came from a sign in a laundromat: the artist had used a stencil to generate the characters but had not kept within the edges, so creating irregular stroke widths. Many of the fonts created for *Fuse* magazine have been the result of intellectual ideas based on a given theme, rather than for text-based information.

Whatever the inspiration for a font, you will have to go through the process of digitizing it. It pays to think about what you want to achieve with the font and how complete the character set is going to be. Should it be a one-off face with limited glyphs or a complete family with various weights and widths? This in itself will determine the best method to digitize it.

Once you have settled on an idea, you can go about designing the font. Most designers begin by designing a series of glyphs that complete a word. This allows you both to experiment with forms and to see how characters sit together. The standard option is to use the word Hamburgerfonts. This set of letters covers the basic lettershapes of upper- and lowercase, the use of ascenders and descenders, and the differences in character widths. It also involves both vertical and curved strokes within glyphs.

Interesting letterforms can be found in a wide variety of places, from old signs to stencils on a ruler. Once drawn out, these glyphs can be digitized and turned into a fully working font.

abc defghijklmnopqrstuvw

1 Interesting letterforms can be generated from a stencil font on a Helix ruler. With a little imagination, it is relatively easy these characters into a font.

2 This is one of the first sketches for a font inspired by the rounded boxes available within most software and monospaced typefaces. Some of the glyphs change quite subtly from original inception to finished font but the character of the font remains intact.

4 The nonsense word Hamburgerfonts is often used in font design, to make consistent glyphs that retain the same characteristics and personality. It has both ascending and descending characters along with vertical and curved strokes. As such, it is possible to see the relationships apparent throughout all the glyphs.

abcdefgh
ijklmnopq
rstuvwxyz

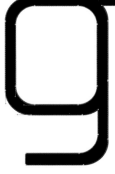

3 Here, the polished glyphs were created in Illustrator and manipulated using the Bezier curves until they looked consistent.

5 The finished lowercase characters of the font show regular attributes throughout the set. Notice that certain shapes and positions remain constant across the whole font.

■ the basics—character sets

Each letter in a font has particular characteristics that make it unique to the rest. When designing a font, be aware that not all characters are the same width or height.

Glyphs tend to be based on the three basic shapes of the square, circle, and triangle. Those based on a circle or oval tend to be slightly bigger than the rest by about $1/15$th em. Such characters overlap the baseline slightly to make them look the correct size. Similarly, characters based on triangular shapes, such as "A" or "V," should overlap the baseline or cap line by the same amount. This maintains the size optically rather than mathematically.

A full, working font needs a complete set of characters to make it functional. If you are planning to design fonts to be used for purposes other than simple display text, think about additional characters. For example, you may need numerals, punctuation marks and special glyphs including currency symbols and foreign characters. Should you wish to submit your font to a type foundry for inclusion in their portfolio, you will need to produce these characters. It is best to check with the font foundry in question for their criteria, before you submit. This way you avoid the need to design additional glyphs at a later date. If the font is purely for your own use, however, this will not be necessary.

When designing a character set, keep the features within the glyphs consistent. They need to relate to each other and be recognizable as part of a family. Most designers begin by drawing the characters on graph paper, using the grid to define height and stroke widths, so keeping the glyphs uniform.

ABCDEFGHI
JKLMNOPQR
STUVWXYZ
ÆŒÂÅÁÅÇÊËÈ
ÍÎÏÌÓÔÒØÚÛÙŸ
abcdefghijklmn
opqrstuvwxyz
æœfifl∑∂Ωß∞
≠√≤≥÷/‹›°±«»
åáäâãàçéëêè íïîìí
óöôòøúüûùÿ & #
0123456789
¢ $ £ ¥ % ‰ +=* ¶ †
™ • { [()] } , : ; ¿ ? ¡ !
' ' " " • _ _ — © ®

◀◀ A full character set of the Bitstream font, Classic Garamond Roman. Most fonts include more than the upper- and lowercase characters alone. Most amateur type designers overlook the additional glyphs needed for a versatile font. These must include numerals, punctuation marks, ligatures, and special characters including accents and mathematical symbols.

2 The height and width of characters actually varies by small amounts. Characters that are rounded or angled need to be slightly larger than those based on a square or rectangle in order to look optically correct. This diagram demonstrates how some characters are slightly larger than they appear visually.

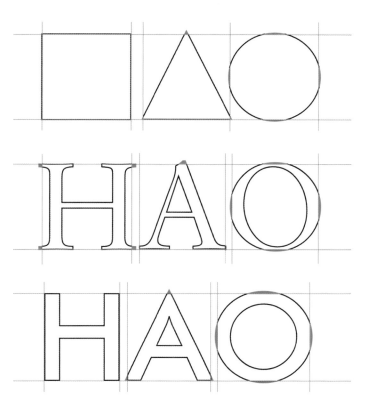

3 Certain glyphs can be omitted when completing a font. You can never be certain what sort of "job" your font will be utilized for. You should therefore make sure you incorporate special characters and symbols, such as the dollar and yen.

£$€¥

ΩßΩ

[]{}()

éèûç

öœæ

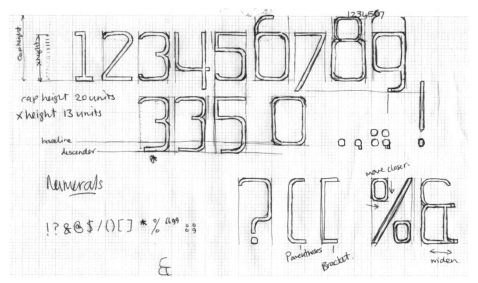

4 These rough sketches show numerals and punctuation marks for the font presented on the previous page. The uniformity of the characters should be retained while considering the design of such glyphs.

■ the basics—building the glyphs

There are two ways to go about digitizing your sketches, building the glyphs, and making them into a complete working typeface.

The first is to scan the sketches into an image manipulation program. Here you can turn them into bitmap files and import them into the font editor to use as templates to autotrace. Alternatively, you can use Adobe Streamline to trace the shapes before importing them. These will then become outlines, saving you the job of tracing them by hand. The second method is to draw them directly in a vector-illustration program like Illustrator or FreeHand. They can then be imported directly as outline characters into the font software.

Both methods depend on your skill with the packages and the style of typeface you are designing. If you are producing a hand-written font it is probably more advantageous to scan and autotrace the glyphs.

If you are skilled in illustration software, you can use the Pen tool in Illustrator or FreeHand to trace around your scans or to draw your characters directly on a grid. The best tip here is to use as few anchor points as you can to construct the letters. Too many will take up more memory and are difficult to control, causing potential problems printing the font at a later stage.

Fontographer automatically scales imported files to a set size. Combat this by placing each character within a box that is slightly bigger than the measurement from the bottom of the descender to the top of the cap height. This guarantees that the glyphs remain the correct size. You can delete the box once imported.

Overlay Sheet

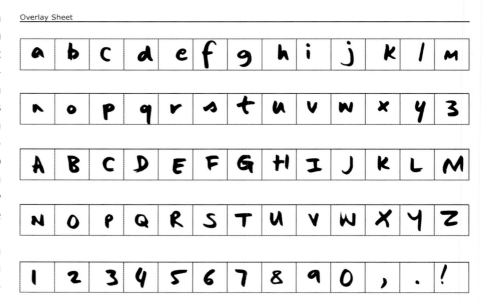

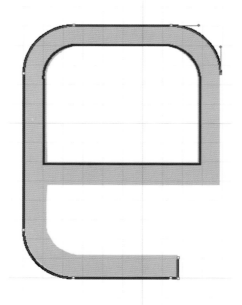

1
◀◀ You can scan glyphs and save them as bitmap EPS files. These can then be imported into the font-editing software for tracing around. You can use the autotrace functions but the software tends to generate too many points, which become problematic later on.

2
▲ With a steady hand and some practice, it is relatively easy to draw around the shapes. You can generate the glyph in the least number of points possible.

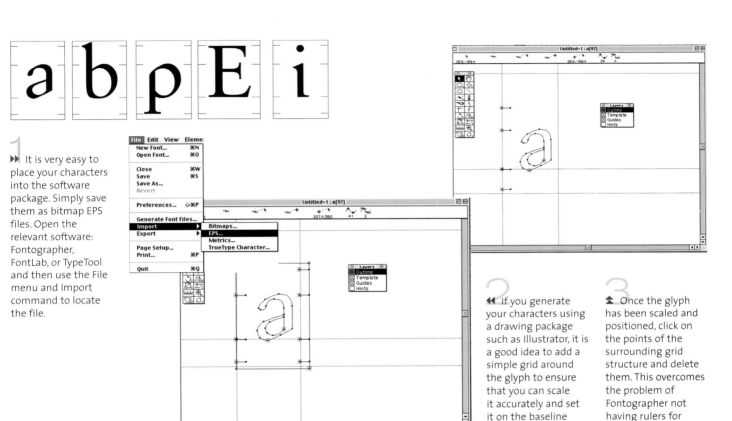

1 ▶▶ It is very easy to place your characters into the software package. Simply save them as bitmap EPS files. Open the relevant software: Fontographer, FontLab, or TypeTool and then use the File menu and Import command to locate the file.

2 ◀◀ If you generate your characters using a drawing package such as Illustrator, it is a good idea to add a simple grid around the glyph to ensure that you can scale it accurately and set it on the baseline in Fontographer.

3 ▲ Once the glyph has been scaled and positioned, click on the points of the surrounding grid structure and delete them. This overcomes the problem of Fontographer not having rulers for measuring characters.

4 ▼ Leaving the excess points can lead to problems when you generate the font file and use it in a big point size. This large character has some inaccuracies to its shape, which would remain unseen by the naked eye at smaller point sizes.

5 ▼ These glyphs have been traced by hand. Notice the smooth shapes that result from discarding all the extraneous detail.

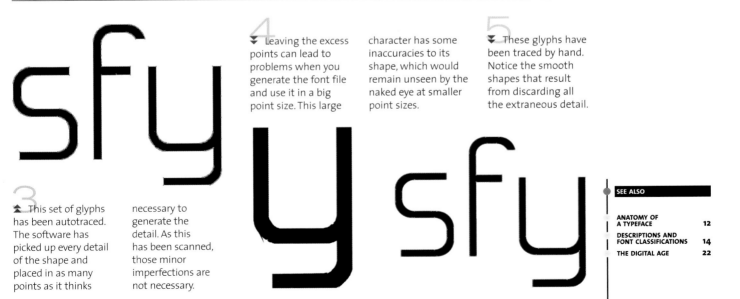

3 ▲ This set of glyphs has been autotraced. The software has picked up every detail of the shape and placed in as many points as it thinks necessary to generate the detail. As this has been scanned, those minor imperfections are not necessary.

creating your own handwritten font

Type designers can spend months creating typefaces. For a more individual approach, you can create a font from your handwriting in a relatively short time.

Using software such as FontLab's ScanFont 4.0, you can digitize your handwriting and convert it into a full working font. Write out your letterforms in boxes on plain paper. They need to be legible and aligned. Go over the characters with a marker to make the strokes easy to pick up on the scan. Scan your image at 300dpi.

Tidy up the scan in Photoshop to make the letterforms darker and more legible. Adjust the contrast and brightness to bring out individual shapes. You need to make sure that the forms are evenly spaced and that you can draw a box around each character. For the software to read the image it needs to be in the form of a bitmap image. In Photoshop, change this by locating the Image Menu and changing Mode to Bitmap. Save it as a TIFF format.

Open up ScanFont and open up your image. ScanFont recognizes individual shapes once they have been imported. You can also set up the preferences to import directly into a font editor such as FontLab, Fontographer, or TypeTool. The Separate Shapes command allows you to distinguish the shapes and to group parts together, such as the stroke and dot of the letter "i." It also sits all characters on a baseline, ready for importing. For this to work quickly and smoothly it helps if you name the glyphs so that the software places them within the correct glyph window in the font editor. In the Operation menu select Assign Names. Type out the glyphs you have produced ("a," "b,""c,"...), including punctuation. Once the characters are in the font editor you can adjust the spacing within the Metrics window and tidy up any characteristics that are not to your liking.

Name the typeface by locating Font Info in the File menu. To turn it into a working font file, choose Build Suitcase from the File menu and select PostScript or TrueType. This generates the font file for you to use.

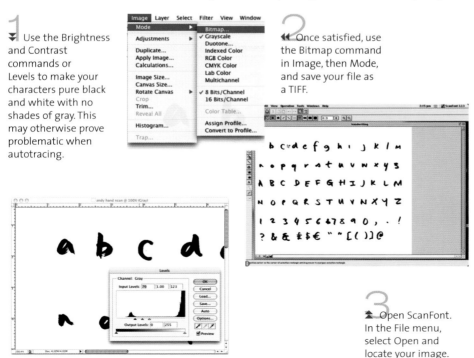

1 ⥥ Use the Brightness and Contrast commands or Levels to make your characters pure black and white with no shades of gray. This may otherwise prove problematic when autotracing.

2 ◀◀ Once satisfied, use the Bitmap command in Image, then Mode, and save your file as a TIFF.

3 ⥣ Open ScanFont. In the File menu, select Open and locate your image.

4 ⬆ In the Operation menu, along the top of the screen, select the Separate Shapes command. You will see boxes appear around each of your characters on screen. You will need to join certain elements together such as the dot and stroke on a lowercase "i" in order for the software to recognize them as one glyph and not two. This function also provides the host software, such as FontLab, with information about the baseline.

5 ▶ Assign names to the glyphs. Use the Assign Names command located in the Operation window. This will make sure that each shape is placed in the appropriate glyph window within the host software.

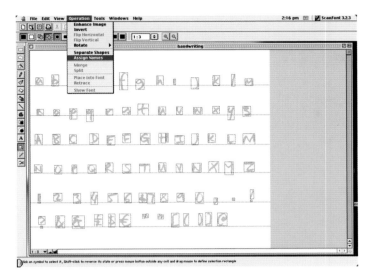

6 ▲ In order for this command to work, you need to select the characters' names by typing the appropriate key on the keyboard in the order they appear on the scanned image, from left to right and top to bottom. When complete, click the Apply Now button.

7 ▼ To export the characters into a font package, first specify which software to place them in. Select Preferences in ScanFont from the Tools menu. This will bring up a dialog box. Use the arrow buttons to locate the Fontlab server options. If using software other than FontLab, such as Fontographer, click on the Custom button. Use the dialog box to locate the software on your hard drive to place the glyphs into.

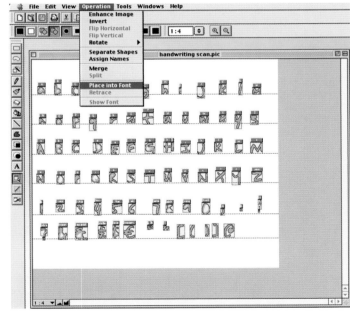

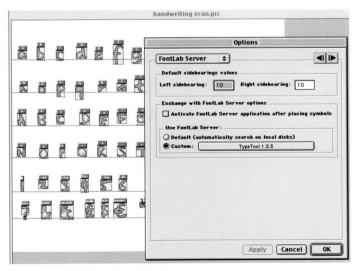

8 ▲ Use the cursor to click and drag around all the glyphs. Then use the Operation menu to select the Place into Font command. This will import the characters into the correct glyph windows.

■ creating your own handwritten font continued

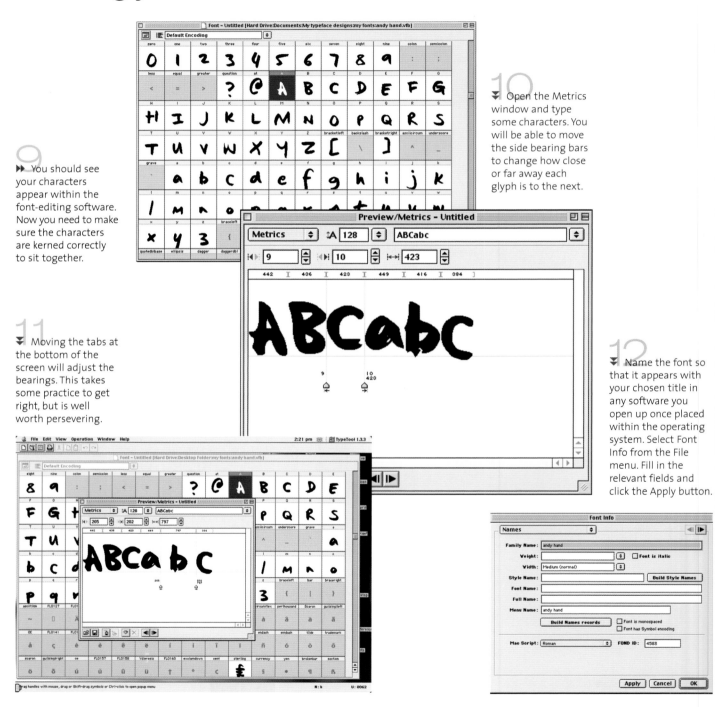

10 ▼ Open the Metrics window and type some characters. You will be able to move the side bearing bars to change how close or far away each glyph is to the next.

9 ▶▶ You should see your characters appear within the font-editing software. Now you need to make sure the characters are kerned correctly to sit together.

11 ▼ Moving the tabs at the bottom of the screen will adjust the bearings. This takes some practice to get right, but is well worth persevering.

12 ▼ Name the font so that it appears with your chosen title in any software you open up once placed within the operating system. Select Font Info from the File menu. Fill in the relevant fields and click the Apply button.

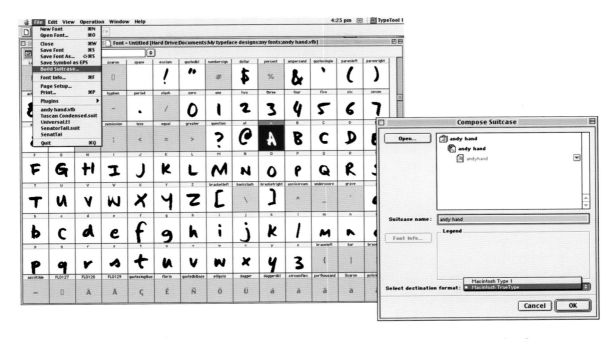

13
▶▶ Generate the font file to provide the information from which the operating system will build the typeface. Select Build Suitcase from the File menu.

14
▲ A dialog box will appear with prompts for the file format of the font. Select a suitable format depending on the operating system and type of computer, either Mac or PC, PostScript or TrueType, and click OK. This file can then be placed within the system folder and used by any software on your computer.

amending existing typefaces

There are times when creating a new typeface from scratch may not be necessary.
Logotypes often manipulate existing fonts to create something slightly different.

If you chose this route, you should check the license agreement for the font on which you wish to base your design, in order to make sure there is no infringement of copyright.

There are a number of ways in which you can manipulate an existing font. You can add to it, take sections away, round it off, and so on. The advantages of doing this are, first, that you will already have bought the font and can open it up in the font editor. Second, it will have been spaced and hinted for you and there will be a variety of weights to choose from.

The tools in Fontographer are similar to those of very early versions of FreeHand. As such you can move, merge, or add anchor points to manipulate glyphs. FontLab's tools are a little more difficult to use, as there are two sets that have similar icons but different functions. However, they both have the ability to manipulate glyphs.

You may want to take a historical serif font and update it. Here, Classic Garamond has been manipulated to produce a more modern look by rounding off features and subtracting some serifs. Other options include making it into a sans serif font, or shortening some of the ears, stems, and spurs. You may want to make it into a script by adding adjoining lines to link the letters together. These may be thick, horizontal lines, or perhaps swashes. You are limited only by your imagination.

There are a number of typefaces currently available that combine both the uppercase and lowercase forms together in one shape. One way to achieve this effect is to cut and paste existing glyphs into a separate window and manipulate them so that they overlap. You can then use the Remove Overlap command in the Element menu to merge the two forms, so creating an entirely new font.

By removing some of the serifs and rounding off certain features, a classical font, such as Garamond, can be made to look radically different.

abcdefghijklmn
opqrstuvwxyz

abcdefghijklmn
opqrstuvwxyz

axtegiv

axtegiv

AMEND TYPE

1 Open your chosen font in Fontographer or FontLab. Here, we have selected Classic Garamond in FontLab. The idea is to amend the font by deleting some of the serifs. Double click on an individual glyph window and select the eraser within the toolbox. By clicking on particular anchor points, it is possible to delete them and smooth out the shape.

2 Parts of the tail on this lowercase "a" are removed. It is now possible to reposition individual anchor points using the selection (arrow) tool.

3 Certain characters may require some thought as to how to streamline them to achieve the desired look. With the lowercase "g," for example, the inner counter space of the lower loop is removed and the anchor points of the outside repositioned to form the new loop.

MERGE TYPE

1 Another way to amend a font is to merge two glyphs into one. Simply open up your chosen glyph window—say the lowercase "e"—and click and drag around the entire character to select it. Use the Edit and Copy command. Open up the next glyph window—the uppercase "E"—and use Edit and Paste. This will place the two glyphs together. Use the Selection tool to position them precisely.

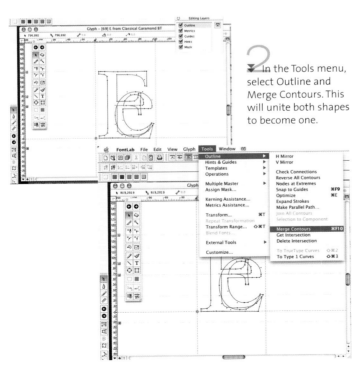

2 In the Tools menu, select Outline and Merge Contours. This will unite both shapes to become one.

3 Above, you can see the effect of the Merge Contours command. This can then be tidied up using the Selection tools to obtain a smooth, consistent outline.

■ combining several fonts (ransom note)

Inspiration for creating fonts can appear in many places, not least the work of other artists or designers.

The Dadaist movement at the beginning of the 20th Century had a distinct typographic look that has been reinterpreted over the years, notably during the punk era of the 1970s. This movement took an irreverent, antiestablishment approach to music and fashion. Designer Jamie Reid applied this to typography, giving it a low-tech, cut-and-paste look, rather like that of a ransom note. He took letterforms from different fonts and combined them to make the logo for the band the Sex Pistols, among other things.

The same effect can easily be achieved with today's software. By choosing several typefaces, and mixing serif, sans serif, regular, bold, italic, and reversed-out characters, you can combine various styles of glyphs into one face. Open up each font and copy and paste individual glyphs into a new font file. Be random with your choices and the sizes of individual letters. Since the letterforms can be copied and pasted from existing fonts and opened up in Fontographer or FontLab, most of the hard work of spacing the sidebearings and hinting has already been done. You will need to pay some attention to spacing, however, and the placing of italic characters next to roman ones. This may take a little working out with the kerning pairs, depending on how tightly spaced you want the glyphs to be. You may decide that the feel of the typeface requires a more haphazard approach and so have more random spacing, too.

1 ►► Begin by opening your font-editing software and starting a new font. Then open an existing font file from your hard drive.

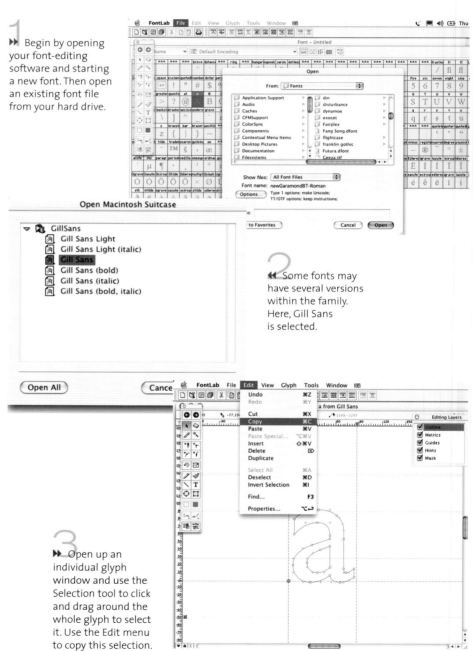

2 ◄◄ Some fonts may have several versions within the family. Here, Gill Sans is selected.

3 ►► Open up an individual glyph window and use the Selection tool to click and drag around the whole glyph to select it. Use the Edit menu to copy this selection.

4 ▼ Open the corresponding glyph window in the new font and use the Edit menu to paste in your copied host glyph. This may require scaling once put in place.

5 ◀◀ Repeat this process with several fonts. The second glyph here is Big Caslon Italic from OSX.

6 ▲ For this kind of font to be effective, it is best to have several contrasting characters—serifs, sans serifs, bold, italic—and a mixture of sizes. The lowercase "f" is from Franklin Gothic.

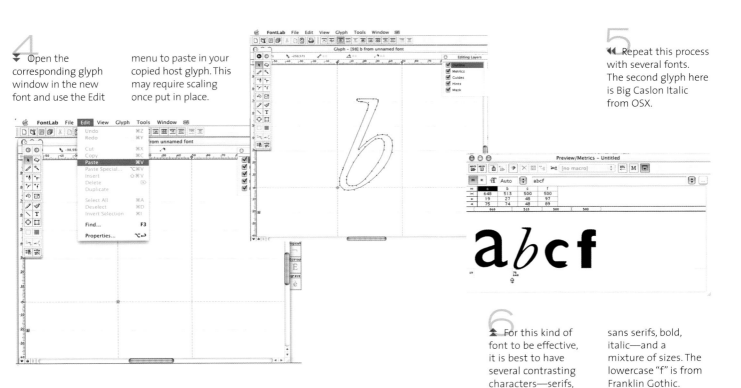

7 ▲ Get the metrics correct. Choosing lots of disparate typefaces can cause problems when placing italics next to regular characters. Pay close attention to the spacing to avoid any overlaps.

■ reviving historical fonts

Hoefler and Frere-Jones Typography, formerly the Hoefler Type Foundry, describes a large portion of their type design work as "revivalist."

Tobias Frere-Jones began a study of lettering on buildings in New York, with a sign for the Port Authority Bus Terminal. This sign became the inspiration and basis of the Gotham font, available through his foundry. Many of the fonts produced by Frere-Jones and Jonathan Hoefler are commissions based on façade signage around the city. They bring together several elements and distinguishing characteristics into one font, or family of fonts, which are then used for a multitude of uses in the company or building it was inspired by.

Old type specimen books can be a great source of inspiration. They tend to include unusual historical faces that may not have been digitized and are therefore unavailable commercially. ScanFont is ideal for digitizing these kinds of typefaces. It is worth checking that, by creating a font from the specimen book, you are not infringing any copyright. Copyright normally lasts for a duration of 50 years. You can overcome the problem by using the letterforms as the basis of a design, but change them subtly to make them more personal.

The beauty of ScanFont is that it takes most of the hard work out of the digitization process. It recognizes shapes and, via a process of naming the glyphs, places them into the correct position in a font-editing package, where you can work on the spacing and kerning pairs. Providing you get a quality scan of the face and clean up the characters in Photoshop, you can produce a new typeface in a just few hours. Although this is an ideal method to use for display fonts, its success for text faces will depend on the quality of your scan.

This particular example is taken from a 50-year-old type specimen book. The resulting font has been manipulated in TypeTool to be slightly different, so as not to infringe copyright laws.

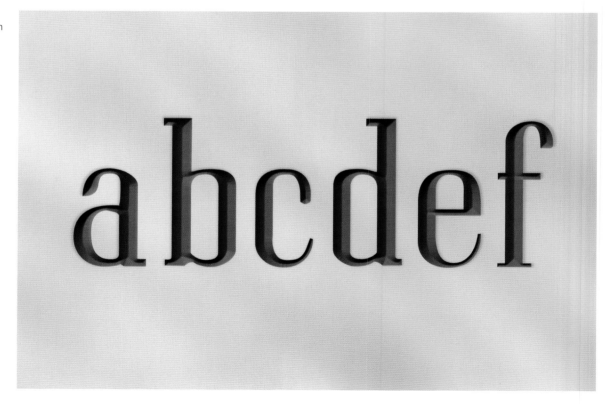

⬇ Clean up your scanned image in an image-manipulation package such as Photoshop, to remove any inaccuracies and to ensure that all the glyphs are clearly separated from each other. Any characters touching may prove problematic when placed in ScanFont. Once the clean-up is complete, save the image as a bitmap file in a TIFF format.

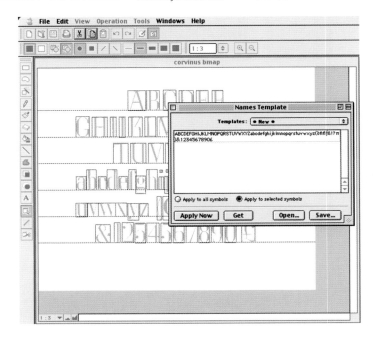

ABCDEF
GHIJKLMNOPQRS
TUVWXYZ
abcdefghijklmnopqrst
uvwxyz (ƈfifflft!?Th)
&1234567890 £

CORVINUS LIGHT AND BOLD

◀◀ Open the ScanFont software and select File and Open to locate the image. Use the Separate Shapes command located in the Operation menu. This command tells the host software to treat each shape on the page as a separate character. You will notice boxes appear around every character on the page.

2 ▶▶ Certain glyphs are made up of two shapes, the stroke and the dot, for example, of a question mark. In order for these shapes to be seen as one letterform, combine them into one glyph. Holding down the Shift key, select the parts of the letterform to be united and select Merge in the Operation menu. The two separate boxes will now become one larger box, encompassing both elements of the letterform.

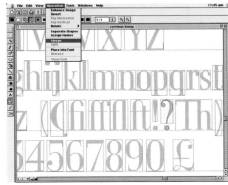

3 ◀◀ The characters are almost ready to export into the font-editing package. In order for the glyphs to appear in the correct position within the software it is necessary to name them. Select the Operation menu and the Assign Names command. In the dialog box, type the characters in the exact order in which they appear on the scan—from top to bottom and left to right—otherwise they will end up in the wrong glyph windows when exported.

■ reviving historical fonts continued

4 Once the operation is complete, a title bar will appear over each character with its name on it. If any of these are incorrect, it may be that you have mistyped the order of the character names or failed to merge certain glyphs together. If this is the case, use Edit and Undo to rectify the problem first.

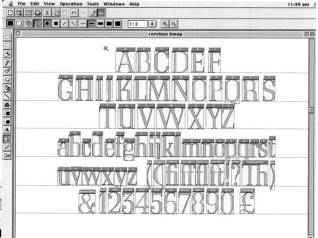

6 Since the letterforms have been generated from a scanned image they may require some cleaning up once they are in the font editor. Here, some of the shapes have lost detail and have become slightly misshapen. The software is designed to manipulate the glyphs, so these distortions can be corrected fairly easily.

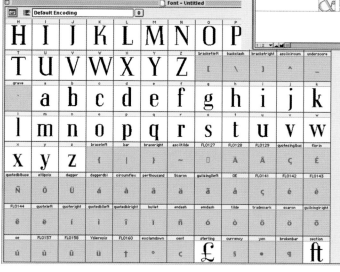

5 Use the Place in Font command located in the Operation menu to export the characters to font-editing software, such as Fontographer, FontLab, or, in this case, TypeTool.

7 Anchor points and handles can be moved and manipulated using the arrow Selection tool. The idea is to generate the character shape with as few anchor points as possible to produce a smooth, fluid shape. Some of the extra points may need to be removed. Use the Eraser tool in the toolbox and click on an anchor point or handle to delete. One of the benefits of TypeTool and FontLab is that you can pull out guides from the rulers, which can be used to line up anchor points.

8

▸▸ The lowercase "b" has become deformed. Many of the straight lines that make up the stem are curved and some of the anchor points do not line up. This makes the shape appear irregular and esthetically unappealing. With some time, a degree of manipulation, and some simplification, it is not difficult to correct these problems.

9

▴ The serif on the lowercase letter "b" should be a slab serif, but here it has become an irregular blob. Move the points and rotate the handles to give the character a more angular look.

10

◂◂ Compare this almost complete lowercase "b" with the one above. The strokes are now more uniform in their appearance, the serifs are angular and straight, and many of the anchor points forming the curves have been lined up to provide a more consistent shape. This process should be repeated for all the glyphs before building the final font suitcase.

creating hybrid fonts

As their name suggests, hybrid fonts are the result of mixing two parent fonts together to create a third. They are simple to generate and offer limitless possibilities.

We live in a postmodern society where the idea of mixing and matching is commonplace. The idea of taking a part of one person's work and combining it with something else has been applied to all the arts and typeface design is no exception.

In recent years, there has been a proliferation of these kinds of fonts and designers have created some unconventional display faces using this method. Whether they are blended together seamlessly or quite crudely cut and pasted, almost anything is possible and the result is a matter of taste. For example, P. Scott Makela designed the font Dead History (available from the Émigré Type Foundry) by simply taking sections of Centennial and VAG Rounded and splicing them together. His methodology was to take half of one and half of the other, using either the left and right or top and bottom of letterforms, depending on how they could be best fitted together. He made no attempt to blend the fonts but left the uncomfortable mismatches as they were. Since then, several other fonts in this vein have become available. Another one worth examining is called Time in Hell, available from the T-26 Type Foundry.

This methodology can be easily replicated using two contrasting fonts and Illustrator and Fontographer. In Illustrator, you can remove sections of the letters and fuse pieces of them together simply by using the Pathway palette. If you then copy these pieces to the pasteboard, they can be used as templates to draw around. Alternatively, you can import the glyphs separately as EPS files directly into Fontographer. In the examples opposite and overleaf, we have used OCR A and Times.

One way of blending two fonts seamlessly is to use Fontographer's Blend Fonts command

The two top fonts have been blended together in Fontographer to create a strange hybrid (below) that still retains some characteristics of both "parent" typefaces.

abcdefghijklmn
opqrstuvwxyz

abcdefghijklmn
opqrstuvwxyz

abcdefghijklmn
opqrstuvwxyz

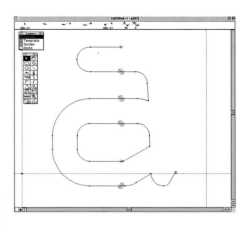

2 Select New Font in the File window and open the appropriate glyph window and paste in your copied selection. Choose the Slice (or Scalpel) tool from the toolbox and while holding down the Shift key on the keyboard, drag a line across or down the glyph. You will notice new anchor points appear with concentric circles around them. These are the slice points.

3 It is possible to select points on either side of these new anchor points and delete them, leaving only half the letterform.

1 There are two ways of completing this kind of font. One is to use Illustrator or another similar drawing package and then export the EPS files into the font editor. The other is to directly manipulate the glyphs in a font package to create a working font. Here, we have done this using Fontographer. Begin by opening up the two fonts you intend to cannibalize. Then select the letterforms one by one. Using the Selection tool, click and drag around the entire character and copy it to the pasteboard.

4 Now open the corresponding glyph in the other font.

5 Copy and paste the glyph into the new font file you have already started. By placing the characters side by side it is easier to scale and position the second letterform before slicing it.

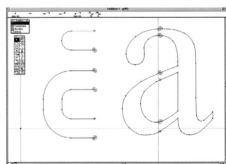

6 Repeat the Slice command as you did previously. However, this time, remove the opposite side of the letterform.

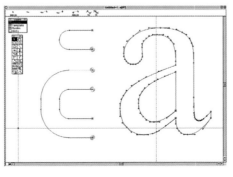

■ creating hybrid fonts continued

in the Element menu. This interesting feature was originally designed to produce inter-weights between bold and light faces but it can be used more creatively. It takes the two outlines and creates an interpolation between them. The result is a strange hybrid that you have little control over but that can be manipulated further later on.

With a little ingenuity, you can create some very unusual hybrid fonts. Try taking serifs from one font and adding them to another, or taking the vertical strokes of one font and adding them to the bowls of another.

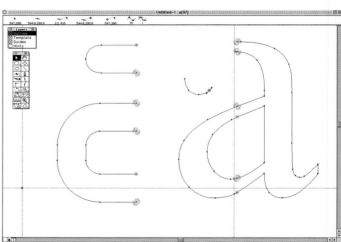

7 ▶▶ Erase the unwanted anchor points by either selecting them individually or clicking and dragging around all of them in one movement and pressing the Backspace key.

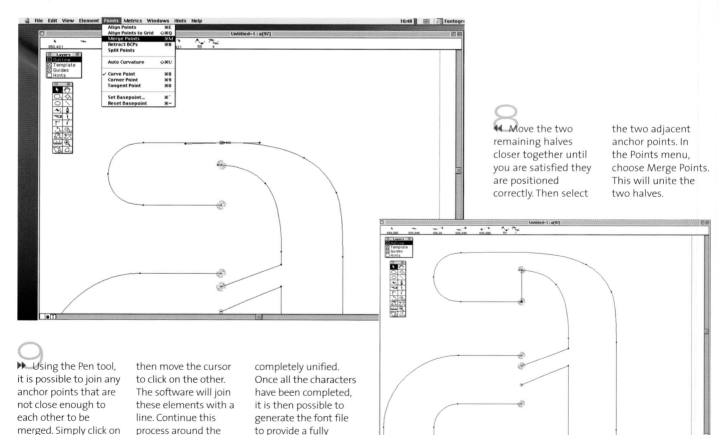

8 ◀◀ Move the two remaining halves closer together until you are satisfied they are positioned correctly. Then select the two adjacent anchor points. In the Points menu, choose Merge Points. This will unite the two halves.

9 ▶▶ Using the Pen tool, it is possible to join any anchor points that are not close enough to each other to be merged. Simply click on one anchor point and then move the cursor to click on the other. The software will join these elements with a line. Continue this process around the letterform until it is completely unified. Once all the characters have been completed, it is then possible to generate the font file to provide a fully working font.

10

▶▶ The other, less controllable, way of merging typefaces is to use the Blend Fonts command. This was originally intended to create interweights for font families, but can produce some creative results. Start by opening the two fonts to be blended.

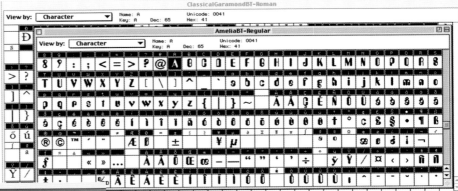

11

◀◀ With both font windows open, select the Element menu and choose the Blend Fonts command. This is an automated function, which interpolates between the two faces. It produces an amalgamation of the two extremes, resulting in a hybrid font.

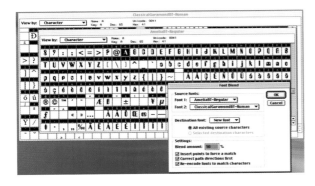

12

▲ In the Font Blend dialog box, set the Blend Amount between the two fonts. Here, we have chosen 50 percent.

13

▲ You can see the original outlines and the new font. The software retains many of the original font's characteristics, creating an unusual typeface. If necessary, the glyphs can then be manipulated further to create a consistent face.

creating your own font from scratch

Creating an entirely new font can be hard work and requires an excellent grasp of the fundamentals of typography.

Most designers start by sketching the letterforms to ascertain the distinguishing characteristics of the font, so draw out your letterforms on graph paper to make sure they all conform to an x-height and similar stroke width.

Once complete, some designers then use the sketches as a template to redraw the glyphs in a vector illustration program, such as Illustrator. However, if the letterforms are relatively simple and only have a limited amount of curves, you can skip the sketching stage and draw the characters on screen with the Square Circle and Pen tool using the Grid in Illustrator. Then combine the characters into single shapes, using the Pathfinder palette.

Save your work as an Illustrator EPS file and import it into Fontographer to refine the glyphs. The importing process can change your forms slightly as the software autotraces the shapes to generate the outlines that appear in the glyph windows. This means you may have to spend a little time tweaking the form to make sure everything is how you want it.

refining your work

Refining a font can be a painstaking process. You need to make sure that the individual glyphs match up and retain uniform features. It is best to construct the glyphs from the least amount of anchor points and Bezier curves as possible so as to ensure no problems with printing.

The next step is to use the Metrics window to look at and manipulate the spacing for the font. Although the software has the capability to space the letterforms, it cannot make the kind of judgments a trained eye can—it is always better to do the final spacing yourself. So try using the automatic function first and then adjust any individual characters by eye.

Then name your font using the Font Info command and generate the appropriate font format by using the Generate Font command.

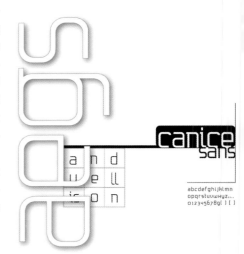

1 First, roughly sketch out your font. It may take several attempts to make the letterforms consistent. Sketching on graph paper makes it easier to replicate the shapes using the grid in Illustrator.

2 Draw out a complete font, including numerals and punctuation.

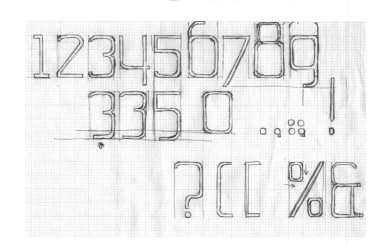

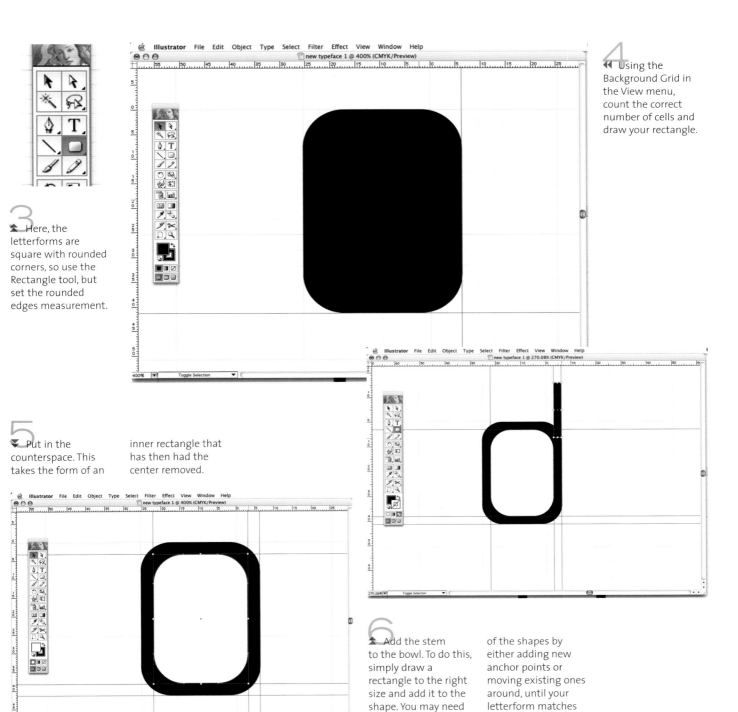

4 Using the Background Grid in the View menu, count the correct number of cells and draw your rectangle.

3 Here, the letterforms are square with rounded corners, so use the Rectangle tool, but set the rounded edges measurement.

5 Put in the counterspace. This takes the form of an inner rectangle that has then had the center removed.

6 Add the stem to the bowl. To do this, simply draw a rectangle to the right size and add it to the shape. You may need to manipulate some of the shapes by either adding new anchor points or moving existing ones around, until your letterform matches your drawing.

■ creating your own font from scratch continued

7
▶▶ Then save each individual character separately in an EPS format. Fontographer does not recognize any file earlier than version 3.0.

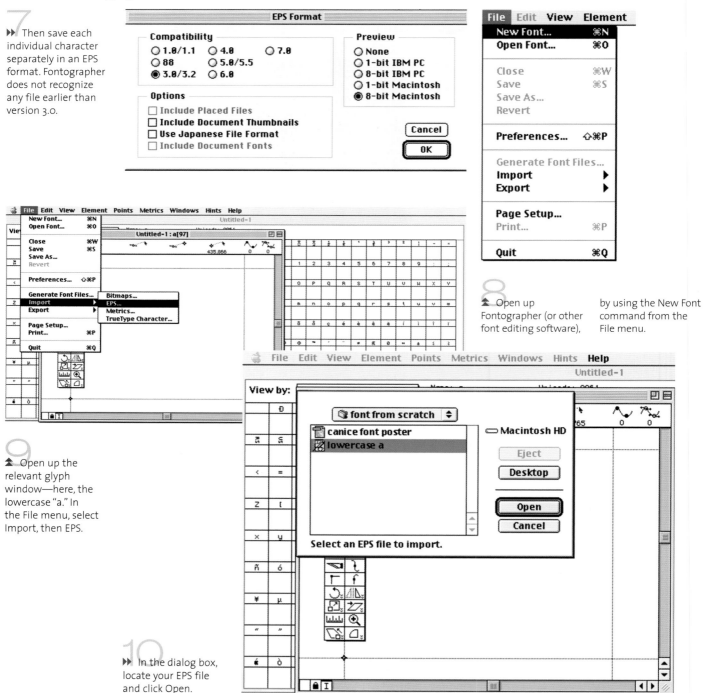

8
▲ Open up Fontographer (or other font editing software), by using the New Font command from the File menu.

9
▲ Open up the relevant glyph window—here, the lowercase "a." In the File menu, select Import, then EPS.

10
▶▶ In the dialog box, locate your EPS file and click Open.

11

▶▶ To produce the glyph in the window, the software autotraces the EPS file. It should produce a fairly smooth character with anchor points. If not, use the tools to simplify the shape.

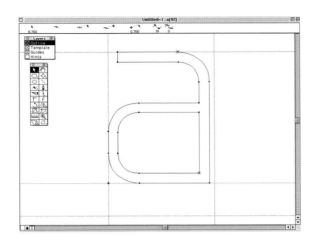

12

▶▶ Repeat the process for all the other characters in the font. Once all the letterforms are in place, work out the correct spacing. The sidebearings (the dotted guides on either side of the letter) control the amount of space around the glyph

when typed on the keyboard. These can be moved in and out to provide more or less space. Open the Metrics window from the Metrics menu to see this in action. By typing combinations of letters, you can see how much space is required for the typeface to be legible.

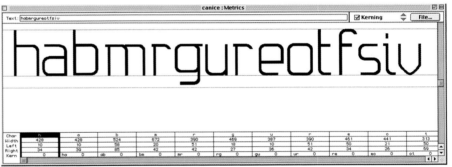

13

▲ Control the side-bearings by clicking and dragging on the L, R, and K markers. Move them in and out to adjust the spacing.

14

▲ Name and save the font. In the Element menu, select the Font Info command.

15

▲ In the dialog box, name the font and encode it for either a Macintosh or a PC, along with setting some of the default

Metrics, such as the Leading. In the File menu, generate the font file as either a PostScript or TrueType font to start using it.

■ modular typefaces

There are three types of font design—proportional serif, proportional sans serif, and fixed width (monospaced). Fixed-width designs are often the basis for modular faces.

Fixed-width fonts all occupy the same amount of space. Each character has the same width whether it is a lowercase "i" or an uppercase "M." These fonts are ideal for the internet, where space needs to be controlled accurately.

As well as this, type forms can be reduced to a basic set. For example, a lowercase "b" is a reversed "d" and an inverted "p," which in turn is a mirrored "q." In effect, a small number of characters can be adapted and amended to produce a full character set.

A modular typeface is one that takes this idea and expands it further by constructing each letter from a certain number of modular units. If you look at digital readouts or dot matrix printers you will see that all the glyphs are made up of set components in varying positions.

You can use this as the basis for designing fonts. Zuzane Licko built coarse bitmap fonts such as Universal, Oakland, and Émigré for the Macintosh using the limited screen grid to dictate the design. Each letter was made up of number of square pixel units. The condensed versions have more vertical units to make them appear thinner.

Fontographer and FontLab can both draw squares, triangles, and curves, which can be the simple building blocks of the font. Here, we took some simple shapes, such as squares, triangles, rectangles, and a curve to build letterforms. These fonts are easy to build within the software, as they don't produce complicated shapes with Bezier curves.

1 ▲ Modular typefaces are often fixed-width (monospaced) fonts, such as Courier. This is based on typewriter faces, where all the glyphs have to be the same width in order to space the letters when typing.

2 ▲ This font is built up from simple geometric shapes—the square and triangle. We have used this as the basis of our design. You can see that each letter occupies the same width as the rest.

3 ▲ This font is based on a simple rectangle and curved shapes. By changing the order of the shapes, you can change the characteristics of each letterform.

4 ▶▶ This font is going to be made up of squares and triangles. Using the Rectangle tool in Fontographer, click and drag out a square shape in the glyph window.

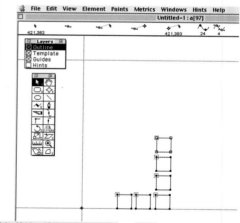

5 ▲ Build up the letterform by copying and pasting the square, stacking one on top of another.

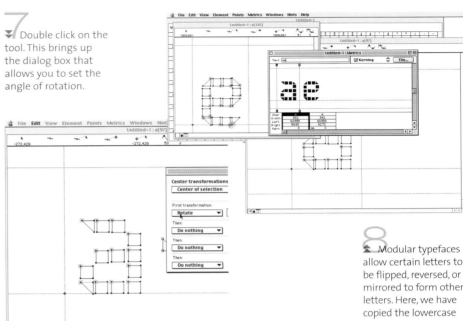

7 Double click on the tool. This brings up the dialog box that allows you to set the angle of rotation.

6 Merging two anchor points together from a square and removing the handles will form a triangle. Rotate these using the Revolve tool to make up the corners of the letterforms.

8 Modular typefaces allow certain letters to be flipped, reversed, or mirrored to form other letters. Here, we have copied the lowercase "a" and pasted it into the letter "e" glyph window by rotating it 180 degrees and then making some changes to give a more rounded or straight shape, where appropriate. This method can be applied to several letters, such as "b" and "d," "u" and "n," and "v" and "w."

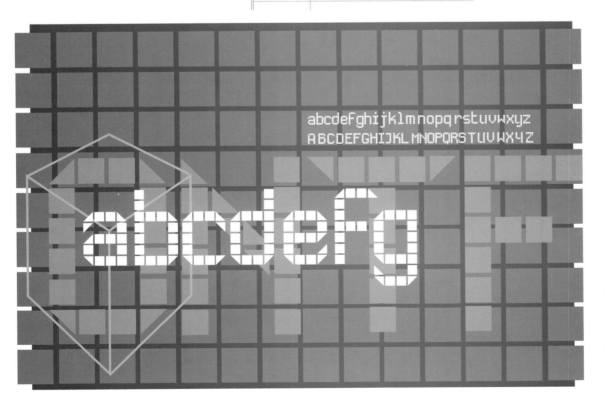

designing pixel fonts

Fonts viewed at low resolution, especially those used on websites, need to retain their legibility. Serif fonts are a problem because their shapes do not reduce well on the pixel grid.

One way around this problem is to use fonts that use square pixels as building blocks. These use only horizontal and vertical lines and so have fewer problems when reduced in size. A simple modular approach results in a font that is legible and relatively simple to create.

As with designing other typefaces, it is usually best to sketch out your letterforms by hand (see p. 164). By using a grid and an existing font as a template you can fill in the squares on the graph paper to generate character shapes. If you keep it simple and use a large grid with no curved shapes, you can create a bitmap font that can be used at any size while still retaining all the shapes of its characters.

The grid is essential for designing an effective face. The software works by turning pixels on and off to generate the letterforms. The more consideration you give to the pixel grid and how this will make up the letters, the better the appearance of the alphabet.

In addition, the characters in your font need to be consistent. If you are creating a small font, you will have to bear in mind the minimum number of pixels needed to create each letter. A lowercase "e" needs to be at least five pixels high. This means other glyphs have to use this measurement even if they can be constructed in fewer pixels. Photoshop can be used to generate the characters as you can set the brush size to one pixel. Using guides, you can then construct your glyphs to actual size. Once you have completed the character set, type combinations of letters to make sure they have a uniform consistency. These can then be saved as bitmaps and imported into Fontographer or FontLab to space and generate the appropriate font files.

Pixel fonts can look coarse and ugly at large sizes. When designing for the screen and to be viewed at small sizes, however, pixel fonts become much more legible. They can also be used to give a modern or "tech" feel to any piece of design.

1 ↥ Pixel fonts are typefaces that use the strict modular approach of using individual pixels to construct letterforms. Above is a font based on this premise.

2 ▼ Work out the shapes of the letterforms on paper first before attempting them on screen. This results in a more consistent font and also means you can take accurate measurements from the graph paper to work out how many pixels are needed for each glyph.

3 ▶▶ Since there are no curves, any rounded strokes have to be made up from joined rectangles. The easiest way to achieve this is to leave white gaps where the arches would usually occur.

4 ◀◀ Open Photoshop and set your canvas size to a resolution of 72dpi—standard screen resolution.

5 ▲ In the View menu, select Show, then Grid. This provides a structure of cells, which can be used to construct the letterforms.

6 ◀◀ This is the grid structure. In the Preferences menu you can control the measurements between the intervals and the subdivisions.

▪ designing pixel fonts continued

7 ►► Use your sketches as a guide to the number of cells within each glyph. Then use the Marquee tool to draw out simple rectangular shapes and use the paint bucket to color them black.

8 ◄◄ This is a completed lowercase "e" letterform.

9 ◄◄ So that Fontographer can read the file, change the Mode in the Image menu to Bitmap, then save it as an EPS file.

10 ▲ In EPS Options, set the Encoding to Binary, then click OK.

11
▶▶ Open Fontographer and begin a new font. Select the appropriate glyph window, then choose Import EPS from the File menu.

12
▼ In the dialog box, locate the image file to be imported.

13
▶▶ Your EPS file will appear in the window as an outline. It may need minor adjustments, so check the character has all its anchor points positioned correctly.

14
◀◀ With all the letterforms imported, adjust the metrics to get the best spacing and then generate the font file.

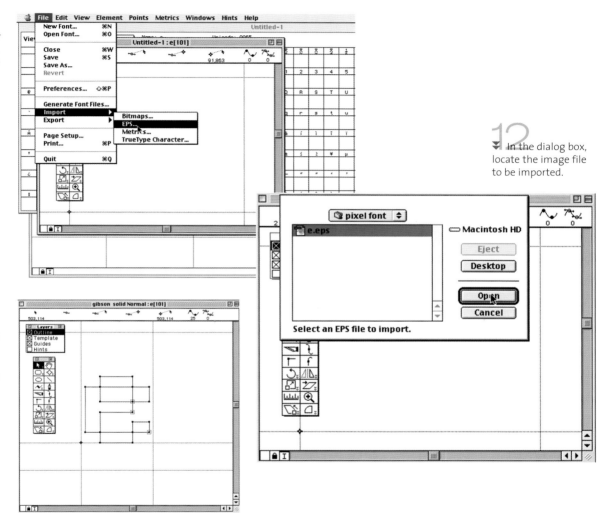

■ creating a font from found objects

Inspiration for fonts can come from a variety of sources. Quite often, designers can find their inspiration in places other than existing letterforms.

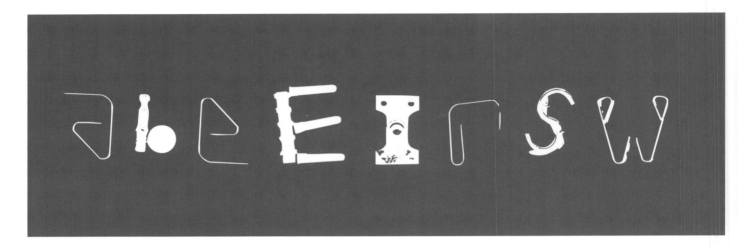

One designer who uses found objects is Paul Elliman. His typeface, Bits, was created originally to feature in the typographic publication *Fuse 15* (1995), with cities as its theme. The font was constructed from of all kinds of found materials he then assembled into letterforms. The letters were made from metal and plastic items such as wire, washers, keys, and brackets. Some of the glyphs were singular items, others were a combination of objects used to make up a shape. Elliman has amassed hundreds of characters over the years to form an organic face that defies many typographic conventions.

getting objects onto the screen

Constructing a face like this takes time. You have to spot the potential for typography within objects. The resulting typeface may also have a very limited use but it still has a place within type design. By scanning either photographs of the object or even the object directly, you can create a similar font. First, the shapes need to be reduced to simple black-and-white images. This can be achieved by manipulating the Contrast and Brightness, or Levels, in Photoshop. The resulting images can then be retraced using either Adobe Streamline or another vector illustration package and pasted directly into the font editor.

You don't have to base your font on several different found objects. You can base letterforms on only one object in particular and manipulate it to complete an alphabet. You can use almost anything. Fonts exist based on objects as mundane as plastic stirring implements and ring-pulls from cola cans. The trick is to spot the potential in the object and adapt it to make up an entire typeface.

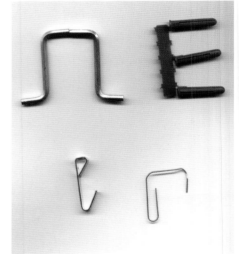

Type forms can be made up from a variety of unusual objects. These may provide a quirky and arresting image. Assemble and combine your objects and then either photograph them and scan the image, or place them directly on the scanner. Above is a small section of the strange glyphs created.

1 Scan the letterforms in Photoshop, then change the Mode in the Image menu to Grayscale to begin the process of making the shapes into glyphs.

2 Select Adjustments in the Image menu to increase the contrast and make the shapes pure black and white with no midtones.

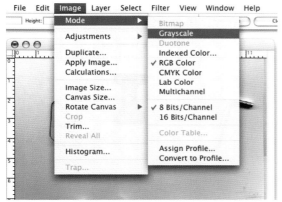

3 Arrange the letters into one file and then in Mode, change them from Grayscale images to Bitmap. Save the image as a TIFF file, to be read by the font editor.

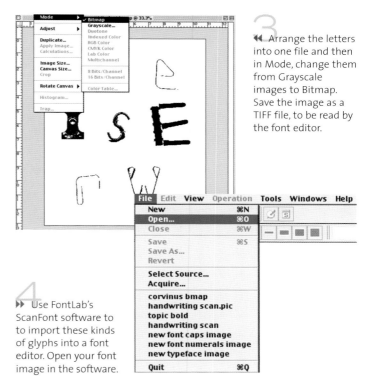

4 Use FontLab's ScanFont software to to import these kinds of glyphs into a font editor. Open your font image in the software.

5 With the image placed, use the Separate Shapes command in the Operation menu to identify the glyphs and place them on a baseline. Some of the characters are made up of more than one shape. In order for them to be recognized as one glyph, select and combine all the elements using the Merge command, also found in the Operation menu.

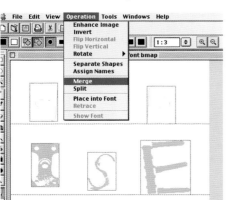

6 Name the glyphs so that they are placed in the correct window in the font editor. Type the characters as they appear from left to right and top to bottom across the image. Click the Apply Now button and the glyph names will appear.

7 Select the Place into Font command from the Operation menu. This is an automated function that positions the glyphs in the appropriate windows within the chosen font editor.

8 Once in the font editing software, adjust the spacing and generate the font file to create a working typeface.

■ creating extra weights

Once you have created your typeface, you will need to create different weights. The majority of font editing applications allow you to embolden the type you have created.

The software works in typographic units of measurement known as "ems." The program increases the measurements of the character based on the number of units you specify. This not only increases the width of the font, but also the height. It also affects the contrast.

The software can simplify the process of type family design by taking two weights of font, for example bold and light, and interpolating them into a third font, in essence, a regular or medium version. This is known as the Multiple Master. The software pinpoints the two glyphs and plots points to create an average. Using this function can result in several weights of a face. Fontographer has the easiest way to achieve this result by using the Element menu and setting the Change Weight command.

As with all software, it has default settings and performs operations on an esthetic, not mathematical, basis, so cannot produce the same result as a carefully considered hand-drawn font because it does little more than increase the stroke weight of the original outline. A hand-drawn version of the character is always much better as the designer can make judgments on the distinctive qualities of the letterform and increase the vertical strokes more than the horizontal ones to produce a more pleasing character. It is much better to redraw a bold version and then autotrace it or amend the software's bold version by moving and manipulating anchor points.

1 ▶▶ Once you have opened your font in Fontographer, you can create extra weights. To do this, select all the characters in the font window, then choose Change Weight from the Element menu.

2 ◀◀ In the dialog box, select the amount of change in em units. As most fonts become bolder, the x-height increases along with a slight increase in the width. If you do not wish this to happen, check the boxes marked Don't Change Vertical Size and Don't Change Horizontal Size.

3 ▶▶ Compare the original character with the new one. Notice how the new one sits just below the baseline whereas before, it sat on it. Make any adjustments necessary to ensure that the face is correct before generating the font file.

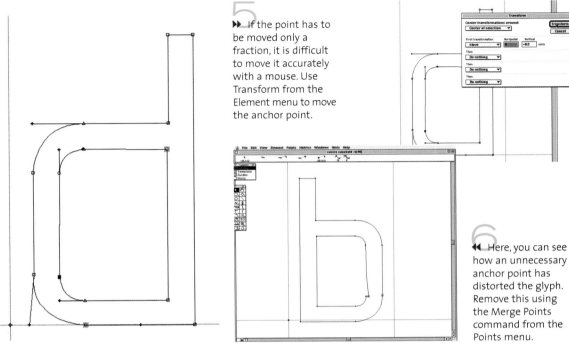

5 ►► If the point has to be moved only a fraction, it is difficult to move it accurately with a mouse. Use Transform from the Element menu to move the anchor point.

4 ►► In the process of increasing the weight, be aware that certain points may move. Here, you can see that the stroke on the top of the bowl of this lowercase "d" is slightly misaligned.

6 ◄◄ Here, you can see how an unnecessary anchor point has distorted the glyph. Remove this using the Merge Points command from the Points menu.

7 ◄◄ The other way to create extra weights is to interpolate between two extremes. So if, for example, you have a very heavy face and a very light one, you can create a weight in between them. To do this, open up both fonts, then in the Element menu, select Blend Fonts.

Element	Points	Metrics	Windows	Hints	Help
Transform...			⌘\		
Arrange			►		
Font Info...					
Selection Info...			⌘I		
Bitmap Info...					
Auto Trace...			⇧⌘T		
Change Weight...			⇧⌘W		
Clean Up Paths...			⇧⌘C		
Expand Stroke...			⇧⌘E		
Recalc Bitmaps...			⇧⌘R		
Remove Overlap			⇧⌘O		
Correct Path Direction			⇧⌘K		
Clockwise					
Counterclockwise					
Blend Fonts...					
Multiple Master...					

Font Blend

Source fonts:
Font 1: canice sansbold
Font 2: canice sanslight

Destination font: New font

● All existing source characters
○ Selected destination characters

Settings:
Blend amount: 50 %

☑ Insert points to force a match
☑ Correct path directions first
☑ Re-encode fonts to match characters

OK
Cancel

8 ▲ In the dialog box, set the Source fonts and the Blend amount. Here we have entered a figure of 50 percent.

9 ▲ The resulting glyph has the outline guides of both source fonts with its own outline placed between them.

creating outline fonts

Specialist, outlined versions of a font can be created by using some simple commands in the font generation software. This allows you to control the width and style of the stroke.

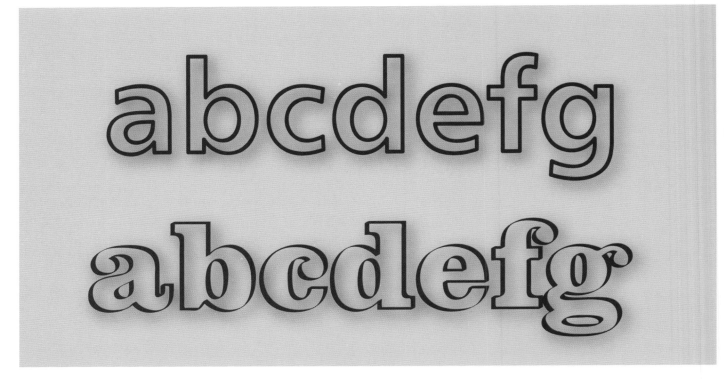

If you are using Illustrator or FreeHand, you only have to apply a stroke of a set measurement and a fill of None to obtain an outline face. By contrast, QuarkXpress does not produce a true outline font when using the Outline command in the Measurements tool palette. The fill always remains a solid color and you have no control over the depth of the stroke width.

You may also need to produce type with an outline of a set width. Illustration packages allow you to control the weight of the stroke, a function that page layout software may not provide. In this case, it is best to produce a version of the font where you can set the stroke measurement yourself.

Fontographer and FontLab give you the control to create an outline version of any font. You can specify how thick the stroke width is by specifying it in a measurement of ems. It is easy to use and you can manipulate the letterforms by using Expand Stroke, which appears in the Element menu in Fontographer and the Outline submenu in the Tool menu in FontLab. By keying in different values you can experiment until you obtain the desired result, controlling not only the number of em units that make up the width of the outline but also whether the end caps and joins have mitered, rounded, or beveled corners.

Fontographer also gives you the option to use the calligraphic pen commands. By selecting all the characters, the software applies this to the font in the glyph windows. You then just have to generate the font file in the appropriate format. The spacing and hinting may need manipulating depending on the amount of stroke you have applied. A large stroke may require that you increase or decrease the spacing between characters.

1 ►► First, open the font in Fontographer. In the Element menu, choose Expand Stroke. In the dialog box, select Normal pen or Calligraphic pen and set the Pen width in em units. Also select the join options—Miter, Round, or Bevel.

2 ◄◄ In the same dialog box, select the Cap option—Butt, Round, or Square.

3 ◄◄ Once you have clicked OK, the stroke width appears in the glyph window. This may take some practice to get right.

4 ▲ If you select all in the font window, you will be able to apply the command to all the characters at once. You can see how this has worked in the metrics window.

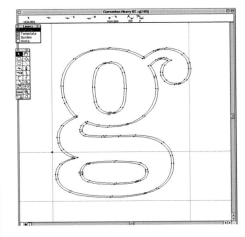

6 ◄◄ As you can see in this screenshot, the outline is more uneven in its stroke width. Experiment with different pen angles to obtain various effects.

5 ►► To gain a slightly more expressive atmosphere, try using the Calligraphic pen option. Set the Pen width and Pen angle to make the type look as if it has been created with a flat nib.

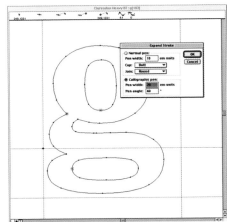

■ spacing

Letterspacing is just as important as the shapes of the glyphs themselves. Without careful consideration of the spacing, the font won't create an even tone of text on the page.

The best way to control letterspacing is to alter the sidebearings. These are guides the software generates on either side of the character to determine its proximity to another glyph. The sidebearing for each character is not uniform. Optically, some characters, such as those generated in thinner fonts, require more space than others. Conversely, extra bold or black characters require much tighter sidebearings.

Altering the spacing is a painstaking process but is always worth it. The basic principles are that letters with vertical strokes have larger sidebearings than curved ones, which in turn have larger sidebearings than letters with angled strokes.

Test letters against each other in the Metrics window. Start with a lowercase "n," placing five characters together (nnnnn).

Each character should have enough space around it so that it still looks like an "n," rather than running together to form an "m." The left upright stroke should have slightly more space than the right curved stem. Repeat for the lowercase "o," whose sidebearings should be equal on each side and less than those on the letter "n." You can then adapt these values to suit the other letters. Certain letters, such as "g," "s," "t," and "z," are best spaced by eye.

Start spacing capitals with an "H," an "O," and an "A," which form the three basic shapes of a square, a triangle, and a circle. Repeat the process as before. "H" receives the most space, "A" the least.

Some of the characters on the left have an appropriate amount of space around them, whereas others are too close to each other. Character recognition can be difficult with certain glyph combinations when spacing is too close, such as an "r" and an "n" looking like an "m."

1
▼ To start, see how the characters look when set next to each other. In Fontographer and FontLab, this is shown in the Metrics window. Select Open Metrics Window from the Windows menu.

2
▲ First, set individual characters such as a lowercase "n." Here, we have the Bitstream type library's version of Classic Garamond. Notice the amount of space surrounding the glyph and how, when they are placed side by side, each one is easily recognized.

3
▼ Curved characters, such as a lowercase "o," can cause problems when set next to each other, so check their spacing. This should be less than that given to horizontal glyphs, such as "n," to compensate for the curvature and to make them look optically correct.

5 To set the spacing, open the glyph window and move the dotted sidebearings closer to, or farther away from, the glyph. To set an identical amount of space on either side of the character, use the Equalize Sidebearing command in the Metrics menu. This will center the letterform within the guides. This should be used for letters such as a lowercase "o."

4 These are different weights of the same font in the Metrics window. To be easily recognized, condensed typefaces and those with light stroke widths require more space than those of a bolder nature.

6 Once you have completed the adjustments, review them in the Metrics window to make sure they are adequately spaced.

7 Certain characters require more space on one side than on the other. An example of this is shown here. Since the glyph has a prominent serif on the left-hand side it needs less space on that side than on the right-hand side.

8 Uppercase letterforms conform to three basic shapes—a circle, a square, and a triangle. By looking at an "H," an "O," and an "A," you can ascertain the amount of space required for each of these shapes and apply them throughout. As a basic rule, the "A" and "O" will need less space than the "H."

9 Space uppercase letters exactly the same as with the lowercase letters, repeating glyphs to see how well they sit next to each other.

SEE ALSO

■ kerned pairs

Kerned pairs are instructions built into the type file to correct spacing between certain characters when placed together.

No matter how carefully you set up the sidebearings, certain glyphs require the space between them to be altered further when placed side by side. Pairings such as "Av" and "To" end up with spacing that looks optically incorrect. To fix this, the letters require kerning, but instead of doing it manually in the page layout software, you can embed instructions into the type file to correct certain character combinations. If you imagine that two glyphs, complete with sidebearings, are placed in separate boxes, kerning allows those two boxes to be overlapped to reduce the amount of space between the letters. A font can have many kerned pairs. These are best edited by

eye. Correction can be a laborious process and although Fontographer and FontLab have the ability to automatically kern a typeface, it is never as successful as doing it manually.

The Metrics window in the software allows you to adjust kerning pairs. It is a simple process of typing in the glyphs then picking up the guides for the sidebearings and dropping them in the correct position. This information is saved with the font so your instructions remain in the file. A successful text face relies on paying special attention to spacing and kerned pairs, so it is always worth taking some time over these elements.

typical pairs

The design of the font will typically determine how many kerned pairs you will need. Lots of circular, curved, or diagonal strokes require more kerned pairs as they sit better with less spacing between them. The characters that normally require attention are the numerals 4, 6, 7, and 9, and the uppercase letters A, C, D, F, G, J, K, L, P, S, T, U, V, W, and Y. Professional type designers can spend weeks going through this process to make sure that the text has rhythm and definition by generating a uniform tone for the typography. They do this in the knowledge that their designs can then be used for a multitude of functions.

AV ov
AO to
AV ov
AO to

1 ▲ Within the font file, embed instructions to kern particular combinations of letterforms. Certain glyphs require extra kerning when placed side by side. Particular pairings, such as "A" and "V," need special attention due to the angled strokes. You can see in the Metrics window that the space between them looks too large.

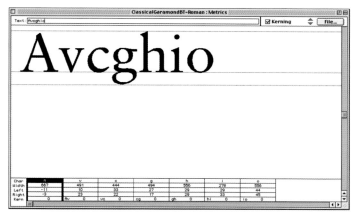

ClassicalGaramondBT-Roman : Metrics

Text: Avcghio ☑ Kerning File...

Char	A	v	c	g	h	i	o
Width	667	491	444	494	556	278	556
Left	-11	10	33	27	29	29	44
Right	-3	23	22	17	29	33	45
Kern	0	Av 0	vc 0	cg 0	gh 0	hi 0	io 0

2 ◀◀ The space between the letters "A," "v," and "c" in this Garamond face looks much greater than that of the other characters. By generating kerning pairs it is possible to rectify this without the need to kern manually in the layout software.

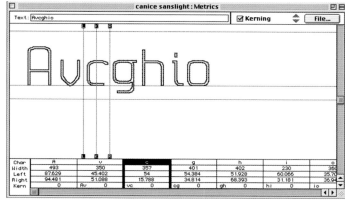

canice sanslight : Metrics

Text: Avcghio ☑ Kerning File...

Char	A	v	c	g	h	i	o
Width	493	350	357	401	402	230	360
Left	87.629	45.402	54	54.384	51.928	60.066	35.70
Right	94.481	51.088	15.788	34.814	68.393	31.181	36.94
Kern	0	Av 0	vc 0	cg 0	gh 0	hi 0	io

3 ▶▶ "A" and "v," and "c" and "g" need some kerning. By clicking on the letterform in the Metrics window you will see the Left, Right, and Kern guides appear. By dragging these guides closer or farther away from the character, you control the amount of kerning between them.

canice sanslight : Metrics

Text: Avcghio ☑ Kerning File...

Char	A	v	c	g	h
Width	451	329	357	401	402
Left	88	24	54	54.384	51.92
Right	52.11	51.489	15.788	34.814	68.39
Kern	0	Av 0	vc 0	cg 0	gh

4 ◀◀ In the kern field at the bottom of the window you will see the letter combinations along with the values of the amount of kerning required on the left or right of the glyph.

canice sanslight : Metrics

Text: Avcghio ☑ Kerning File...

Char	A	v	c	g	h	i	o
Width	451	308	343	401	402	230	360
Left	88	24	40	54.384	51.928	60.066	35.70
Right	52.11	30.489	15.788	34.814	68.393	31.181	36.94
Kern	0	Av 0	vc 0	cg 0	gh 0	hi 0	io

5 ▶▶ This process is labor intensive, but it is worth doing to produce typography that is both legible and has rhythm. Once the adjustments are complete, the software will save the information in the font file. This will then be used to display the font in other programs.

■ controlling hinting

Software developers and typographers need to consider the problem of rendering scalable type on low-resolution devices. Controlling hinting can help with this.

The eye makes high demands for visual consistency on typography—any inconsistencies are immediately visible. Character outlines scaled to a given size and resolution are often visually unappealing or illegible when using mathematically correct procedures. One way to make sure the type looks consistent throughout varying sizes at 72dpi is through hinting. Hinting is the name for the set of techniques for restoring, as far as possible, the esthetics and legibility of a given typeface.

In general, the process consists of careful, small adjustments to the process of filling the outline. At low resolutions, rounding effects mean that parts of some characters can disappear, and other parts can appear too thick or too thin. Hints attempt to correct this by equalizing weights of stems, preventing parts of glyphs disappearing and generally maintaining esthetic appearance and legibility down to as low a resolution as is possible.

TrueType format fonts have more complex hinting instructions. The nature of the file allows each little glyph to have its own hint program to make sure it remains consistent throughout the sizes. PostScript fonts do not have as effective a system.

Hinting is a complicated process, where each individual letterform has to be assessed at a set resolution to figure out where the hinting needs to be applied. There are hints to make sure that stroke widths appear to be the same width vertically and horizontally, along with how thick the serifs are and how far round figures overshoot the baseline.

The software does offer autohinting functions. These work mathematically and do reduce the need for laborious work on the part of the designer. But these may still need some adjustments later on to make letters look optically correct at low resolution.

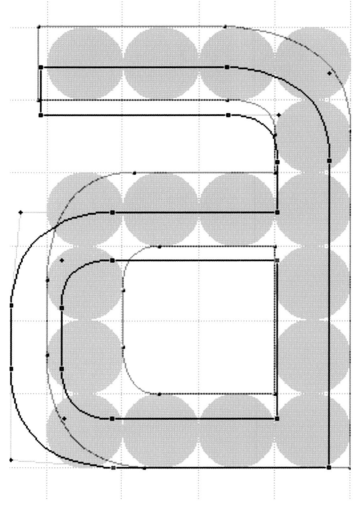

Hinting is time consuming and complicated. It is a process of going through every character and making sure that it renders legibly at every point size. If you have a large font family this could mean working on up to 2,000 glyphs. Most designers use autohinting and then fine-tune the results.

1 FontLab has all the hinting information located in the Tools menu. Select Hints and Guides and then choose Autohinting from the submenu. There are two different types of hinting—Type 1 and TrueType. TrueType is the most complex but also the most effective as it generates a hinting program for every character. These options can be found in Operations in the Tools menu.

2 If you select the Type 1 option, you may see a warning box. It is worthwhile making any corrections before proceeding. A preview box will then appear with your typeface shown at a variety of sizes. You can see how the software has manipulated certain letterforms to be legible at a variety of point sizes.

3 In the glyph window, you will see a series of points and guides. The black areas are the active contours; arrows are the direction of the contours; yellow areas are overlapping zones of hints; and yellow marks the starting points for contours. Green "HR" marks are points for hint substitutions. To delete a hint, hold the Control key and click with the mouse on the outline. In the resulting dialog box, choose Delete this hint.

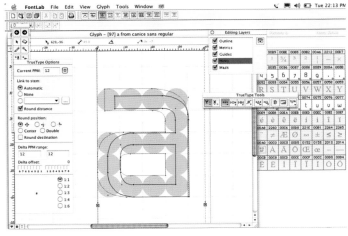

4 If you need to add a hint to a character, press the Control key, click with the mouse and choose Add Horizontal, Vertical Hint, or Link. With the TrueType option selected, the method and tools are quite different. In the glyph window, you can see the number of pixels available and how it affects the character.

5 Work your way through a variety of point sizes to see how the glyph is affected. A new toolbox appears with a selection of specialist hinting tools available. These control horizontal and vertical directions, along with alignments and links. Links are important as they are used to set a relationship between outline points and set distances between stem points.

generating font files and using fonts

When you have completed the design of your font, the next stage is to write the font files to generate a working typeface.

When generating your font file, you need to decide two things: first, the format; second, the platform the font will run on. The two main formats supported by the majority of operating systems are TrueType and PostScript Type 1. TrueType was developed by Apple and Microsoft and is the easier of the two to install and use. PostScript fonts are traditionally considered to be higher quality and are favoured by designers and output bureaus. They may require additional software such as Adobe Type Manager (ATM) to render the fonts correctly on screen.

As regards formats, it is best to create both Macintosh and Windows versions of your fonts to make sure they work on almost all systems.

commercial use of fonts

If you are designing a font to be sold it is important to check it for any anomalies or technical errors. Print it from as many printing devices and platforms as possible to ensure it works correctly.

If you want to sell the face, submit it to one of the many type foundries. They will promote and market the font, taking a percentage of sales revenues in return. You can also make your font available through your own website. This will give you greater control of revenues but you will have to do your own marketing. Alternatively, make the font available as a free shareware download from your site.

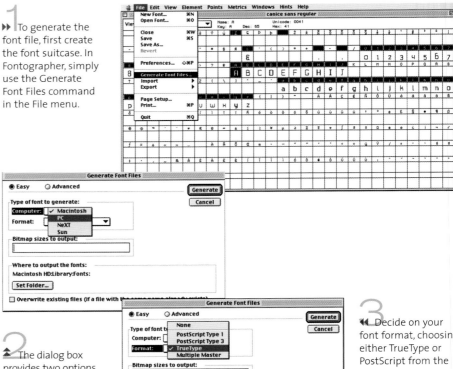

▶▶ 1 To generate the font file, first create the font suitcase. In Fontographer, simply use the Generate Font Files command in the File menu.

▲ 2 The dialog box provides two options, Easy and Advanced. Select Easy then choose your desired format from the Computer menu.

◀◀ 3 Decide on your font format, choosing either TrueType or PostScript from the Format menu.

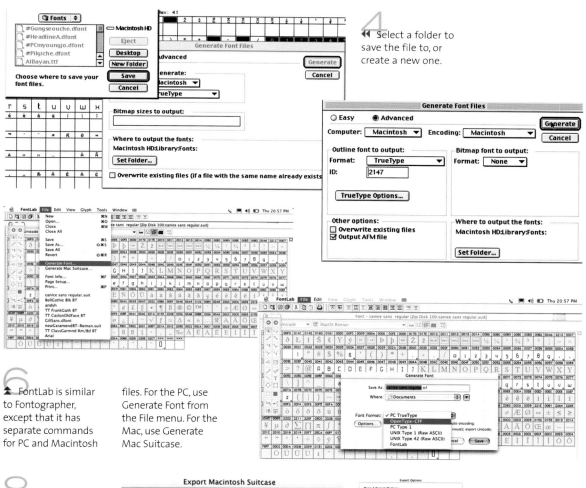

4 Select a folder to save the file to, or create a new one.

5 The Advanced option is more complicated. You still select your platform from the Computer menu but this time you can set your desired Encoding. You can also output an AFM file in Other options, giving details of the font.

7 Select your desired Font Format. FontLab differs from Fontographer in that it has the advantage of being able to generate OpenType file formats. These can contain hundreds of characters, including foreign language glyphs, all in one file.

6 FontLab is similar to Fontographer, except that it has separate commands for PC and Macintosh files. For the PC, use Generate Font from the File menu. For the Mac, use Generate Mac Suitcase.

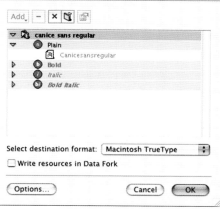

8 The commands for creating a Mac file use simple icons rather than text. After deciding the file format, set the destination folder in Export Macintosh Suitcase then click OK.

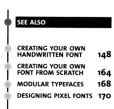

9 Finally, the Export Option dialog box allows you to turn on and off certain functions such as hinting, along with the AFM file.

■ index

■ index continued

DEC 1 3 2007

0 1341 1043069 8

■ picture credits and acknowledgm

Every effort has been made to contact the copyright holders for all the images in this book.

Axis Publishing Ltd. apologize for any omission, which, if drawn to our attention, will be corrected on a reprint.

Adobe Systems, Inc.: 25 (middle and bottom), 54, 55, 59 (left top to bottom), 61 (top and middle), 63, 64, 65 (center and bottom right), 67, 69 (top left and right; bottom left), 70, 71 (bottom left and right), 72 (top right and left), 73 (top row), 74 (right), 75 (all images except center right), 77, 78, 79, 80, 81 (center right and bottom), 83, 84, 85 (bottom left and right), 86 (top and bottom right), 87, 88 (bottom three images), 89 (all images except top), 90 (left, center, and bottom), 91 (all images except bottom right), 93 (all images except bottom), 94 (right), 95 (all images except top right), 97 (all images except bottom), 98 (center and bottom), 99 (all images except bottom left and right), 100, 101 (center and bottom), 103, 104 (center left and right), 105 (center left and center right below), 107, 108, 109 (all images except top), 110 (all images except bottom right), 111 (all images except bottom), 112 (top), 113, 114 (all images except top), 115 (all images except top), 117, 118, 119 (all images except top two), 121 (all images except bottom left), 124 (bottom), 131 (all images except top and center left), 132, 134 (top and bottom right), 135, 136 (center), 137 (all images except top and bottom right), 140, 143 (bottom left), 148 (top and bottom left), 151 (bottom), 165, 171 (all images except top left and right), 172, 175 (center left)

Apple Computer, Inc.: 11, 23, 24, 25 (top), 50, 51 (top), 120 (center and right), 121 (bottom left)

Axis Publishing Ltd.: 16 (left), 62, 65 (top and bottom), 66, 71 (top), 76, 82, 88 (top and second top), 89 (top)

Andy Ellison: 42, 44, 45 (top images), 46, 47, 58, 60, 61 (bottom), 62, 68, 69 (middle left and right; bottom right), 72 (bottom), 73 (bottom three images), 74 (left), 75 (center right), 81 (top and center left), 85 (top), 86 (bottom left), 90 (top and center right), 91 (bottom right), 92, 93 (bottom), 94 (top), 95 (top right), 96, 97 (bottom), 98 (top), 99 (bottom left and right), 101 (top), 102, 104 (bottom right), 105 (top and center right; bottom left), 106, 109 (top), 110 (bottom right), 111 (bottom), 112 (bottom), 114 (top), 115 (top), 116, 119 (top two images), 122, 123, 128, 130, 131 (top and center left), 134 (left), 136 (top and bottom), 137 (top and bottom right), 142, 143 (top, center left, bottom right), 145 (top and bottom), 146 (top), 147 (top and

bottom), 152, 155 (bottom left), 157 (center left), 160 (bottom), 164, 168 (top and center left), 169 (bottom), 170, 171 (top left and right), 174, 175 (top left), 176 (top), 178, 180 (top), 182 (left), 184

Extensis, Inc.: 51 (bottom), 52, 53

Paul Felton: 43 (left)

FontLab Ltd.: 141, 143 (center right), 147 (center and center right), 148 (center and center right), 149, 150, 151 (top), 153, 154, 155 (all images except bottom left), 157 (all images except center left), 158, 159, 161, 162, 163, 166, 167, 168 (center right and bottom), 169 (all images except bottom), 173, 175 (all images except top and center left), 176 (all images except top), 177, 179, 180 (all images except top), 181, 182 (right), 183, 185, 186, 187

Adrian Frutiger/Linotype GmbH: 20

Microsoft product screen shots reprinted with permission from Microsoft Corporation: 120 (left), 133

Quark. Reprinted with permission of Quark, Inc. and its affiliates: 22, 40, 41, 45 (middle and bottom), 48, 49, 59 (right top to bottom)

Staffordshire University: 43 (right)

Volker Steger/Science Photo Library: 11

Topfoto/HIP: 16 (right)

Author acknowledgments

I would like to thank Canice for his support, patience, and understanding while completing this book; Paul Felton and Staffordshire University for allowing me to use examples of their work to illustrate my text; and finally Apple—without my trusty PowerBook G4, this project wouldn't have been possible.